Geography is both a form of common knowledge and an academic discipline; its language of cartography and topography is so familiar that it seems natural and incontestible. But it is far more than a mode of charting the known world; geography is a source of authority in the fundamental questions of inclusion and exclusion and plays a crucial role in the determination of identity and belonging. But how adequate is geography as a source of authority in the modern world? And can contemporary art challenge and transform that authority?

Terra Infirma explores how geography writes relations between subjects and places, and examines both the truth claims and the signifying practices of geography as a language in crisis, unable to represent the immense changes that have taken place in the post-colonial, post-migratory and post-communist world. Combining an analysis of the way in which geography defines the concept of belonging with an investigation of its visual signification, Irit Rogoff asks whether contemporary art can rewrite geography's relations with place and identity.

Examining contemporary art practices from around the world, including the work of Joshua Neustein, Mona Hatoum, Hans Haacke and Alfredo Jaar, Rogoff explores these issues through the themes of luggage, mapping, borders and bodies. In the process the book reveals the complexity of contemporary art's engagement with the problematic of geography and the immense variety of alternative strategies available to review our relationship with the spaces we inhabit.

Irit Rogoff is Chair of Art History and Visual Culture at Goldsmith's College, University of London.

Terra

Infirma

Geography's visual culture

Irit Rogoff

London and New York

First published 2000 by Routledge
11 New Fetter Lane, London EC4P 4EE

Simultaneously published in the USA and Canada
by Routledge
29 West 35th Street, New York, NY 10001

Routledge is an imprint of the Taylor & Francis Group

Typeset in Perpetua by Florence Production Ltd, Stoodleigh, Devon
Printed and bound in Great Britain by Bell and Bain Ltd, Glasgow

British Library Cataloguing in Publication Data
A catalogue record for this book is available from the British Library.

Library of Congress Cataloging in Publication Data
 Rogoff, Irit
 Terra Infirma: geography's visual culture / Irit Rogoff.
 p. cm.
 Includes bibliographical references (p.).
 1. Geography in art. 2. Art, Modern—20th century. I. Title.
 N8217.G437 R63 2000
 709'.04–dc21 99–052594

ISBN 0–415–09615–4 (hbk)
ISBN 0–415–09616–2 (pbk)

To Alexander and Malka Keynan

Contents

Illustrations

Figures

Colour plates

Acknowledgments

The geographical multiplicities and fragmentations that are the concern of this book can equally be traced through the scattered conversations and friendships that have helped me bring my ideas to fruition. In the course of these musings, I have incurred more debts of friendship and hospitality in more countries and languages than I can begin to recount and certainly more than I can express gratitude for on these pages. A few individuals intervened directly and to great effect; Moira Roth, Abigail Solomon-Godeau, Sarat Maharaj and Neil Smith read the manuscript and made important suggestions for its improvement. Others authored the work on which I have tried to build, particularly Homi Bhabha, Victor Burgin, Ella Shohat, David Lloyd and Vincente Raphael, among others. Beyond the theoretical, my main interlocutors have been the many artists whose work spurred me on to engage with the great authority of 'geography'. All of them gave generously of their time, huddled for hours in draughty cafés, and discussed our mutual and separate ideas. All of them have allowed me to print their work and supplied me with the means of doing so. In the case of the work of Ana Mendieta I owe a particular debt to the Lelong Gallery in New York and to its director Mary Sabbatini and its archivist Cecile Panzieri, whose friendly helpfulness is always accompanied by that most miraculous quality of efficiency.

The work on this book benefited greatly from several faculty development grants awarded by the University of California at Davis, by a research fellowship at the UCHRI as part of the 'Minority Discourse' initiative overseen by Mark Rose, the then director of HRI, and by Valerie Smith, the group's convenor. It was equally important to have spent a year at the Kulturwissenschaftliches Institut in Essen and to have had many conversations with Sigrid Weigel, then the co-director of the Institute and with the members of the group on 'Topographies of Gender'.

Much of the conceptual work on this book took place in trying to formulate it as a subject for teaching; my students at UC Davis, particularly Stephanie Ellis and Vincente Golveo, as well as guest professorships at UC Santa Barbara and at the Ruhr Universität Bochum and the student work produced in those seminars, helped convince me that there was indeed a subject to be formulated and explored. In 1997 I co-taught a seminar with Orly Lubin at Tel Aviv University on the subject of 'Home' which introduced me to new conversations that have turned into new and important friends and opened up possibilities of thought that, though not yet fully hatched, are reverberating through this writing as possibilities beyond the work of critical analysis. Rebecca Barden, my editor at Routledge, is probably most responsible for these thoughts finally being collected into book form and I thank her for wresting them away from me, and Kate Trench and John Banks have my gratitude for the enormous amounts of work they have put into trying to make the manuscript more coherent.

In the shadows of my work lurk two presences. The one is the accumulated thought and writings of Edward Said who has served as an indicator of possibilities – for many years of the possibilities of critically and imaginatively unthinking and rethinking the political legacy of violent usurpation we had inherited in the Eastern Mediterranean in the second half of the twentieth century. The other presence is that of the two very different families from which I came. One was the orthodox and devout and moved to the Holy Land in the eighteenth century to live out a life of religious study. The other was modernist and secular and moved to Palestine in the twentieth century to participate in establishing the state of Israel. Two families inhabiting one place that is three very different countries: Holy Land, Palestine and Israel. Two families who despite their many differences shared an odd passion for travel and movement and a delight in narrative. It is to their restless movements and endless stories and their great sense of adventure that I owe this book.

Introduction

This is not . . .

. . . unhomed geographies

THIS IS NOT A BOOK about identity politics nor is it about art works that reference the iconography of geography, as might be inferred from its title. It is certainly not a study in cultural geography nor an exercise in dragging geographical metaphors across fields of cultural production.

The obvious absence of a clearly recognized subject for the work led me to spend a considerable amount of time trying to avoid altogether compiling these essays into a book, because I could not see a way to avoid its becoming any of the subjects I have listed above in negation. What I had in mind was a subject-in-formation, on the one hand far too ambitious and on the other far too personally motivated, and these seemed respectively unachievable and unavoidable, given the intellectual tools and models of analysis and the modes of writing I had at my disposal. Nevertheless, while mulling all this over, I encountered certain kinds of work such as that of Henri Lefebvre, Neil Smith,[1] Rosalyn Deutsche,[2] Iain Chambers,[3] Sara Suleri[4] and Anton Shammas,[5] to mention only a few, that emboldened me to make the attempt despite the obvious pitfalls this entailed.

So what was it that I had in mind as the project? I wanted to set up an exploration of links between, first, the dislocation of subjects, the disruption of collective narratives and of languages of signification in the field of vision, and second an epistemological inquiry which stresses difference rather than universal truth. This is indeed somewhat ambitious, and the project's point of departure is not quite as clearly indicated or grounded as one might wish. Nevertheless the conjunction of emergent rhetorics of deterritorialized subjects with the theorization of deterritorialized epistemologies seemed

an opportune moment for thinking through all the investments and certainties which define and anchor themselves to the arena of geography. By this I mean a historical correlation or mutuality of the current moment in which one might be able to trace links between subjects' experiences of disruption and between a prevailing condition of disrupted knowledge orders. Thus, in the case of this particular epistemological order and its linked experiences – the degree to which 'geography' as a set of understandings regarding belonging and rights has clearly been masking a great many fundamental shifts in identity formation – has made me feel an urgency in the attempt to re-write those relations so that they actually reflect contemporary conditions.

Issues such as rights and belonging which determine and shape the conditions of our lives, and entail the kind of horrific consequences we have seen throughout the former Yugoslavia since 1992, are bound to be dealt with in political rhetoric, both instrumentally and in high moralizing tones. Such discussions respond to the imperatives of current political crises and to the human tragedies they spawn, but they also assume an unchanging set of criteria by which the rights and wrongs of the situation are to be adjudicated. As I began this project Serbia had just invaded Croatia; when I was completing the first draft the violence of 'ethnic cleansing' was taking place in Bosnia-Herzegovina; and, as publication approaches, NATO has just ceased bombing Serbia and Kosovo. At each of these moments both the official line of the West and the discussions I was taking part in were paralyzed by an inability to act; the long shadows cast by both demographic and ideological occupations and transitions, by the Ottoman and Austro-Hungarian empires, by two World Wars, by allegiances with fascism to the West and communism to the East, did not translate into a clear-cut policy, into an unequivocal knowledge of what was right or wrong in this case. Everyone in the West had some sort of dirty history in the Balkans and everyone in the West had also taken part in demonizing some part of its population in the context of other conflicts located elsewhere on the globe.[6]

In a pragmatic sense those histories prevented a deductive process resulting in the kind of clear-cut action of miltary intervention or strict economic sanctions that was being called for by parties in Yugoslavia and in some quarters of the Western military alliance. Living through this period of war while trying to think through issues of geographies in crisis has been instructive to say the least. Clearly the sum total of the many histories which can be excavated regarding the Balkans in the early modern era does not add up to an obvious set of resultant policies. Equally the traditional methods by which countries have responded – bombings, invasions, sanctions – are seemingly unequal to the task, which in itself is quite unclear. More than anything, the crisis in the Balkans – in dialogue with the general crisis of

the ability to represent any form of stable geographic knowledge as a set of guidelines regarding identity, belonging and rights – has made manifest the degree to which we have collectively lost the navigational principles by which such questions were determined in the recent past such as mid-century. These silences and confusions carry with them a great eloquence of the inability to respond, they have in the particular circumstances mentioned here, been dovetailed by another set of even more muffled confusions regarding the events in Rwanda, which, not taking place at the heart of the West, have been accompanied by less obvious knowledge of the histories, the colonial histories, which have set up the conflict between entities (named tribal) and authorities (named the state).

Therefore part of the overall problematic of this area I have been trying to conceptualize has been the issue of the loss, or better the absence, of navigational principles by which such questions were determined. While the loss of such navigational principles is mourned and the ensuing paralysis of action is a source of grief and of mutual condemnation, the twin legacies of psychoanalysis and deconstruction have also allowed us to conceptualize this loss as the point of departure for something else. The moment in which loss is clearly marked and articulated is also the moment in which something else, as yet unnamed, has come into being. Learning and transitional processes are not so much the addition of information as they are the active processes of unlearning which need to be carefully plotted out into active theories of unlearning which can be translated into active positions of unbelonging.

I have of late become increasingly tired of books which start off by preaching a certain position and a certain ideological platform at me in certain knowledge of what the right position to take on an issue is and often in highly moralizing tones to boot. More and more I find that certain automatic assumptions regarding the rightness or wrongness of intellectual projects actually require ever-increasing doubt and clarification. And I feel I would like to know why the writers feel that their project is important, what is motivating them to embark on it and by what perilous and circuitous routes they have managed to bring it to fruition, including the risks and dangers of being wrong, before I embark on the reading. It is the effort of arriving at a positionality, rather than the clarity of having a position, that should be focused on.

As the lessons of post-structuralism have taken hold, it seems imperative to shift from a moralizing discourse of geography and location, in which we are told what ought to be, who has the right to be where and how it ought to be so, to a contingent ethics of geographical emplacement in which we might jointly puzzle out the perils of the fantasms of belonging as well as of the tragedies of not belonging. Therefore this work has mostly to do

with a particular condition of intellectual or cultural work, in which all of the work seems to be going into the production of a subject for the work. To my mind identity politics or geographical metaphors or discourses on rights (and consequently wrongs) of emplacements are not the framing devices for the following thoughts. While these may be of great use to the inevitable detective work that accompanies the search for a subject, *the subject*, they do not constitute that subject in and of itself.

And so I thought I should write a preamble to *Terra Infirma* in which I might share my doubts regarding the efforts to produce a subject for the work and the inadequacy of the discourses and epistemic structures at my disposal, and yet tell you why it nevertheless seemed urgent and important to do despite these shortcomings. Beyond that it also seemed important to say something about the very attractions of 'geography' as an arena in which to articulate my questions. 'Geography', like the discourses of space and spatialization, allows for certain conjunctions of objectivities and subjectivities within the framework of an argument. It allows for a set of material conditions of subjects' lives which co-exist with and both shape and are shaped by psychic subjectivities. As an active critical rather than a disciplinary entity, 'geography' works to defy the difficulty that Jacqueline Rose outlines in her recent book *States of Fantasy*, in which she states 'One of the reasons the idea of fantasy has a hard time getting into the political argument is, I believe, because it is seen as threatening political composure. In politics, at least, we can be sure of our psychic ground, shedding if only for the brief moment of our political being all tortuous vagaries of the inner life.'[7] In the same vein that Rose claims that 'fantasy can give us the inner measure of statehood'[8] – I would claim an argument for my concept of 'unhomed geographies' as a possibility of redefining issues of location away from concrete coercions of belonging and not belonging determined by the state.

There are two issues in this attempt at positionality. The first is the conviction that politically informed intellectual work is founded on certain disenchantments and frustrations with existing ways of knowing and with the very possibilities for visibility and representation which they allow, and that it is the mobilization of this discontent that is the driving force behind the need to arrive at new articulations. The second is that this condition of epistemic dissatisfaction is equally a product of a particular and specific self-situatedness. While I do not believe in privileging autobiography as an analytical tool, I nevertheless must recognize the animating conditions for critique in a particular individual set of beliefs, a set of intellectual histories and a set of experiences. Primary among these has been the growing understanding that relations between subjects and places are, in the first instance, refracted through structures and orders of belonging, whether that means state-granted rights or the celebrations of mututal heritages and customs.

Early on in my reading I had been very excited by the work of Michel Foucault, and following along the lines of his thought it became increasingly clear that the constitution of belonging – of any belonging, whether it be institutional, disciplinary, national, regional, cultural, sexual or racial – has never been an exclusive function of its shared terms but also of its shared exclusions. I do not mean exclusions in the simple sense of 'I am in and you are out' but in the sense of the necessary constitution of an active form of 'unbelonging' against which the anxiety-laden work of collectivities and mutualities and shared values and histories and rights can gain some clarity and articulation. Thus far the discussion of belonging has largely ceded primary power to the state with its various apparatuses for the granting, policing and preventing of rights of belonging or conditions of expulsion.

Seen from the perspective of state-sanctioned rights and the immensity of their power to wreck and disrupt subjects' lives, the theoretical pre-occupation with an active process of 'unbelonging' might seem somewhat frivolous. My discussion is intended not to promote an illusion that the state is not powerful but rather to examine some of the terms by which it has limited and shut down our capacity to understand and thematize issues of belonging beyond those annexed purely to the juridical status of its subjects. I do not wish to make light of the wrecked lives, annihilations and displacements that various fascisms, nationalisms, fanaticisms and redrafted migrant labour economies have visited upon both individuals and groups marked out by difference and by the absence of fundamental rights. It is precisely in the wake of those horrific histories that several generations of thinkers have now claimed their stake in the necessary evolution of an active category of 'unbelonging' – not as marginality and not as defiant opposi-tion and certainly not as a mode of 'dropping out', but as a critical refusal of the terms – and of the implications of those terms – which come to be naturalized within the parameters of any given debate. All this by working from within those parameters rather than outside of them and by examining their constitutive components as an epistemological structure in which 'difference' rather than homogeneity determines what we know, how we know it and why we know it.

It seems important to say in this context that, though I am currently on my fourth country and third language, none of my displacement has been in the least tragic, like the plight of those forced to leave homelands for political and intellectual reasons. My movement has had to do with a rest-less curiosity, opportunities and the making of certain choices, not much more, and in the process I have acquired some skills in cross-cultural trans-lations and in adapting to situations – but these are skills, not values, certainly not illusions about being able to understand a culture, any culture, from within. Though my movements do reflect, to some extent, the colonial

beliefs in the scholastic and cultural superiority of Europe and the United States over those of my native Middle East, they are equally part of the professionalization and global circulation of the late twentieth-century world of ideas. Nevertheless my own displacement entails complex daily negotiations between all the cultures and languages and histories which inhabit me, resulting in the suspension of belief in the possibility of either coherent narratives or sign systems that can actually reflect straightforward relations between subjects, places and identities.

These negotiations are the political and cultural conditions of my life, and, like those of countless others, are determined by migratory, racial, sexual and class locations. While the causes of displacements and of the ruptures that ensue are subject to differentiation, some of the effects these engender produce a set of linked states of subjectivity through which an alternative set of readings might become possible.

In the wake of ten years of what has come to be called 'identity politics' it is necessary to distinguish between such currently much-reviled notions as 'cosmopolitanism' or 'assimilation' and the activity that constitutes the daily texture of our lives as we negotiate the mixed signals and cross-references in a post-colonial, migratory reality. Initially I take my cue for the commitment to strangeness, to unhomedness, from Theodor Adorno, who, in a postwar essay, 'On the Question "What is German"?' said in the thundering voice of a stern moral authority that 'It is immoral to feel at home in one's own home'[9] – probably the only advantage of such stern authorities is that they do make you sit up and pay attention. I admit to not being a great admirer of the Frankfurt School per se – there is a monolithic singularity to their analytical models, and an unquestioned authority to the voices, that has always kept me at a distance. In addition there is the thorny problem of afternoon naps – childhood memories from Jerusalem of not being allowed to play on the street between two and four in the afternoon when our neighbors, the refugee remains of the German Jewish intelligentsia, had their afternoon naps. We children of the Eastern Mediterranean were extrememly resentful of the Central European hush that was being imposed on us – of the collective Mrs Scholem, Leibowitz, Spiegel and Davis who stood in the doorways and told us off for being so loud and so exuberant, of the idea that we had to subjugate our habits to the intellectual imperatives of these revered men. In return, we mocked them mercilessly – their habits, their accents and their extreme foreignness: we set ourselves up in opposition, and in a sense of organic belonging to our place of birth, that was at least in part a response to the extreme unease which underlay anything connected with a tabooed place called 'over there' in which frightening and unmentionable things had happened. Things we were only vaguely aware of and which were surrounded by a shamed silence. There was,

however, also one moment of great delight in this story, when my little sister having learned to read stood in front of a shelf laden with books on Judaica and asked if all these books had really been written by the neighbors. Someone said that yes, they had been written by those revered men, and she said in a very puzzled voice: But when did they have the time to write these books, they were always sleeping?'

So frozen in time was that old world for us, the world of the exiled intelligentsia of old Europe, that you can well imagine my surprise when a long time later I find myself embedded in a Frankfurt-School-style geography of the exact opposite to that childhood posturing, a geography of unbelonging. A geography which is an interplay between these old memories, between the current lives of my friends in Frankfurt who edit *Babylon – a Journal of Jewish Perspectives in Contemporary German Culture* – a journal that insists that Germany is not the monoculture it currently believes itself to be and that those old intellectual and cultural traditions have oblique and complex continuities in the present. These are friends whom I believe to be the actual continuation of the Frankfurt School though they may not be identified so through their models of analysis – and beyond Europe between an intellectual radicalism in California that had its beginnings in Adorno's and Horkheimer's brief stays there and Marcuse's and Lowenthal's much longer ones – and between my own endless movements between English and Hebrew and German.

This therefore is the notion of 'geography' I have been working with in recent years – an uncanny geography, uncanny in Freud's sense of 'that class of frightening which leads back to what is known of old and long familiar'. We have to remember that Freud's 'uncanny' is actually the 'unheimlich', the unhomed or that which is not at home. Both its frightening and its familiar qualities come from its awkward relation to being not at home, to the 'strangeness' which that condition assumes.[10] I was drawn to try to work in the arena of geography because it seemed possible to locate within its revised understanding an alternative set of relations between subjects and places – an alternative set of relations in which it is not scientific knowledge or the national categories of the state which determine both belonging and unbelonging, but rather linked sets of political insights, memories, subjectivities, projections of fantasmatic desires and great long chains of sliding signifiers.

Part of the work that seems to face us at present is the need to articulate the specific intellectual and cultural discourses that reflect those states that Homi Bhabha names 'inbetweenness,' and Edward Said describes as never being 'of' anything, or that Paul Gilroy (following Du Bois) terms 'double consciousness'.[11] This is as true of political discourse as it is of literature, and it is certainly true of the world of visual representation in which we are immersed in our media-saturated culture. Since these power

relations inevitably get translated into knowledge systems and disseminated through structures of representation, we must recognize geography to be as much of an epistemic category as gender or race, and that all three are indelibly linked at every stage. All three categories share an engagement with belonging which plays out around dichotomies of self and other and around strategies of 'emplacement' and 'displacement'. Geography therefore is a system of classification, a mode of location, a site of collective national, cultural, linguistic and topographic histories. All of these are countered by the zones which provide resistance through processes of disidentification; international free cities, no man's land, demilitarized zones, ghettos, red light districts, border areas etc., and work towards our recognition of traditional geography as a sign system in crisis.[12]

Therefore I see my task as an attempt to trace a certain meeting ground within the arena of visual culture; to narrate my own way between a set of discourses about the aftermaths of colonialism – of twentieth-century mass population shifts and of disrupted and revised national narratives and a recent self-consciousness about our own inhabitation of or by multi-subjectivities – with a body of theoretically informed and critically oriented visual work which has taken on the task of rewriting the sign systems of geographical relationality.

What seemed then at the outset of the project so problematic – and still does – was that I wanted an analysis in which no disciplinary or empirical mode prevailed so that I would not end up examining the ways in which historical, economic or cultural condition are reflected in art works, or read contemporary, critical geographies through art works. The danger of that was obviously that the work I was attempting would be hijacked by some academic paradigm which would dictate a relation between theories, contexts and objects. As someone who had her initial training in the field of art history, I knew that this form of knowledge territorialization needed to be avoided in favor of some new object of knowledge in which a semblance of parity and reciprocity might take place between the constitutive components of the study and through which a form of cultural politics could emerge from the work rather than be imposed on its materials.

In the shift that took place from art histories to discourses on representation within cultural criticism informed by post-structuralism and questions of difference during the 1980s, a move was made from looking at cultural artifacts as reflective to perceiving them as constitutive. This was of course part of a much larger question to do with the establishment of meanings. How and where are meanings determined? By whom? For which readers or viewers? And through what structures of identification or disidentification? Alongside the dismissal of the authority of the author in fixing meanings in culture, certain critical questions arose regarding social history's

determination of meaning. It entailed a recognition that information (even superbly researched and wide-ranging information tracked down in ever more obscure and eccentric archives, regarding the material conditions and contexts for the making of certain works) could not transform 'us', the viewers, into subjects of the period. This is not to devalue the immense importance and relevance of the social history of art project in the 1970s which, for the first time, allowed class, gender, race and language to enter into the analysis and location of visual representations and began the project of dehierarchizing images in culture.[13]

Regardless of how much we might know about the historical moment in which a text was produced, we would always inhabit a contemporary context and always bring our contemporary issues and associations to the texts we were encountering. In the process, we would fragment, appropriate, rewrite and utterly transform those texts. Instead of art as reflective, an approach was elaborated which we might name constitutive, in which – through historical unframings and psychoanalytically informed perceptions of desire and subjectivity as projected on to texts and images – an understanding of how images (regardless of their origins) shape our conscious and unconscious perceptions of cultural values. Images in the field of vision therefore constitute us rather than being subjected to historical readings by us.

One of the most important aspects of this shift, from the reflective to the constitutive mode by which visual representations are understood to signify, is that it has opened up the field of relevant materials to the location of images almost beyond limits. It is in the wake of this emergent study of visual culture – a study devoid of generic boundaries or hierarchical media, in which difference and subjectivity are constitutive components of the field rather than analytical additions to it – that it becomes possible to trace the language shifts that have begun to take place in the aftermath of displacements, migrations, enslavements, diasporas, cultural hybridities and nostalgic yearnings undergone by contemporary subjects.

In addition to attempting these links, I wanted the work to reflect somehow the processes which I myself experience as I move back and forth between critical theory, feminist studies and contemporary art practices.

Again and again in recent years I have found myself dealing with a particular question, critically analyzing the contexts and conditions of its emergence, the assumptions on which it might rest and the languages in which it is articulated. But having gone through all of these analytical steps I would find myself at a loss to imagine the next step: beyond critical analysis into the possible imagining of an alternative formulation, an actual signification of that 'disrupted-through-analysis' cultural phenomenon. On occasion, certain encounters with conceptual art works which are taking up the same issues would provide a bridge to the next step for thought: an

actual cultural making, not an analysis, of a condition I perceived theoretically. Encounters with the work of Jochen Gerz, Mary Kelly, Faith Ringgold, Vera Frenkel and Glenn Ligon, Toni Morrison, Patricia Williams, Bruce Chatwin and Chinua Achebe suggested theoretical models for conceptualizing absence, gendered fantasy, cultural hauntings. They address how culture is perceived when it is viewed from the back door and what it means to be in a position of culturally longing for that which is historically and politically forbidden. Art, then, is my interlocutor rather than the object of my study, it is the entity that chases me around and forces me to think things differently, at another register or through the permissions provided by another angle.

It is precisely because art no longer occupies a position of being transcendent to the world and its woes nor a mirror that reflects back some external set of material conditions, that art has become such a useful interlocutor in engaging with the concept of geography, in trying to unravel how geography as an epistemic structure and its signifying practices shape and structure not just national and economic relations but also identity constitution and identity fragmentation. Two generations of postmodern geographers and theorists of urban and other spaces have made it possible to launch into this discussion at the level of identity and cultural constitution. The work of Henri Lefebvre, Michel Foucault, Edward Soja, Neil Smith, Doreen Massey, Liz Bondy, Rosalyn Deutsche, Jane Jacobs, Derek Gregory, Gillian Rose, Dennis Wood, Cornelia Vismann and Victor Burgin, among numerous others, has created an intellectual and scholarly terrain in which 'geography' is as unbounded a meeting ground between the epistemic, the historical/experiential and the significatory as is the arena of visual culture.

The final component in my inquiry, and probably its main starting point, is feminist work in theory and epistemology. The moment in which I encountered feminism in the early 1980s was a highly theoretical moment in which gender became a category of analysis for existing cultural entities and a tool for trying to point to some of its most glaring absences and lacunae. It was a moment in which a set of emergent links between semiotics, psychoanalytical theory, gender theory, post-colonial analyses and deconstructionist work began indicating that subjects cannot simply be re-included in the cultural narratives from which they had previously been excluded. Instead a complex formulation, focusing on having a language to speak within culture and a position to speak it from, began emerging as a response to absences and exclusions.

Concurrently, in the early 1980s, an epistemological inquiry which has insisted on positioned and situated knowledge (as in the work of Donna Haraway, Teresa de Lauretis and Gayatri Spivak and its obvious links with

the epistemological project opened up by Michel Foucault) has done much
to erode the neutral, empirical and positivistic base of Western knowledge
structures and the discourses they have produced to ground and legitimate
themselves. Feminist theory has in my experience been a major driving force
in the critical interrogation and the ultimate undoing of the traditions of
universal knowledge. One of the critical models which feminism has contin-
ually insisted upon is that gender, race and location are, in and of themselves,
epistemological categories; they determine what we know, how we know
it and why we know it. The positionality and situatedness that feminist
theory has brought to epistemological investigation, feminist theories of spec-
tatorship have brought to the arena of space and to the field of vision. As
articulated initially by feminist film theory in the 1970s, spectatorship locates
the power relations and gratifications of the gaze in a positioned and situ-
ated looking: who is looking at whom and through what apparatuses and
structures of viewing. A division is made apparent between the subject, the
bearer of the gaze and the object which is being looked upon. The struc-
tures through which this looking is done are dependent on cultural narratives,
projected desires and power relations, while the space in which the activity
of looking takes place is animated with all of the material and cultural
complexities which represent the obstacles to the very idea of straightfor-
ward comprehension of what is being seen.

Coming to 'geography' in the wake of all this work, we realize that it
has always been a form of positioned spectatorship; that such categories as
'the Middle East' or 'the Far East' or 'the Sub-Saharan' are viewed from
positions (in this instance centers of colonial power) which name and locate
and identify places in relation to themselves as the center of the world. Like
spectatorship in the filmic arena, geographical naming of this kind equally
reflects certain desires for power and dominance and certain fantasies of
distance and proximity and transgression which come into expression in the
act of geographical naming.

In the introductory chapter which follows I will try flesh out this under-
standing of geography as an epistemological structure, of visual culture as
the arena in which it circulates, and of feminist theory and spectatorship as
some of the links which connect the two by means of critical interrogation.
This is followed by a series of readings of particular geographic sign systems
– luggage, mapping, borders and bodies – in which I try to link these
thoughts to some contemporary visual cultural production that is rewriting
these sign systems way from colonial offices, universal knowledge fantasies
and utopian scenarios and towards a more complex multi-positionality. The
work I have chosen is simply the work I have encountered, encounters deter-
mined by the discussions I inhabit and the accesses I have. It by no means
pretends to be a comprehensive survey of all of the work which takes up

Subjects/places/spaces

Wailing/positionality

'WHERE DO I BELONG?' seems to be the question that plagues so many of the discussions I participate in. As a constant lament it refers to dislocations felt by displaced subjects towards disrupted histories and to shifting and transient national identities. Equally, it refers to university departments and orders of knowledge, to exhibiting institutions and market places and, not least, to the ability to live out complex and reflexive identities which acknowledge language, knowledge, gender and race as modes of self-positioning.

It is one of those misguided questions which nevertheless serve a useful purpose, for while it may naively assume that there might conceivably be some coherent site of absolute belonging, it also floats the constant presence of a politics of location in the making. This very act of constant, plaintive articulation serves to alert to the processes by which identity comes into being and is permanently in flux. As a quest(ion) it brings to mind a memorable sentence from Salman Rushdie's 'Outside the Whale' in which he advocates taking issue with George Orwell's assumption that there is an inside in which to be passively swallowed up. 'In place of Jonah's womb, I am recommending the ancient tradition of making as big a fuss, as noisy a complaint about the world as is humanly possible. Where Orwell wished quietism, let there be rowdyism; in place of the Whale, the protesting wail.'[16] Therefore the geography I am examining, so totally outside the whale, is the geography of keening and wailing, of trying to find both

articulation and signification for that constant unease between efforts at self-positioning and the languages and knowledges available for us to write these into culture. It is an unease inscribed both with a sense of loss of that earlier seamless emplacement we might have thought we had and with the insecurity of not yet having a coherent alternative to inhabit.

My inquiry does not attempt to answer the question of a location for belonging; it is by no means prescriptive since I have no idea where anyone belongs, least of all myself. It is, however, an attempt to take issue with the very question of belonging, with its naturalization as a set of political realities, epistemic structures and signifying systems. Thus it views questions of belonging through the cultural and epistemic signifying processes which are their manifestations in language.

My choice of geography as a site which links together these relations between subjects and places and the grounding discourses that legitimate them is only partly metaphoric. I take it up in full knowledge that it has of late become an excessively overused metaphor which runs the danger of being evacuated of all meaning. This is most succinctly expressed by Neil Smith and Cindi Katz, whose criticism is that

> The breadth of interest in space is matched by the breadth of spatial metaphors newly in vogue. In social theory and literary criticism, spatial metaphors have become a predominant means by which social life is understood. 'Theoretical spaces' have been 'explored', 'mapped', 'charted', 'contested', 'de-colonized' and everyone seems to be 'traveling'. Perhaps surprisingly, there has been little attempt to examine the different implications of material and metaphorical space. Metaphorical concepts and uses of 'space' have evolved quite independently from materialist treatments of space, and many of the latter.[17]

In fact there is a considerable body of work that applies issues of mapping, displacement and location to the material conditions of their making, and some of the most interesting of it is by these very same authors. Metaphor is indeed a very limited and comfortable way of understanding sets of conditions and their articulations through the similar which is by definition also the familiar. It is far more in the relations between structures of metaphor and metonymy that a complexly elaborated perception of 'geography' can be played out. The duality of relating both objectivities and subjectivities within one order of knowledge can be found in this twofold concept; to quote Kaja Silverman:

> while metaphor . . . exploits relationships of similarity between things, not words . . . metonymy exploits relations of contiguity

> between things, not words; between a thing and its attributes, its
> environments and its adjuncts . . . Since things are only available
> to us cognitively, metaphor is in essence the exploitation of
> conceptual similarity, and metonymy the exploitation of concep-
> tual contiguity.[18]

Surely concepts of 'geography' as metaphor, as an order of knowledge and
as a narrative structure are not mutually exclusive and allow for a certain
amount of interplay which extends beyond the binarism of material condi-
tions versus psychic subjectivities as the determinants of place and its
implications. In Silverman's words

> metaphor and metonymy assert neither the complete identity nor
> the irreducible difference of similar and contiguous terms but
> rather what Proust calls their 'multiform unity' . . . [thus] the
> primary and secondary processes find a kind of equilibrium, one
> which permits profound affinities and adjacencies to be discov-
> ered without differences being lost.[19]

Among much of the work that remains to be done, however, at the
level of 'geography' as a metonymical structure, is that which mediates
between the concrete and material and the psychic conditions and metaphor-
ical articulations of relations between subjects, places and spaces. Geography,
space and subjectivity at the level of narrative have long been explored in
the arena of literary criticism. Edward Said's essay 'Narrative and Geography'
takes the examples of Joseph Conrad and Albert Camus to work out relations
between texts and emplaced interpretative communities. In the case of
Conrad, Said locates this as the effort to delineate the edges of 'West' and
of 'Empire', the attempt to write a 'Western Consciousness' out of the
unease of being positioned at the edge of a West, a knowledge of there
being a non-West at that border. In Conrad's work, Said finds a geograph-
ical project of 'maps of English as world knowledge and of the penetration
beyond the European frontier and into the heart of another geographical
entity'.[20] Alternatively in the work of Camus an entirely different moment
of colonial history is made visible, a moment in which the very same
subject is part both of a colonizing culture and of the turmoil and double
consciousness of decolonization conflicts. While Conrad in Said's reading is
a subject in motion traveling through the territorialities articulated by colo-
nialism, Camus is a geographical terrain of convergences in and of himself.
Camus, like Frantz Fanon, is one of the canonical figures of histories of
intellectuals displaced simultaneously through the legacies of colonialism,
through the political radicalization of Right/Left politics in the 1940s and

through the wars of decolonization and national liberation of the 1950s and 1960s. In both cases, their actual practices – writing and psychoanalysis respectively – provide another aspect of displacement away from bourgeois norms of professionalization. In the narrative of Camus the writer and the political man, as in that of Fanon, we find one of the early examples of the ability to broach a contradictory range of 'belongings' as well as to access opposite and even opposing interpretative communities. Shoshana Felman has argued most interestingly of Camus's novel *The Plague* as both 'The Project of Recording History' and bearing witness to the Holocaust. This, argues Felman, is because

> Camus . . . exemplifies the way in which traditional relationships of narrative and of history have changed through the historical necessity of involving literature in action, of creating new forms of narrative as testimony not merely to record, but to rethink and in the act of its rethinking, in effect transform history by bearing literary witness to the Holocaust.[21]

Although Felman admits that Camus's text neither clearly refers to the Holocaust nor claims to deal with it, she charts out a very interesting journey by which Camus after 1945 leaves behind the underground oppositions and resistances to the German occupation in which he was involved during the Second World War for a set of external critical positions. Through the writing of *The Plague* in 1947 he shifted from an internal French paradigm of involvement with anti-German occupation to assume a series of highly critical positions against the very 'France' whose liberation he was so invested in during the war as a member of the French Resistance and as the editor of the underground newspaper *Combat*. Camus's critical positions range from a 'witnessing' of collaboration in France and its active contribution to the genocide of European Jewry to a 'witnessing' of French colonialism of North Africa. I am not entirely sure what I think of Felman's claim for Camus as witness of the Holocaust as such, but I am certainly convinced by the argument that to bear historical witness is to effect a shift in the very paradigms one is perceiving. However, given that Camus has traditionally been claimed either by Left-wing French intellectuals in the battle against fascism or by Algerian intellectuals in the struggle against French colonialism, this interpretation with its triple inscription of Europe, France and Algeria seems very welcome in the search for links between narrative and geographical subjectivities. In her reading of Camus the writer, Felman produces another model for a politics of 'belonging': here we find a contingency, a taking up of positions of belonging and unbelonging in relation to shifting political spectrums which write the writer as the author of self-determined

relations to 'place'. Not only does 'belonging' here become problematized but the writer who is its subject becomes 'de-essentialized' in the process – the 'real' Camus is neither Algerian colonial subject, French Left-wing mobilized intellectual nor Existentialist citizen of the Left Bank but rather the traveler between these positions who understands the need to 'unbelong' himself as the manifestation and signification of shifting political paradigms.

To 'unbelong' and to 'not be at home' is the very condition of critical theoretical activity – one in which as Homi Bhabha states

> one is not homeless nor can the unhomely be easily accommo-dated into that familiar division of social life into public and private spheres. The unhomely moment creeps up on you stealthily as your own shadow and suddenly you find yourself with Henry James' Isabel Archer 'Taking the measure of your own dwelling in a state of incredulous horror'.[22]

Often this active form of 'unbelonging' is both the express purpose of journey and its unexpected consequence. A couple of years ago I was fortu-nate enough to come across Abraham Verghese's account of his medical practice in rural Kentucky at the beginnings of the AIDS epidemic in the early 1980s. I had heard a tantalizing bit read on the radio and recognized immediately that this was an alternative and fascinating geographical charting. The subsequent hunt for the book itself, a chronicle of one doctor's work among the dying in rural America, was an even greater lesson in how much work still needs to be done in producing new categories for emergent bodies of knowledge and for complex, unfamiliar identities. The book could not be found in the sections on Biography, Medicine, Non-Fiction or any other categories the staff at one of New York's gigantic Barnes and Noble stores could think of – our search finally discovered it in a category called 'Health and Fitness'.

The book contains two geographical narratives, two cartographies. The first is that of the journey made by the protagonist doctor:

> I had arrived in America as a rookie doctor in 1980.
>
> I first came to America from Africa in 1973. War and polit-ical unrest had interrupted my medical education in Ethiopia, the land where I was born and where my parents had worked for 35 years as expatriate teachers. After a hiatus spent working as an orderly in a succession of hospitals and nursing homes in New Jersey during my first period of American citizenship, I had even-tually completed medical school in India and by 1980 had passed

all the necessary exams to come back to the United States as a doctor. I considered myself lucky.

My father and mother were born in Kerala, the south of India, to Christian families that trace their religion back to the apostle Thomas. After Christ's death, 'Doubting' Thomas travelled east and arrived on the Malabar coast of India. There, long before St. Peter arrived in Rome, long before Christianity had taken any sort of hold outside of Palestine, 'Mar Thoma' converted the South Indian Brahmins he encountered to Christianity. They named their children with Christian names. My surname, Verghese, has the same derivation as Georgios or George . . .

. . . As I crisscrossed the country, in search of a residency slot, by way of Greyhound, sleeping on friends' couches (or on their beds if they were on call), I was amazed by the number and variety of foreign interns and residents I met in these hospitals. I overheard snatches of Urdu, Tagalog, Hindi, Tamil, Spanish, Portuguese, Farsi and Arabic. Some hospitals were largely Indian in flavor, others largely Filipino. Still others were predominantly Latin or Eastern European . . .

Verghese describes US hospitals which recruit in India, are surrounded by Indian food stores, sari shops and bootleg videos outlets – all serving a hospital staff that could have been in Bombay.

Now that I had returned to America with my medical degree, a certain perverseness and contrariness made me want to bypass this system. What was the point in coming to America to train if I wound up in a little Bombay or a little Manila . . . Through a relative who was on the faculty I heard of a new medical school; East Tennessee University. It had started a residency program in internal medicine.[23]

This is one geography, a cartography of trying to find a residency in the US that will not replicate the culture he has just come from and which builds on a historical sweep of migrations from the beginning of the Christian era to the present and whose sources are routes of the ancient world from Palestine to India and to Africa culminating in the New World. The second cartography is the unexpected consequence of the first, the sharpness of vision regarding an 'unbelonging' whose viewing position can have been arrived at only through the preoccupation with journeys. This second cartography, following later in the book, is one which Verghese commences to chart once he has begun to treat HIV-positive patients in Tennessee, and through it he tries to understand how a small, largely rural area, with

seemingly so little gay culture in the sense of urban encounters and social life, can be experiencing such a large number of cases of AIDS. He begins a map whose outset is in the present in Tennessee and which folds out to encompass the earlier movements of these same people, when they had left their home town for the big cities of the East and West coasts of the United States. Verghese discovers through his cartographic charting a movement back and forth that begins with the sexual liberation of young men moving away from the rural community to the big cities and their subsequent move back once they have reached the late stages of illness. I will return to Verghese's detailed account of the process he underwent in plotting out his map, in Chapter 3. In this initial context what seems important and worth marking is the way in which a geographical exposition of a medical and social set of questions produced, in this case, an answer that had not been evident or available previously. Neither medical case studies nor rural histories had produced any form of explanation, while a geographic charting of journeys of sexual liberation and of medical insurance policies and care for terminally ill patients, neither of them the subject matter of traditional map-making, had been able to spatialize these relations and thus to provide a narrative in which they could be brought together.

My particular effort is to situate this discussion within the field of vision and of its articulation within the arena of visual culture. It might be useful at this point to elaborate briefly on some of these contexts of vision and the visual for the discussion of signs of identity, displacement and location or dislocation. The links between visuality and identity/location are of interest because they establish references to, and enable the inclusion of, far broader materials than those which could be categorized as visual arts or visual representations. Visual culture is a form neither of art history nor of art criticism – it designates an entire arena of visual representations which circulate in the field of vision establishing visibilities (and policing invisiblities), stereotypes, power relations, the ability to know and to verify: in fact they establish the very realm of 'the known'. Why then 'geography' and why locate it within the field of vision?

Geography and spatialization as epistemic structures

Geography is at one and the same time a concept, a sign system and an order of knowledge established at the centers of power. By introducing questions of critical epistemology, subjectivity and spectatorship into the arena of geography we shift the interrogation from the center to the margins, to the site at which new and multi-dimensional knowledge and identities are constantly in the process of being formed.

What is geography beyond the charting of land masses, climate zones, elevations, bodies of waters, populated terrains, nation states, geological strata and natural resource deposits? Geography is

- a theory of cognition and a system of classification
- a mode of location
- a site of collective national, cultural, linguistic and topographical histories
- a homogeneous space which becomes an order of knowledge through universal indexical measure of the land.

Geography therefore is a body of knowledge and an order of knowledge which requires the same kind of critical theorization as any other body of knowledge. Geography as an epistemic category is in turn grounded in issues of positionality, in questions of who has the power and authority to name, of who has the power and authority to subsume others into its hegemonic identity (as France subsumes North African identities, Israel subsumes Palestinian identities, Anglo-American ideology in the USA has until recently subsumed ethnic minority identities etc.). Critical activity which locates geography as its field therefore pursues an active form of unnaming, renaming and the revising of such power structures in terms of the relations between subjects and places.

In the wake of such work as Derek Gregory's *Geographical Imaginations*[24] which articulates the connections between social practice, cultural production and human geography; of David Hooson's edited collection *Geography and National Identity*[25] which undoes the supposedly symbiotic relationship between named geographies and national identities; and of Neil Smith's *Uneven Development* with its articulation of 'deep space' as quintessentially social space – 'a physical extent infused with social intent'[26] – one does not need to labor to insist that geography is knowledge underpinned by nationalism, sustained by the regulating bureaucracies of the state and disseminated through cultural fantasies of otherness. All this has been operating in the name of a traditional and centuries-old assumption. All had been made possible through a traditional assumption which, to quote Blaut's *Colonizer's Model of the World*, is grounded in 'The unique historical advantage of the West – the West makes history, it advances, progresses, modernizes . . . the rest of the world keeps up or it stagnates'.[27] Blaut argues that the entire geographical world system was constructed through a process of 'Eurocentric diffusionism' – the flow of cultural processes over the world as a whole. This in turn was founded on the myth of 'the autonomous rise of Europe' (a myth which persisted concerning the period prior to 1492 and up to the advent of colonialism and large-scale European/Non European interaction).

These combined conceits, of influencing all global presents while not being influenced by any forces outside of Europe, make up Blaut's model of the colonizer's vision.

To counter this basic assumption of modern Western thinking about place and its relationality, geography, as it is perceived today within cultural studies, is as much an issue of positionality, a situated knowledge, as are the critical models of gender and race. In addition to geography, there is an ever more urgent need to engage with issues of space and the spatialization of social relations and epistemological conventions. For while geography can be viewed as the relation between subjects and places refracted through orders of knowledge, state structures and national cultures, that relation is produced as socio-cultural narratives which are geographically emplotted. Space on the other hand is the production of another dimension of inhabiting location through subjectivity and representation. The connection between discourses on geography and those on space is the understanding that power produces a space which then gets materialized as place. Thus spatialization precedes geographical determination conceptually while at the same time it is one of the tools by which geography might be analyzed theoretically as a structure of subjectivity. Claude Nicolet, a historian of the early Roman Empire, argues in his book *Space, Geography and Politics* that the transition of Rome from a free republic to an empire is rooted in considerations of space.

> In order to set boundaries to their empire and to claim to have reached those that have been marked out, the Romans needed a certain perception of geographical space, of its dimensions and of the area they occupied . . . Yet this space was forced upon them, to the extent that they had to become and remain its masters, to dominate its overwhelming distances, to recognize and exploit its resources, to gather information and convey orders from one end of the empire to the other, to assemble troops or have them patrol this space. The ineluctable necessities of government are to understand (or to believe one understands) the physical space that one occupies or that one hopes to dominate, to overcome the obstacles of distance.[28]

Thus in Nicolet's terms 'empire' is the spatialization of a concept which is played out through the evolution of technologies of mobility and surveillance and through a consciousness of boundaries that expand far beyond the self. The expanding boundaries inhabited by the self or by the republic as a greater self are termed by Nicolet 'an inventory of the world', an index of measure – of territory, of 'empire', of the known inhabited world – that

can be viewed from a position that is detached from the self as the locus of viewing.

The dimension of subjectivity and of differentiation is added to the model of geography as named and emplaced location with the analysis of space, through the social and psychic constitutions of differentiated and defined realms. Its significance initially for a critical discussion of 'geography' is that space is not understood through the named activity for which it is intended (a tennis court as a place in which the game of tennis is played) or through the titles that its buildings or other solid entities might uphold. Instead an active process of 'spatialization' replaces a static notion of named spaces and in this process it is possible to bring into relation the designated activities and the physical properties of the named space with structures of psychic subjectivities such as anxiety or desire or compulsion. Therefore the meaning of a named place is never its designated activity or physical properties but their interaction with far less obvious subjectivities and with the actions and signifying practices that elicit (or mask) these.

Henri Lefebvre – whose *The Production of Space* has inspired many of us to integrate the critical concept of spatialization into our various projects – brings as an example for this psychically constituted space the concept of the antechamber, a space of negotiation between absolutist royal power and those of lesser status who are petitioning it.[29] In this space they (the petitioners) become more empowered since they are representing others outside of the space, while the absolute monarch diminishes in power, as his space has been infiltrated by commoners. The space of the antechamber is a space of negotiation, the exact same space whose physical extent or aesthetic properties never changes, gets re-written and re-constituted through conjunctions of social position and psychic subjectivity. The enormity of Lefebvre's contribution which introduced the notion of 'social space' was to shift from space as a context for material activity or manifestation to space which is produced by subjectivities and psychic states, and in which nevertheless social relations take place.

In the same way both feminism and post-colonial theory have insisted on the need for a multi-subjectivity, so does the critical process of geographical spatialization insist on the multi-inhabitation of spaces through bodies, social relations and psychic dynamics. This is in contrast to nation states, for example, which insist on a singular spatial inhabitation under one dominant rule, and the pragmatic result of a spatial multi-inhabitation within the context of the nation state is armed conflict. A spatial analysis puts into play a dialectical system in which opposing claims can be positioned in a relation to one another which is not conflictual.[30] Lefebvre, whose work on space is too rich and too complex to be reduced to a schematic summary, nevertheless insists on some fundamental points of departure for his argument.

First, space is social as opposed to the mathematical space of Euclidean geometry, to mental space or to dream space. This is not to categorize distinct spaces named this or that, but to insist that no space, including the Euclidean space guided by strict rules of geometry or the dream space subject to irrational and unconscious forces, is ever devoid of social relations.

Second, that space is constantly in the process of production: 'Spatial practice consists in a projection onto a spatial field of all aspects, elements and moments of social practice'. Since all of these are contingent and in constant process of renegotiation, so therefore is the space which come into being via this form of projection.

Third, Lefebvre speaks of spatial analysis as negating the illusion of transparency. Since it is this illusion of transparency that naturalizes knowledge and power relations between subjects and since it is situated within the field of vision, it is a very important part of the discussion on conjunctions of geography and visual culture. Within the illusion of transparency, Lefebvre argues, space appears as luminous, as intelligible, as giving action free rein. It is a view of space as innocent and free of traps.

> Anything hidden or dissimulated – and hence dangerous – is antagonistic to transparency, under whose reign everything can be taken in by a single glance from that mental eye which illuminates whatever it contemplates . . . Comprehension is thus supposed, without meeting any insurmountable obstacles, to conduct what is perceived, i.e. its object, from the shadows to the light. It is supposed to effect this displacement of the object either by piercing it with a ray or converting it from a murky to a luminous state . . . The illusion of transparency turns out to be a transcendental illusion: a trap operating on the basis of its own quasi-magical power, but by the same token referring back immediately to other traps – traps which are its alibis, its masks.[31]

Lefebvre's negation of the illusion of transparency is of the utmost importance to numerous endeavors in cultural studies and cultural criticism. It provides a critical apparatus for dealing with positivistic thought and with analyses which do not take on board issues of situatedness, of unmediated positionality, and which believe unselfconsciously both in exteriority and in the ability to define the realm of the 'known'.

Feminist theory/situated knowledge and the spatialization of difference

In view of these concerns I will go back to the historical moment of my original project with a series of critical analytical thoughts about geography and location viewed from a contemporary perspective which requires a discourse of space and spatialization. My own inquiry is deeply rooted in feminist epistemology which, building on language, race and gender as epistemic categories, has produced a series of theories of positioned, situated knowledge. Perhaps best articulated by Donna Haraway is the argument

> for politics and epistemologies of location, positioning and situating, where partiality and not universality is the condition of being heard to make rational knowledge claims. These are claims on people's lives; the view from the body, always a complex, contradictory, structuring and structured body, versus the view from above, from nowhere, from simplicity. Only the god-trick is forbidden. Here is the criterion for deciding the science question in militarism, that dream science/technology of perfect language, perfect communication, final order.
>
> Feminism loves another science: the sciences and politics of interpretation, translation, stuttering and the partly understood. Feminism is about the sciences of the multiple subject with (at least) double vision. Feminism is about a critical vision consequent upon a critical positioning in unhomogeneous gendered social space. Translation is always interpretative, critical and partial. Here is a ground for conversation, rationality and objectivity – which is power-sensitive, not pluralist, 'conversation'. It is not even the mythic cartoons of physics and mathematics – incorrectly caricatured in anti-science ideology as exact, hyper-simple knowledges – that have come to represent the hostile other to feminist paradigmatic models of scientific knowledge, but the dreams of the perfectly known in high technology, permanently militarized scientific productions and positionings, the god-trick of a Star Wars paradigm of rational knowledge. So location is about vulnerability; location resists the politics of closure, finality or to borrow from Althusser, feminist objectivity resists 'simplification in the last instance'. That is because feminist embodiment resists fixation and is insatiably curious about the webs of differential positioning. There is no single feminist standpoint because our maps require too many dimensions for that metaphor to ground our visions.[32]

So it is in this sense – as Haraway has voiced it – of feminist theories of situated knowledge that I approach geography as a conjunction of epistemology and spectatorship in the field of vision. In a series of exceptionally rigorous and cogent articles on the location of feminist critiques within discourses of space and of so-called 'postmodern geography', Rosalyn Deutsche has mobilized space and spectatorship for the necessity of feminist interventions in critical geographical discourses and for their ability to undo masculinist scholarship's metatheoretical position of 'voyeur'. In arguing against David Harvey's *The Condition of Post Modernity* and its complete disavowal of feminist theory as a part of that condition and as a set of arguments which view the fragmentation of the subject as a necessary condition for self-reflexivity, Deutsche brings up issues of visuality.[33] She points out that what is missing in Harvey's modernist, totalizing and unity-seeking arguments of knowledge as positive is that such knowledge, like vision, is highly mediated by fantasy, by denial and by desire. In fact what is missing is the entire gamut of feminist discourses on spectatorship begun in the mid-1970s within film theory and since extended across the humanities as a mode of establishing notions of subjectivity across every mode of looking and being looked at.[34] Instead of to Harvey, Deutsche turns to Michel de Certeau's analysis of 'disembodied viewpoints' which yield 'panoramas' which correspond to objectifying epistemologies that produce a fiction of knowledge. De Certeau poetically describes this process:

> To be lifted to the summit of the World Trade Center is to be lifted out of the city's grasp. One's body is no longer clasped by the streets that turn and return it according to an anonymous law; nor is it possessed, by the rumble of so many differences or by the nervousness of New York traffic. When one goes up there, he leaves behind the mass that carries off and mixes up in itself any identity of authors or spectators . . . His elevation transfigures him into a voyeur. It puts him at a distance. It transforms the bewitching world by which one was 'possessed' into a text that lies before one's eyes. It allows one to read it to be a solar Eye, looking down like a god. The exaltation of the scopic and Gnostic drive: the fiction of knowledge is related to this lust to be a viewpoint and nothing more.[35]

Against this disembodied and despatialized viewpoint, Deutsche brilliantly mobilizes feminist art practices of the 1980s such as Cindy Sherman's *Film Still* series or the posters and billboards of Barbara Kruger or the electronic boards of Jenny Holzer:

Neither autonomous in the aestheticist sense – embodiments of transcendental aesthetic ideas – nor social because they are produced by external society, representations are not objects at all but social relations, themselves productive of meaning and subjectivity. In considering this kind of socio-spatial relation, urban discourse can only benefit from encounters with critical aesthetic practice. For the critique of art as representation and therefore as signification – not transparency – necessary fully to politicize urban discourse has already been forged in some of the postmodern art that Harvey rejects and particularly in the feminist theories of representation which play such a significant role in that aesthetic production.[36]

In the work by critical and theoretically and conceptually informed feminist artists, spectatorship is enlisted to constantly agitate public space and to undo its certainties. By remaking public urban space in the form of filmic anxieties regarding women in the public sphere, by creating linguistic confrontations and unexpected demands for thought and reflexivity where nothing but illusion and gratification normally dwell, these artists actually gender space. Their work results, to follow Deutsche's argument, in the negation of meta-vision and of totalizing vision, the specificity of its subjectivity refuses the lofty disembodied viewpoint in urban public space. Perhaps most importantly in Deutsche's argument, this work and the critical discourses in which it is embedded facilitate a recognition – through spatialization, geographization and location – of the constitutive dimensions of disavowed difference. Such a recognition subsequently permits difference to be re-positioned in the world via a manipulation of an ocular/spectatorial regime.

Thinking of more current examples of disavowal in the public sphere, a recent work by Glenn Ligon comes to mind, made for an exhibition on Urban Space at New York's New Museum of Contemporary Art in 1993. In the work entitled *Picky*, which comprises a map of Williamsburg and some texts, a story unfolds of looking for studio space in Williamsburg, a working-class district of Brooklyn with few African-American residents. A narrative unfolds full of suspicious looks and averted gazes by locals; fears of blackness, of queerness of artistic excess and unconventionality fuel an urban landscape in which tensions are disavowed and naturalized through a supposed normative 'niceness'. The accompanying text reads:

North Williamsburg is a white ethnic working-class neighborhood in Brooklyn into which young white artists have moved. There are a few Asian and Latino families. There are Arab grocery stores

and bodegas. There are a few black people. Years ago, I was looking for an apartment and went to several real-estate brokers in the area. I was told repeatedly that apartments were scarce because they were rented by word-of-mouth. 'It must be a tough business for you, if everything is rented by word-of mouth,' I said. One man, perhaps feeling sorry for my naivete, gave me some words of advice. 'People out here are picky,' he said. 'You know . . . picky.'[37]

Living in a black neighborhood in Brooklyn and renting a studio in white working-class Williamsburg sets forth a deluge of irreconcilable spatial tensions, finally halted for a very brief moment in which a lady shopkeeper with a Texas accent requests payment ending the sentence with the word 'sweetheart'. A word suffused with memories of other places and other relations. An entire gamut of demographic, urban economic, racial and sexual factors is set out in specifically named spaces and the surface of all are momentarily pierced by a word that elicits a response at another level, that of desire, of nostalgia and subjectivity.

Geography and space are always gendered, always raced, always economical and always sexual. The textures that bind them together are daily re-written through a word, a gaze, a gesture.

Visual culture – vision as critique

The structures of knowledge and the situated images I have been discussing come together in the field of vision and are part of what we now term visual culture. How can we characterize the emergent field of 'visual culture' as an arena of study? To begin with, we must insist that this encompasses a great deal more than the study of images, even the most open-ended and cross-disciplinary study of images. At one level we certainly focus on the centrality of vision and the visual world in producing meanings, establishing and maintaining aesthetic values, gender stereotypes and power relations within culture. At another level we recognize that opening up the field of vision as an arena in which cultural meanings get constituted also simultaneously anchors to it an entire range of analyses and interpretations of the audio, the spatial, and the psychic dynamics of spectatorship.

Visual culture thus opens up an entire world of intertextuality in which images, sounds and spatial delineations are read on to and through one another, lending ever-accruing layers of meanings and of subjective response to each encounter we might have with film, television, advertising, art works, buildings or urban environments. In a sense we have produced a field-of-

vision version of Derrida's concept of *différance* and its achievement has had a twofold effect both on the structures of meaning and interpretation and on the epistemic and institutional frameworks which attempt to organize them. Derrida's conceptualization of *différance* takes the form of a critique of the binary logic in which every element of meaning constitution is locked into signification in relation to the others (a legacy of Saussurian linguistics' insistence on language as a system of negative differentiation). Instead what we have begun to uncover is the free play of the signifier, a freedom to understand meaning in relation to images, sounds or spaces not necessarily perceived to operate in a direct, causal or epistemic relation either to their context or to one another.

If feminist deconstructive writing has long held the place of writing as the endless displacement of meaning, then visual culture provides the articulation of the endless displacement of meaning in the field of vision. This insistence on the contingent, the subjective and the constantly re-produced state of meanings in the visual field is equally significant for the institutional or disciplinary location of this work. If we do not revert to ascribing meaning exclusively to an author, nor to the conditions and historical specificities of its making, nor to the politics of an authorizing community, then surely we simultaneously evacuate the object of study from the disciplinary and other forms of knowledge territorialization. Only then are we at long last approaching Roland Barthes's description of interdisciplinarity not as surrounding a chosen object with numerous modes of scientific inquiry but rather as the constitution of a new object of knowledge.[38]

The following brief attempt to engage with the arena of visual culture will touch on some of these themes as well as on the thorny politics of historical specificity, its advantages, its limitations and the dangers inherent in attempting to move out of a traditional and internally coherent and unexamined model of what it means to be historically specific.

In today's world, meanings circulate visually in addition to orally and textually. Images convey information, afford pleasure and displeasure, influence style, determine consumption and mediate power relations. Whom we see and whom we do not see, who is privileged within the regime of specularity, which aspects of the historical past actually have circulating visual representations and which do not, whose fantasies of what are fed by which visual images? Those are some of the questions which we pose regarding images and their circulation. Much of the practice of intellectual work within the framework of cultural problematics has to do with being able to ask new and alternative questions, rather than reproducing old knowledge by asking the old questions.

By focusing on a field of vision and of visual culture operating within it, we create the space for the articulation (but not necessarily for the

answering) of such questions as: What are the visual codes by which some are allowed to look, others to hazard a peek and still others forbidden to look altogether? In what political discourses can we understand looking and returning the gaze as an act of political resistance? Can we actually participate in the pleasure and identify with the images produced by culturally specific groups to which we do not belong?

These are the questions which we must address to the vast body of images which surrounds us daily. Furthermore we need to understand how we actively interact with images from all arenas to remake the world in the shape of our fantasies and desires and to narrate the stories which we carry within us. In the arena of visual culture the scrap of an image connects with a sequence of a film and with the corner of a billboard or the window display of a shop we have passed by to produce a new narrative formed out of both our experienced journey and our unconscious. Images do not stay within discrete disciplinary fields such as 'documentary film' or 'Renaissance painting', since neither the eye nor the psyche operate along or recognize such divisions. Instead they provide the opportunity for a mode of new cultural writing existing at the intersections of both objectivities and subjectivities. In a critical culture in which we have been trying to wrest representation away from the dominance of patriarchal, Eurocentric and heterosexist normativization, visual culture provides immense opportunities for rewriting culture through our concerns and our journeys.

The emergence of visual culture as a trans-disciplinary and cross-methodological field of inquiry means nothing less and nothing more than an opportunity to reconsider some of the present culture's thorniest problems from yet another angle. In its formulation both of the objects of its inquiry and of its methodological processes, it reflects the present moment in the arena of cultural studies in all of its complexities. How would I categorize this present moment?

From the perspective I inhabit it seems to reflect a shift from a phase of intensely analytical activity we went through during the late 1970s and throughout the 1980s – in which we gathered a wide assortment of tools of analysis – to a moment in which new cultural objects are actually being produced. While deeply rooted in an understanding of the epistemological denaturalization of inherited categories and subjects revealed through the analytical models of structuralist and post-structuralist thought and the specific introduction of theories of sexual and cultural difference, these new objects of inquiry go beyond analysis towards figuring out new and alternative languages which reflect the contemporary awareness by which we live out our lives. All around us fictions such as Toni Morrison's *Beloved*, autobiographies such as Sara Suleri's *Meatless Days*, films such as Terry Zwygof's *Crumb* and complex multi-media art installations such as Vera Frenkel's

Transit Bar live out precarious and immensely creative relations between analysis, fiction and the uneasy conditions of our critically informed lives.

One of the most important issues cultural studies has taken on is to provide a 'hands-on' application of the epistemological shift. Gayatri Spivak has characterized this as follows: 'It is the questions that we ask that produce the field of inquiry and not some body of materials which determines what questions need to be posed to it.'[39] In doing this we have affected a shift from the old logical-positivist world of cognition to a more contemporary arena of representation and of situated knowledges. The emergence of a relatively new arena such as visual culture provides the possibility of unframing some of these discussions we have engaged in. Among them are ones regarding presences and absences, invisibility and stereotypes, desires, reifications and objectifications from the disciplinary fields – art history, film studies, mass media and communications, theoretical articulations of vision, spectatorship and the power relations which animate the arena we call the field of vision – which first articulated their status as texts and objects thereby unframing them from a set of conventional values as either highly valued or highly marginalized or outside of the scope of sanctioned vision altogether. Equally they are unframed from the specific histories of their making and the methodological models of analyses which have more recently served for their unmaking. The field that I work in, which labors heavy-handedly under the title of the critical theorization of visual culture, or visual culture for short, does not function as a form of art history or film studies or mass media culture but is informed by all of them and intersects with all of them. It does not historicize the art object or any other visual image and provide for it either a narrow history within art or a broader genealogy within the world of social and cultural developments. It does not assume that, if we overpopulate the field of vision with ever more complementary information, we shall actually gain any more insight into it.

Nor does this field function as a form of criticism – of art or of any other visual artifact. It does not serve the purpose of evaluating a project, of complementing or condemning it, of assuming some notion of universal quality that can be applied to everything. Furthermore it does not aim at cataloguing the offenses and redressing the balances, of enumerating who is in and who is out, of what was chosen and what was discarded. These were an important part of an earlier project in which the glaring exclusions, erasures and distortions of every form of otherness – women, homosexuals and non-European peoples – had to be located and named and a judgment had to be passed. All of this, however, would constitute a 'speaking about', an objectification of, a moment in culture such as an exhibition or a film or a literary text, into a solid and immutable entity which does not afford us (the viewing audience) the possibilities of play, the possibilities of

set of images, viewed through specific apparatuses and serving the needs of distinct subjectivities.

Furthermore, the discussion of spectatorship in (rather than and) sexual and cultural difference, begun within feminist film theory and continued by the critical discourses of minority and emergent cultures, concerns itself with the gaze as desire which splits spectatorship into the arena of desiring subjects and desired objects. Currently such binary separations have been increasingly tempered by the slippages between the ever-eroding boundaries of exclusive objecthood or coherent subjecthood. At present we have arrived at an understanding that all sexual and racial identity in the field of vision is formed out of processes of negative differentiation – that whiteness needs blackness to constitute itself as whiteness, that masculinity needs femininity or feminized masculinity to constitute its masculinity in agreed-upon norma-tive modes, that civility and bourgeois respectability need the stereotypical unruly 'others', be they drunks or cultural minorities or anyone else posi-tioned outside fantasmatic norms, to define the non-existent codes of what constitutes 'acceptable' behavior. But at the same time we have understood that all of these are socially constructed, 'performative' rather than essen-tially attributed, and therefore highly unstable, entities. Thus the field of vision becomes a ground for contestation in which unstable normativity constantly and vehemently attempts to shore itself up. Films such as *The Crying Game* or *The Last Seduction* played precisely with the erosion of assump-tions that something – gender identities in both cases 'looks like' that which names it – and the cataclysmic results which such processes of destabiliza-tion have. Specatorship as an investigative field understands that what the eye purportedly 'sees' is dictated to it by an entire set of desires and by a set of coded languages and generic apparatuses.

Finally, the field of vision is sustained through an illusion of transparent space. A perfect example of the conjunction of political discourse, disavowed spectatorship and the illusion of transparency can be found in this quotation from Newt Gingrich: 'I raise my eyes and I see America' (*New York Times*, April 19, 1995). In this scenario he has the ability to see. America, in all its supposed unity and homogeneity, is there available to his vision, it can be seen by him and the space between them is a transparent entity in which no obstacles obscure the directness and clarity of (his) vision. To return to Lefebvre's formulation:

> Here space appears as luminous, as intelligible, as giving action
> free rein. What happens in space lends a miraculous quality to
> thought, which becomes incarnate by means of a design (in both
> senses of the word). The design serves as a mediator – itself of
> great fidelity – between mental activity (invention) and social

activity (realization); and it is deployed in space. Anything hidden or dissimulated — and hence dangerous — is antagonistic to transparency, under whose reign everything can be taken in by a single glance from the mental eye which illuminates whatever it contemplates.[43]

To some extent the project of visual culture has been to try and repopulate space with all the obstacles and all the unknown images which the illusion of transparency evacuated from it. Space, as we have understood it, is always differentiated, it is always sexual or racial, it is always constituted out of circulating capital and it is always subject to the invisible boundary lines which determine inclusions and exclusions. That is to some extent what is happening in the arena of spectatorship: we have left behind the simple binaries of male gazes objectifying female subjects and expanded the arena to contain all the nuances of located difference. When Kobena Mercer writes his critical responses to the photographs of Robert Mapplethorpe he is simultaneously a Black critic (British/Ghanaian) marking a White (American) photographer's objectification of black male bodies (African-American). At the same time as a gay man he writes in his desire for those bodies and his readings of a language of gay erotica which nevertheless functions also outside of gay culture as a language of racialized menace and fear of black bodies.[44] Mercer transforms these images into a dialectical space of the relations between race and desire which produce one another. He has spatialized his responses by producing a geography of desire in which positionality — an endlessly conflicted and unresolved positionality — allows for the multi-inhabitation of a problematic.

Clearly space is always populated with the unrecognized obstacles which never allow us actually to 'see' what is out there beyond what we expect to find. To repopulate space with all of its constitutive obstacles as we learn to recognize them and name them is to understand how hard we have to strain to see, how complex the work of visual culture.

These then are the modes by which we can link the important discussions of situatedness, of positionality, of visuality, of spectatorship and of spatialization to geographies. In the following chapters I attempt to read some components of the geographical vocabulary as a set of signifying processes and practices which are being re-written and renegotiated from within contemporary visual culture.

Luggage

That which has been left behind

THOSE WHO HAVE VISITED contemporary art exhibitions over the past decade have become accustomed to seeing a plethora of suitcases within art gallery installations. Like many other important terms such as 'exile', 'diaspora', 'migration' or 'hybridity', the suitcase has become the signifier of mobility, displacement, duality and the overwrought emotional climates in which these circulate. These closed suitcases in their art world settings seem to require a certain taxonomy, decoding and differentiation so that they might inhabit a place away from the instinctive, empathetic responses they are assumed to elicit – if they are to maintain their potency within the visual signification of geographic complexities. I wish to remove the 'suitcase' from its relation to a concrete past, a nostalgic trace. Instead it might be animated as a split trace of meaning within specific contexts of dislocation, of that which is absent in a very particular way: half 'not there' half 'not that' to paraphrase Derrida. In order to affect a reading of such an active split entity we need to examine critically the various nostalgic and other triggers which metaphors of luggage are assumed to set off.

I want to open the present study with a discussion of luggage since it seems to me to function as a signification of the 'degree zero' of displacement both temporally and symbolically, an originary moment after which all familiarity is lost while change and difference shape life. In a study which aims to track the shifting significations of what constitutes belonging and the naturalized relations to place, luggage, with its double inscription both of

concrete material belongings and of travel and movement away from the naturalized anchorings of those belongings, certainly deserves pride of place. Within these readings 'luggage' is perceived as a multiple marker: of memory, nostalgia and access to other histories. Equally it is read as the tool of ideological constructions either of utopian new beginnings or of tragic doomed endings. Finally it is understood to be the signification of the permanently circulatory, infiltrating and co-inhabited nature of both contemporary cultural and economic organization.

In its cultural stagings the rhetoric of luggage is sometimes glamorous and adventurous, as in the images of transcontinental trains and trans-Atlantic ocean liners in the 1920s and 1930s. More often, however, it is associated with flight, exile and immigration, with incomprehensible and tragic events 'over there' and incomprehensible host cultures 'over here' and it is often referred to as 'sad', 'pathetic' or 'forlorn'. Indeed, not limited to the trials and tribulations of actual migrants, the confusion and incomprehension that luggage signals rear their ugly head on virtually every occasion on which we pack a suitcase and invariably do not have the right clothes for the occasion or the climate or have forgotten the manuscript of the paper we are to give or the report we need to deliver. Even in these more advantaged 'touristic' understandings of luggage in association with travel rather than flight, it is nevertheless a sign imbued with an indisputable frisson of unease, of displacement and dislocation or, at the other extreme, of excited speculation and expectations.

Traditionally luggage is one of the main metaphors of 'sadness at leaving'[45] and the privileged terrain of 'exile' tropes within the historical avant-garde in Europe in the first quarter of the twentieth century. The experiences of Joyce, Beckett, Hemingway, Stein and Kojève in Paris, to paraphrase James Clifford, enjoy a particular coded privilege in modernist culture through their 'Special pain, uprootedness, authority'.[46] At the other extreme we find a body of readings such as those begun by John Berger in *A Seventh Man* and continued in ever more complex ways, in which Europe's invisible migrant work force – the abject of the metropolitan space – was internalized and read as part of its current urban topographies while these in turn were fragmented and rendered less heterogeneous via a range of multiple cultural inhabitations.[47] Between this poetic privilege and the material realities of the daily wretchedness of migration and exile there exists a certain process – of movement, of memory, of learning new things, of repressing old knowledge, of forbidden nostalgias and of material exchanges and cultural circulations – which an analysis of the suitcase might be useful for drawing out.

The suitcase signifies the moment of rupture, the instance in which the subject is torn out of the web of connectedness that contained him or her

through an invisible net of belonging. This equation of the suitcase with some thing, some part of the self's being or history which has been left behind, both affirms and celebrates feelings of loss and of nostalgia. In addition there is an assumption of recouperability within the sign language of suitcases and other luggage, a semblance of being able to maintain a presence in several cultures and historical moments simultaneously. Mostly, however, the suitcase circulates in culture as the cipher of memory, of that which is lost and to which one has no direct or easy access. It is the concrete embodiment of memories that cannot be recounted for they will not be understood, their context having changed in a highly dramatic rupture. As 'luggage', memories and cultural symbols are objectified, concretized, virtually museumified in a suitcase. Thus they simply are and do not run the danger of being misunderstood or altered.

As Rosemary Marangoly George argues

> The contemporary literary writing in which the politics and experience of location or rather of 'dislocation' are the central narratives, [are] being called the 'immigrant genre'. Distinct from other post-colonial literary writing and even from the literature of exile, it is also closely related to the two. For the immigrant genre, like the social phenomenon from which it takes its name, is born of a history of global colonialism and is therefore an undeniable part of post-colonialism and of de-colonizing discourses. And, like the distance that exile imposes on a writing subject, writers of the immigrant genre also view the present in terms of its distance from the past and future . . . Most importantly, the immigrant genre is marked by a curiously detached reading of the experience of 'homelessness' which is compensated for by an excessive use of the metaphor of luggage, both spiritual and material.[48]

George very usefully reads a series of literary works, novels by M. G. Vassanji,[49] Anita Desai[50] and Samuel Selvon[51] among others, to mobilize the metaphor of luggage against the concept of 'writing the nation' from either the center or the margins and thereby engages with the body of thought on community and displacement put forward by Benedict Anderson in *Imagined Communities*[52] and by Homi Bhabha in 'DissemiNation: Time, Narrative and the Margins of the Modern Nation'.[53] Thus she posits an alternative reading in which the production of nation is not the subject of writing in this genre but rather that immigration '*unwrites* nation and national projects because it flagrantly displays a rejection of one national space for another more desirable location, albeit with some luggage carried over'.[54] In a related manner

I would like to argue 'luggage' within visual culture away from modernist utopias of new beginnings and away from modernist narratives of doomed endings. In the process I am hoping to open an understanding of how a particular sign system has taken on the reflection of the circulations and the circulatory dynamics which more than any other reflect post-colonial global capital.

In addition there is the exceptionally thorny question of nostalgia for which luggage is probably the most overlaid and overdetermined sign. It is problematic because one needs to somehow separate the sign from the signifier; the tragedies and human ruptures involved in forced migration and flight are horrendous and must not be trivialized at any level. However, the sign system which has most conventionally and commonly been used to signify these subsequent wrenches has imprisoned their meanings within a convenient language of universal empathy. Edward Said, in *After the Last Sky*, provides an empathic account of the textures and griefs of Palestinian lives in camps and in numerous exiles in an unresolved condition of despair yet within some proximity to their former land. Here on the relics which have traveled with them:

> These intimate momentos of a past irrevocably lost circulate among us, like the genealogies and fables of a wandering singer of tales. Photographs, dresses, objects severed from their original locale, the rituals of speech and custom: much reproduced, enlarged, thematized, embroidered, and passed around, they are strands in the webs of affiliations we Palestinians use to tie ourselves to our identity and to each other.
>
> Sometimes these objects, heavy with memory – albums, rosary beads, shawls, little boxes – seem to me like encumbrances. We carry them about, hang them on every set of new walls we shelter in, reflect lovingly on them. Then we do not notice the bitterness but it continues to grow nonetheless. Nor do we acknowledge the frozen immobility of our attitudes. In the end the past owns us.[55]

Here is luggage suspended between an unrecoupable past and an unimaginable future and bearing the entire weight of those longings, to a point that it will not allow for any form of reflection on the textures of life in the present, on the new cultural artifacts that are being constituted out of life among other peoples and other languages and objects.

Unclaimed luggage

The former immigration center on Ellis Island is a large imposing red-brick building with turrets and scalloped edges faced in white stone (Figure 2.1). Together with the nearby Statue of Liberty it dominates the skyline as one approaches New York from the sea, twin emblems of utopian investments in immigration and of the links with the old world of Europe.

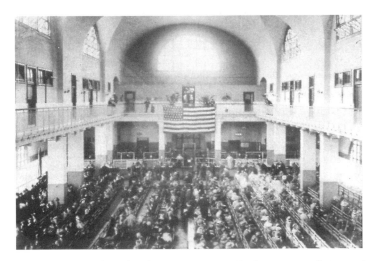

Figure 2.1 Ellis Island, *The Great Hall*. Courtesy of *Art in America*, September 1991

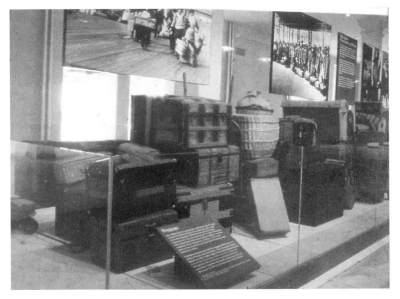

Figure 2.2 Ellis Island, *Suitcase Wall*. Author's photograph

Visiting Ellis Island off the coast of Manhattan one is faced, immediately on entering the main hall, with a wall made of suitcases, baskets, hampers and bundles (Figure 2.2). Nearly 30 feet long, cordoned off by low plate-glass barriers, accompanied by explicatory plaques and topped by vintage photographs (Figure 2.3) of arriving immigrants accompanied by their makeshift luggage, this display is artistically arranged to virtually block one's progress along the vast arrival hall. In effect it proceeds to do two things: to condense the experience of immigration to a single visual metaphor and to produce a concrete borderline for a nation or a national culture, to embody the moment of crossing over to the United States. Thus these suitcases and bundles have been drafted into the cause of nation

Figure 2.3 Ellis Island, *Suitcase Wall.* Author's photograph

building or nation imagining by drawing a line and then crossing it, but have in the process been evacuated of the meanings they once held in another culture. In the present they serve as the relics of the so-called 'old world' and their very clumsy concreteness signifies a lack of sleek, pragmatic modernity necessary for visibly concretizing the encounter with the abstract modernist dream of immigrations and 'new worlds'. In the photographs which accompany the wall of luggage, immigrants have their back to the island, to the ocean and to the old world they have come from (Figure 2.4). Accompanied by their bundles and suitcases and organized in regimented lines, they look forward to the new world and to their own new beginnings. The line has been crossed and there is no looking back. Museologically this point is brought home to the contemporary visitor through the display of the most extreme, esoteric and exotic objects that some of these migrants had brought with them arranged in cabinets in the manner of the nineteenth-century museum of natural history. These include pre-mechanization farm implements, odd cooking utensils and impractical clothing, objects so unfamiliar and incomprehensible that the visitor can hardly imagine their use – the line has been crossed, there

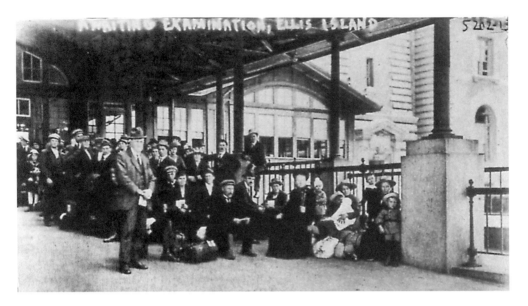

Figure 2.4 Ellis Island, *Awaiting Examination*. Courtesy of *Art in America*,
 September 1991

is no looking back, and these relics stand guard to ensure that the past has
been made well and truly 'strange'.

 I would like to use this example to clarify what I mean by a sign system
in the crisis of signification.[56] Ellis Island, which for two centuries served
as the main point of European immigration entry to the East Coast of the
United States, is now a museum of immigration. Here immigration becomes
a middle period, akin to the use of the 'High' Renaissance in Italy in the
fifteenth century, a golden moment suspended between the two things it is
not – eighteenth- and nineteenth-century slavery and the more recent mass
migrations of the period of decolonization and of Cold War politics. As such
it provides an account of immigration as being primarily within the modern
era, primarily European and primarily voluntary. Its exhibits signify the end
of a utopian journey away from poverty, discrimination, disease and back-
wardness, racism and political persecution and the entry into a new culture,
an enunciatory arrival in the most complex sense of a new beginning. The
suitcases piled up in its display cabinets are the nostalgic embodiment of
old-world memories which are to be preserved as cultural relics but ulti-
mately are meant to be lost within the assimilation culture of the United
States. Certainly these artifacts and the narratives they animate play a central
role in the constitution of a national narrative, one in which individual
arrival, individual possibilities and individual hopes become a collective iden-
tity within the modern era and cohere, simultaneously from both margins
and center, into a concept of 'nation'. Ellis Island, which has long served

to symbolize both the 'New World' aspect of the United States and the all-important emphasis on a migration from 'Europe' (as opposed to other regions considered less culturally privileged) has now become the site of mourning for this lost metanarrative of modernity and progress through mobility. After the dwindling numbers of immigrants from Europe in the late 1950s the site was closed down as an immigration port and was abandoned and unoccupied for over twenty years. At present Ellis Island is a museum, both to the earlier immigrations and to the later abandonment of the site. It has achieved this transformation by undergoing a process of self-museumification in which the years of abandonment between being a point of entry for migrants coming into the United States and becoming a museum of that very project in the 1990s are being put on display as a series of 'tableaux-vivants' of Ellis Island in ruins. Clearly what is at stake is neither the physical site of the building nor the material realities of shifting economic and political conditions in Europe that have lessened the imperative for flight – rather the conjunction of the two displays works to symbolize the loss of hope investment in a rhetoric of self-improvement and fulfilment through a migration from Europe to the New World. In part this display of ruined rooms artfully arranged behind large plate-glass sheets makes it very clear that the classic notion of migration within US culture is writ European. Once the United States can no longer provide refuge and improved circumstances to those coming from the 'mother' cultures of Europe, then the entire project shifts – as do the populations of migrants, now arriving primarily from South East and East Asia, from Latin America – from a euphoric narrative of new beginnings to a completely opposite one of misery, cultural incomprehension and extreme foreignness.

How then has 'luggage' subsequently circulated within everyday *modernist* visual discourses? Primarily either it has served as the signification of utopian beginnings – such as those accompanying the triumphant claims of immigration to the 'new world' – or it has represented doomed journeys of annihilation, of no return. Operating fairly strictly within such binary constraints which serve by necessity to produce one another, 'luggage' within this traditional signifying system seems to have served to affirm national entities and narratives as well as national borders by working back to originary moments of flight, expulsion, ejection, annihilation and crossing over.

Thus, in the traditional signifying practices related to transition and location, the suitcase has marked the end of a journey: this could be a supposedly optimistic journey's end within the culture of assimilation, or a tragic one as signified by the suitcases piled up in the museum in Auschwitz, the Nazi extermination camp in Poland (Figure 2.5).[57] Like Ellis Island, the concentration camp at Auschwitz is also a museum: it attempts to recount what happened

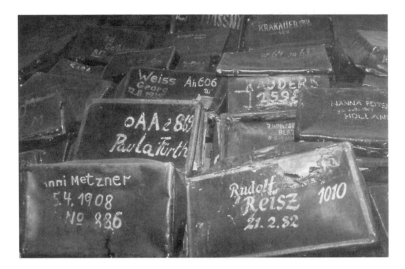

Figure 2.5 Auschwitz suitcases. Source: James Young, *The Texture of Memory–Holocaust Monuments* (Yale University Press, New Haven and London) 1993

on this site while at the same time it serves the purpose of critically negating the very history it is narrating. The suitcase is thus a relic of what is past and museumified, never to return. In Auschwitz the closed suitcases carry on them written emblems of identity: names, places of origin, dates of birth and identity numbers within the machinery of annihilation. As such they are virtually a registration system and an archival order. Like the suitcases in that other museum on Ellis Island, the suitcases in the Auschwitz museum are piled up as a display of a mass, defying their very individual markings. In their multiplicity and in their concreteness and in their closed (and therefore inviolate) state, they become a defiant *presence*, a ploy in a display strategy that wants to insist on driving home both its quite natural disapproval of what took place but also its hopes that this act of museumification serves as a kind of amends against the original purpose of the Nazi genocide.[58] In her brilliant reading of Claude Lanzman's film *Shoa* – itself part of a larger project on witness-bearing and testimony – Shoshana Felman says:

> The essence of the Nazi scheme is to make itself – and to make the Jews – essentially invisible. Not merely by killing them, not merely by confining them to 'camouflaged' invisible death camps but by reducing even the materiality of the dead bodies to smoke and ashes, and by reducing, furthermore, the radical opacity of the *sight* of the dead people as well as the linguistic referentiality and literality of the word 'corpse' to the transparency of a pure form and to the pure rhetorical metaphoricity

of a mere *figure*: a disembodied verbal substitute which signifies abstractly the linguistic law of infinite exchangeability and substitutionality. The dead bodies are thus rendered invisible and voided of substance and specificity, by being treated in the Nazi jargon as *figuren*: that which all at once cannot be seen and cannot be seen through.[59]

Thus the production of invisibility is part of the historical materials being invoked and must itself be seen as part of cause, event and commentary. However, the postwar policy in the service of reparation work seems, at least in the first instance, to address that legacy of invisibility through its binary opposite, through the production of a visibility and therefore continuing the work of commemoration, of countering absence with a symbolic presence.[60] These suitcases on display in Auschwitz are oddly uniform, as are the displays of gold teeth, human hair and other horror artifacts representing activities in the camp. They are also unclaimed, either by the histories of their owners or by any survivors – they are on display as part of the signification of a postwar policy of dealing with the past, supported by German public institutions and public cultural debates in the 1970s and 1980s. They have left me with the task of finding some form of claimed luggage within that same history, to confront narratives of horror and of guilt with lived realities not reduced to tragic closure.

To counter this awful mound of oddly similar suitcases, I have in mind a few pages from the amazing diary of Charlotte Salomon of the 1930s and 1940s, *Life? or Theater?*[61] This astonishing painted, drawn and written diary comprising some 1300 pages was produced by a young Jewish German art student in her safe house in Villefranche between 1940 and 1942, just after she had been released from a French concentration camp in the Pyrenees on account of her eighty-year-old grandfather who seemed to the authorities too old to keep at the camp. Having suffered a nervous breakdown, Charlotte set about producing therapeutically this densely textured work of combined public and private memory which is an account of her entire life up to that moment, told through fictitious code names and taking the form of a *Singspiel*, 'A play with music, a somewhat dramatic musical work, popular in Germany in the latter part of the 18th century, usually comic in nature and characterized by spoken dialogue, interspersed with popular or folk songs . . . the *Singspiel* was the predecessor of the operetta'.[62] Charlotte's diary tells of her parents' marriage after the suicide of her mother's sister, of her birth and of her mother's suicide, of the second marriage of her father, a reputable Berlin surgeon, to the singer Paulina Lindberg, of her own infatuation with her new stepmother and with the world of musicians and artists which now filled their home, of complex

incestuous love affairs and of the texture of metropolitan life in prewar Berlin, of her studies at the Berlin art academy, of the strictures against Jews in Germany after 1933 in which her father lost the right to operate and was interned in a labor camp while her stepmother lost the right to sing, of their rallying to find alternatives and to protect as many friends and colleagues as possible, of her flight at the last moment at which she as a minor could still leave to join her maternal grandparents in the south of France in 1938, of her grandmother's suicide, and her and her grandfather's internment followed by their release and her own nervous breakdown. The whole work is in rhymes and uses colors, actors, texts, music and film to create a familiar stage of early twentieth-century culture. By using humorous fictitious names, explosive colors and a technique somewhat reminiscent of latter-day cartoon strips, she conveys a tragic story of one family's life first under the terror of repeated suicides and then of the terror of the Nazi regime, as a gripping, dramatic, funny and highly personal narrative. Love, in various tortured configurations, is what ties the narrative together, rather than world-historical forces. In fact it was love that was finally responsible for Charlotte and her new husband being discovered by the Gestapo and sent to Auschwitz, where they were both killed in 1943. Having been married at the local municipality in Villefranche, they were so delighted at their marriage that they forgot to use their false identities and registered in their own names, leading to their discovery and arrest.

In one of the middle sections of the diary, in a chapter called 'The German Jews', there is talk of immigration at a dinner party; everyone is thinking of leaving if possible. For Charlotte it is more a question of an enforced separation from the lover she seems to be sharing with her stepmother than an escape from Nazi Germany. One drawing shows her sitting dejected on her bed facing an empty suitcase and the debris of a privileged life of culture and leisure (Plate 1). She then draws a picture called 'The Dark-

Figure 2.6 Charlotte Salomon, 'Viertes Kapitel: Die Deutsche Juden' from *Life? Or Theatre?* 1992. Courtesy of the Jewish Historical Museum Amsterdam, Charlotte Salomon Foundation

est Day', gives it to her lover and then on another page of the diary, surrounded by suitcases, begins a keening song of farewell to her country and to the life she has known in it (Figure 2.6).

In Charlotte Salomon's pictures we find everything that has gone into the suitcases, prior to the departure. Being a savvy participant in 1930s metropolitan culture, she communicates all with great reference to film and other mass media. The life of the family she describes is so psychically complex that what takes place in political culture, though it affects them in every way, nevertheless ends up dominating not the textures and narrative structures but rather the factual framework: Charlotte Salomon's family are being ejected from all the professional institutions in which they had previously worked, studied, performed and earned their living. Internally, within the private sphere however, adjustments are made and all the complex and often confused network of love relationships continues with unabated furor. Charlotte Salomon's suitcases are absolutely full, replete with the images and dramas of everyday life, they bring us to the moment of departure and beyond with a full recognition of the abundance and breadth of the life that had been lived *in situ*. In providing us with such a rich catalogue of pleasures and heartaches and defeats, they do not rewrite the entirety of the subject's identity through her flight from Germany but rather as a life's narrative in which an accommodation takes place between continuity and change. Much of the tragic aspect of *Life? or Theatre?* has been visited upon it with hindsight, through the author's own tragic death in a concentration camp, newly married and four months pregnant. The diary itself is rarely tragic in tone. As she packs her suitcase for a third time, this time in the south of France, en route to an internment camp for German passport-holders in the Pyrenees, Charlotte mutters to herself, 'A little culture, some laws and, inside, a vacuum, that's all that's left of mankind. They should start the world a fresh'. To some extent her modest, partly tragic and partly comic family saga, a kind of Freudian family romance as Gertrude Koch has called it,[63] is in fact an attempt to write a fresh, a very private and very gendered book of Genesis.[64]

'The supplement – codes of travel'

Stella Payne, the protagonist of Terry MacMillen's novel *How Stella Got her Groove Back*, is packing for an impromptu vacation trip to Jamaica.

> I can't wait to pack. I went crazy in Macy's, beserk in Nordstroms and all I want to know is why they do not have shopping carts in malls? And talk about bathing suits? I think I bought six or

seven of them but I can't be sure. And sunglasses. Sexy cotton bras and panties. Cute jogging shorts, tops, leggings. . .

A sea of bags covers my bedroom floor and I've all the windows open as wide as they will go, have the ceiling fan spinning on high and the whole house is thumping with Monteil Jordan's 'This is How We Do It' – it feels like Christmas in the summertime and I'm so excited I almost can't stand it.[65]

While MacMillen's novel is a fairly conventional tale of a middle-aged working woman recovering her inner sense of pleasure via exotic travel told through meticulous listings of consumption details, the excitement made manifest through the excesses of shopping and the act of packing suitcases is nevertheless telling.

Within codes of travel the suitcase is an accompaniment to the actual journey's processes – a compartment which produces a prehistory of wishes, expectations, dreads and desires made manifest through the items packed to either facilitate these or to ward them off. (Stella's combination of slinky evening dress, insect repellent, purgative laxative and condoms is a case in point.) In these travel suitcases we can find a combination of the concrete location from which one has come, marked by the items one has taken along and of the fantasmatic investment in a hoped-for adventure, for a radical departure or a zone of gratification projected on those very same items. In Stella's orgiastic packing we find precisely this geographic double coding – at once a topography of California consumerism and a set of highly charged expectations projected on to a touristically overdetermined and mythical Jamaican playground.

'Travel' has of late grown into an enchanted forest of displacement metaphors. Movement, exploration, adventure, scientific investigations, epistemological colonialisms, military campaigns, voyages of discovery, 'going native', sexual gratifications in exotic locations, 'in-Betweenness', fieldwork, ethnographic fictions and radical ethnographies, getting lost, cultural touring, holidaymaking and many other practices and narratives populate this fascinating discussion which has dedicated itself to complicating the terrain that lies between being 'at home' and resolute 'foreignness'. Travel has been theorized in relation to anthropology, tourism, collecting and displaying, all linked to the workings, legacies and epistemologies of colonialism. Equally, travel has been one of the main metaphors for theoretical activity as well as for the leading thinkers who circulate in the world as much as their work does. 'Theory, by definition, is more than a local act' state the editors of a special issue of *INSCRIPTIONS* entitled 'Travelling Theories/Travelling Theorists':

While it is enmeshed in specific traditions and locales, and while
it is marked by the site and conditions of its production, its
purview is extensive, generalizing, comparative. If theories no
longer totalize, they do travel. Indeed, in their diverse rootings
and uprootings, theories are constantly translated, appropriated,
contested, grafted. Theory travels; so do theorists. In the late
twentieth century the producers and audiences of theory can no
longer be situated in a more-or-less stable map of 'First World'
and 'Third World' places.[66]

Just for a moment, a slightly uneasy and discomfited moment, I want
to try to move away from the two mighty critical interpretations of travel
put forward in part by James Clifford,[67] who has recently said that

> travel has emerged as an increasingly complex range of experi-
> ences; practices of crossing and interaction that troubled the
> localism of many common assumptions about culture. In these
> assumptions authentic social existence is, or should be centered
> in circumscribed places . . . Dwelling was understood to be the
> local ground of collective life, travel a supplement; roots always
> precede routes.
> But what would happen, I began to ask, if travel were unteth-
> ered – seen as a complex and pervasive spectrum of human
> experiences? . . . and is not this interactive process relevant in
> varying degrees, to any local, national or regional domain?
> Virtually everywhere one looks, the processes of human move-
> ment and encounter are long established and complex.

Clifford had begun his project in *The Predicament of Culture* and in a series
of important related essays in which he examined how the movement
inherent in anthropological field work, in finding things out and having them
recounted, in the mobility of objects through colonial-influenced economies
of circulation, in accumulating collections as well as the bodies of know-
ledge which serve to categorize and structure these imported objects – all
of these are rooted in certain colonial legacies of movement and of its denial.
It is in the movement between cultures, their intertextual weavings and
constant readings of one another, that the presumed experience of the
other comes about. In this critical model, as well as in many others such as
the work of Gayatri Spivak for example, it is a complex attempt at self-
location which is mobilized to counter the supposedly seamless and
naturalized movement of knowledge across worlds of profound cultural
difference, of the impossibility of 'knowing' or 'grasping'. At the same time

I also want to move slightly away from that other important idea of move-
ment, from Homi Bhabha's model of 'in-betweenness' in which acts of
location take place

> in the emergence of the interstices – the overlap and displace-
> ment of domains of difference – the intersubjective and collective
> experience of 'nationness', community interest, or cultural value
> are negotiated. How are subjects formed 'in-between' or in excess
> of, the sum of the parts of difference?[68]

In this slight move sideways I would want to think Clifford's notion of
travel as supplement and Bhabha's notion of subjects formed 'in excess'
of their cumulative components, through what had perhaps been an initial
theoretical impetus of some of these thoughts, namely Derrida's concept
of 'the supplement'. To join luggage in relation to travel through the
notion of the supplement is perhaps an attempt in linking those processes
of travel and those symbolically over-invested items which are the suit-
cases, within a system of thought rather than of metaphor or illustration,
and thus provide yet another possibility to configure a relationality between
material conditions and economies and the terrain of the psychic and the
fantasmatic.

While acts of location are of the utmost importance for understanding
difference as an epistemic structure, they need to be accompanied by the
kind of theoretical activity that takes risks with the very act of self-location.
This slight shift, in which it is not only location that accounts for position-
ality, seems reasonable enough since this inquiry, though it occasionally loses
the thread of its own argument, does ultimately attempt an understanding
of a semiotic crisis in which signs fail to reproduce fully the narratives in
which they are embedded. Equally it is an inquiry into the possibilities for
an emergent, dispersed form of alternative significations of the relations
between subjects and places refracted through spatialization practices.
In view of this, the return to an initial stage of undoing the heterogeneity
of the concept of the sign might actually be helpful for the development of
both sets of questions. One of Derrida's most basic claims is the argument
that the sign marks a place of difference, that signification can take place
only because not only is there no identity between sign and signified, but
in fact there exists only a relation of difference. As Spivak writes in her
'Translator's Preface' to *Of Grammatology*:

> Derrida suggests that what opens the possibility of thought is not
> merely the question of being, but also the never-annulled differ-
> ence from 'the completely other'. Such is the strange 'being' of

the sign: half of it is always 'not there' and the other half always 'not that'. The structure of the sign is determined by the trace or track of that which is forever absent.[69]

If we were able to think of luggage as 'the supplement' of travel it would imply that the excitements, expectations, fears and prejudices which are separately packed away in the accompanying luggage are not simply the discursive sphere of the travel but actually its very fabric. In parallel we would want to guard against the loss of its effective ability to shade and agitate the narrative if it were to claim systematic representational value. Derrida writes:

> Writing is dangerous from the moment that representation there claims to be presence and the sign of the thing itself. And there is a fatal necessity, inscribed in the very functioning of the sign, that the substitute make one forget the vicariousness of its own function and make itself pass for the plenitude of a speech whose deficiency and infirmity it nevertheless only supplements. For the concept of the supplement – which here determines that of the representative image – harbors within itself two significations whose co-habitation is as strange as it is necessary. The supplement adds itself, it is a surplus, a plenitude enriching another plenitude, the fullest measure of presence. It cumulates and accumulates presence. It is thus that art, technè, image, representation, convention etc. come as supplements to nature and are rich with this entire cumulating function.[70]

Architects Elizabeth Diller and Ricardo Scofidio, who work as an artistic team in New York, have produced a project entitled *Suitcase Studies – Tourisms of War* (1991), which has traveled around several locations in the world and served as the focal point of different interrogations of tourisms allied, not to the conventional thrills of museums and breathtaking landscapes but to an obsessive taxonomy of bedrooms and battlefields.[71] Concerned primarily with travel to the American past, the project examines the spatial and temporal devices used in the production and sustenance of national narratives by the institution of tourism. The installation travels in fifty identical Samsonite suitcases (Figure 2.7, Plate 2). In addition to transporting the contents of the exhibition, the suitcases double as the display cases for the exhibition of their contents. Each suitcase is a case study of a single tourist attraction in one of the fifty states in the USA. Using official and unofficial representations, both pictorial and textual, two-dimensional and three-dimensional, the attractions are each analyzed and synthesized into

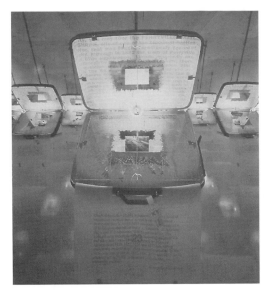

Figure 2.7 Diller and Scofidio, *Suitcase Studies — Tourisms of War*, 1991. Installation, Walker Art Center. Courtesy of the artists

new narratives. The terrain of Diller and Scofidio's project is what Baudrillard terms 'Astral America' characterized by 'the lyric nature of pure circulation.[72] The fifty attractions were selected from only two types of tourist site: bedrooms and battlefields — two sites of conflict. Among tourist attractions the bed (of the public figure) and the battlefield most strongly feed the tourist's yearning for authenticity while playing most subtly in the production of 'aura'. The vacated bed of the popular figure and the vacated battlefield landscape of the soldier are both imbued with 'presence'; a presence which however, accepts the replacement of immediacy with a system of representations.

Each case study begins with the irreducible representation of its sight — the postcard. The postcard is a complex artifact in which image and text are reversible, in which public and personal collapse. It is 'an instrument for converting the public event into a private appropriation which is ultimately surrendered to the public in a gesture that represents distance, appropriated'.[73]

The fifty postcards are cantilevered from the suitcase hinges on edge, at eye level. The front and back surfaces of the cards are thus obscured from view. The postcard faces are revealed virtually by mirror plates. The mirrors visually delaminate the postcard into its discrete text and image. The tourist's personal account, reflected above, floats before an 'adjusted' official text of the sight. The postcard image, reflected below, floats before a system of reconfigured maps, drawings and models that combine information selectively included or eliminated from the official narrative:

> There are three ordering systems at play. First, the suitcases are arranged alphabetically, by state. Then, geographically: the upper lid of each case is pulled open by a cord anchored to its corresponding location on the map which surfaces the 'inverted base' from which the Samsonite field is suspended. Each sight is also ranked economically, in order of profit from tourism.[74]

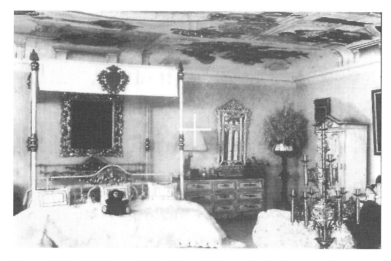

Figure 2.8 Diller and Scofidio, Liberace's Bedroom. Courtesy of the artists

The following are a pair of description panels from the work itself. First a bedroom followed by the battlefield. Although all of the bedrooms belong to historical male figures and most of them are former political figures such as presidents, governors and publishers, I have chosen the bedroom of a flamboyant entertainer as my example, that of Liberace (Figure 2.8).

> *Suitcase no. 12 (Earnings) $6,500,000,000.*
> Take Interstate 15 to downtown Las Vegas, then to the Liberace Plaza Shopping Center on East Tropicana Avenue. Within 5000 square feet is part of the awesome collection of the Liberace Museum. Here are pianos studded with rhinestones and mirror tiles, the world's largest rhinestone (weighing 115.00 carats), Liberace mannequins wearing his favorite costumes. And those cars, oh, those cars. Liberace loved 'em so and here they are including a patriotically painted Rolls Royce and a glittery Bradley GT sports car with candelabra detailing. Known variously as Mr. Showmanship, the Kid, Guru of Glitter, Mr. Smiles, The King of Diamonds and Mr. Box Office, Liberace was undoubtedly America's most beloved entertainer and a remarkable collector. 'My new museum will have several elegant shops selling the things with which I'm associated. From fabulous fur creations from my . . .

Here the text trails off and the image supplants it with an opulence combining Rococo palace and Venetian palazzo with a bit of Regency thrown in for good measure.

The text suspended below refers to commodities of the travel industry quoted by the Tourist Guide:

> Anti-Jet-Lag Formula helps your body adjust to new time zones. Contains amino acids and vitamins. Two or Twelve day supply: $5.95. Inflatable Neck Pillow/Great for trains or planes, has washable cover $9.95 . . .

The items advertised in the tourist guide to the museum are the same ones to be found in the duty-free lists of in-flight magazines: consumer travel paraphernalia. In the context of a museum in Las Vegas at which much of the visiting public arrives by car or coach, these items serve the purpose of extending an illusion of glamour and of fusing the lifestyles of Liberace and of the visitors. At the heart of the fascination with Liberace there has always been a kind of enigma of sexuality overlaid with a madly flamboyant, excessive and performative glamor. The choice of the bedroom, most intimate and private of places, combined with sales catalogue items, continues to work this enigma, to render it less sexual and therefore less dangerous and to make it consumable in every way. The journey to which this suitcase acts as the supplement is precisely no journey – a carefully calculated dead end in which no insight can take place and surface illusion and projected identifications talk to one another through opulence and fantasy. This is a strategy shared by both museums and the tourist industry in which sexuality is always hidden while at the same time it is always overtly manipulated for identificatory or empathic use. In this suitcase we see Liberace's bedroom but translate it into style and consumption – curiosity and prurience propel us straight into the shopping mall.

The next example is Fort Sumter (Figure 2.9).

> *Suitcase no. 22 (Earnings) $4,300,000,000.*
> Boats operated by a National Park Service concession leave from the City Marina on Lockwood Drive just south of U.S.17 in Charleston. The shots fired on this isolated five sided fortress island in Charlston harbor, *Fort Sumter National Monument*, were the fateful sparks that ignited the Civil War. At 4.30 a.m. on April 12, 1861, a single mortar shell rose above the city of Charleston, South Carolina. It zoomed upwards in a fiery arc, hung momentarily, then burst directly over the walls of Fort Sumter. Moments later, forty two other guns joined in and streaks of light flashed in great parabolic curves across the dark sky. The Civil War, America's bloodiest and most diverse armed conflict, had begun. In the end, buttressed with sand and cotton as well as its own fallen masonry, Fort Sumter was stronger than ever.

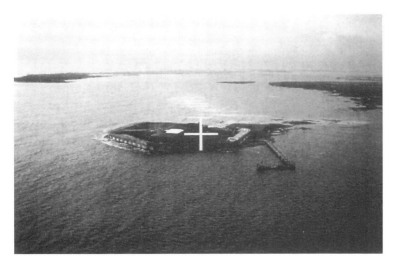

Figure 2.9 Diller and Scofidio, Fort Sumter. Courtesy of the artists

The Civil War in this narrative is a Turneresque extravagance of bursting shells and architectural ruins in which slavery and the battle over demo-cracy have no part. The island's very form in the photograph is remote from the coast and lost in historical time and space. Beneath we find:

> To the American, the landscape of the 1980s seems saturated with 'creeping' heritage – mansarded and half timbered shopping plazas, exposed brick and butcher block decor in historic precincts, heritage villages, historic preservation: 'We moderns have so devoted the resources of our sciences to taxidermy, that there is now virtually nothing that is not considerably more lively after death than it was before.'[75]

The sign of historical conflict, one half *not there* and the other half *not that*,

> The battle field, an otherwise undifferentiated terrain, becomes an ideologically encoded landscape through the commemora-tive function of the 'marker'. As a marker inscribes war onto material soil, *it* becomes the sight. Without a marker, a battle field might be indistinguishable from a golf course or a beach. Guided by a system of markers and maps, the tourist/strategist reenacts the battle by tracing the tragic space of conflict by foot or car.[76]

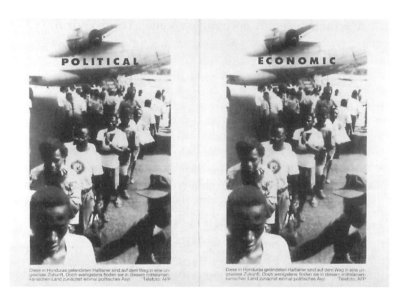

Figure 2.12 Art in Ruins, *Political/Economic* from *Conceptual Debt*, 1992.
 Courtesy of Art in Ruins

their repayment. In the process of this public drama, as in the debates around the GATT and NAFTA agreements which were to follow in the early 1990s, two dimensions of this dynamic were conveniently forgotten. First, it is not only capital which circulates globally but also the actual bodies of the labor forces in its service. Second, an intentional effect of the circulation of capital from the 'First World' to the 'Third World' is the constitution of markets and consumers for imported goods or goods produced locally by multi-nationals run from the centers of power and profit.

Berlin in the early 1990s was a poignant moment and site in which to open up such discussions. In one city two structures of the importation of foreign 'guest workers' – in the west the foreign workers imported from Turkey, Yugoslavia and Spain at the moment of the 'economic miracle of the 1950s and in the east the foreign labor brought in through that other great colonial system, the world of communist influence, from Africa and Asia – were meeting within an economic climate of increasing constraint and unemployment. Similarly, each side of the city had been closed from the international art world for different reasons and had developed habits of the importation of art and artists from elsewhere in order to enliven its cultural climate and keep it current and connected to the so-called 'rest of the world'. The Deutsche Akademische Austauschdienst is an academic and artistic exchange program which brought numerous artists to Berlin in an attempt to maintain an international arts scene during the years of the city's division and distance from the German Federal Republic. In their installation the British collaborative team Art in Ruins (visiting DAAD artists in residence in Berlin)

combined textual statements by various politicians and 'Third World' critics and activists with statistical information and with an attempt to produce a sign language for the 'Third World' presence at the heart of the West. The collusions with an unequal exchange between these two economic and cultural spheres, an exchange of labor, resources, capital and markets and the enormous burden of the interest with which these loans are serviced, have virtually no means of signification. The 'Third World' circulates in the West as a series of pathos-riddled images of famine, poverty and disease or as the frightening specter of extreme, irrational so-called terrorist politics of rebellion or suppression. It circulates as both a collapse of every conceivable Western order and as extremely geographically distant, virtually unreachable. Representations of the 'Third World' signify as the construction of an 'over there' which invariably demands a panacea, a philanthropy, 'aid' or military intervention. It is the excessive form given to the feared and the repressed of the West's political imaginary. The degree to which that world circulates within this world, as goods and natural resources, as laboring bodies, as cultural and linguistic hybridities and indelibly linked economic systems, might be recognized and studied by economists but it is not possessed of a system or language of representation within the wider culture. Only rarely are political figures such as Richard Nixon either sufficiently candid or sufficiently cynical to state, as is quoted in this installation, 'Let us remember that the main purpose of . . . aid, is not to help other nations but to help ourselves.'[78] That kind of recognition of mutual economic and cultural imbrication and its constitution as a visible sign system goes against the very need to repress what is feared and prevent it from freely circulating amongst us as a legible and visible entity. No less invisible are the murky structures and authorities by which all this wealth and labor make their way from one place to the other. In their installation Art in Ruins link material and political histories to produce a visual language with stamps of 'inspection' by leading 'Third World' figures, colors of the African National Congress flag merged with an image of Malcolm X, the North American political figure who beyond all others understood the links between 'Third Worlds' and domestic oppressed minorities, between race and economy as structures of discrimination. Above all the installation is filled with suitcases and with the images of the refugees and migrants who carry them. The suitcases are the cheapest plastic chequered cases, the kind that one could purchase in every supermarket anywhere in the world, and the images are captioned with the statement that 'MY HOMELAND IS NOT A SUITCASE'. In their insistent presence these images make us aware of the degree to which the very concept of 'migrant' is a form of naturalization, of normalization of an abnormal state in order to avoid giving thought to the conditions that have produced it or which benefit by it. In making overt and audible immigrants' own denial of their

migration as a naturalized originary condition, as a condition that can be read through a humane empathy that masks all the clearly reversible conditions that go into its making, we arrive at a recognition of the actual circumstances and reasons for people's forced migrations, a recognition which in turn transforms 'Third World' debt into 'First World' debt. In stating that one's homeland is not a suitcase there is some headway in confronting the museumification of the suitcase as memory and nostalgia, towards establishing that it is at the cost of horrific change and disjuncture that the West's eternal 'unchange,' its permanence and continuing economic superiority, can be maintained.

It is not only the bodies of laboring migrants and the natural resources of their countries which circulate but also commodities and their verbal and visual significations. To quote Ashley Bickerton following an account of some kids in canoes off the shore of Star Harbor in the Solomon Islands who answered his efforts to amuse them with breakdancing with far more sophisticated popping and breaking moves of their own:

> How the hell did they learn this here with no television and no radio and so soon after it was invented in inner cities on the other side of the world . . . Actually in my travels I have encountered this phenomenon again and again. *Terminator* stickers on river boats in Borneo. *Batman* T-shirts on penis-gourd-wearing but otherwise naked tribesmen in the highland valleys of Irian Jaya. In fact I have seen a certain bad New Jersey haircut everywhere that I have been. I cannot help thinking that a bad New Jersey haircut can travel faster and with more precision than all of our best intentions.[79]

While the circulation of commodities and popular cultural images is perhaps not as mysterious as Bickerton might wonder at, linked as it is to the global markets whose communication systems are far more connected to the infrastructures everywhere and far more omnipresent than television advertising might be, it does clearly reflect far more than the lightning speed of communications (Figures 2.13–2.16, Plate 4).

Commodities, their names and slogans, building on a variety of practices that range from travel and tourism, do in fact produce a new language of global connectedness that requires serious examination. In the 1980s Ashley Bickerton produced a series of works which resembled crates and packing cases and containers emblazoned with numerous logos. These cases had all of the formal attributes of commercial shipping cargoes, aluminum frames and black sealed surfaces to protect whatever contents they might hold. In addition they also had the look of much-traveled suitcases of the legendary travelers of the early twentieth century, emblazoned with stickers

which should have read Shepards Hotel Cairo and Ritz Carlton but instead had the logos of multinational corporations such as Alcoa and 3M (Figure 2.13). In addition to the logos there are also several flamboyant signatures by the artist, ensuring that the container be perceived as a signed work of art, one in which the formal attributes and the affiliation of the object to a named author together produce its status as a work of art. His intent was to connect the commodity and the logo with the circulations of art world objects, a form of institutional critique through the workings of another commercial world, that of global industrial shipping: 'So I wanted to look at the entire art scene from a holistic point of view, objects as utilitarian things that operated within that circuit, and were applied to all the different usages of that. I just wanted to make them manifest, to make obvious all those references; lifted, shipped, stored, hung'.[80]

In Bickerton's cases and containers the language of industrial cargo and of touristic adventure fuse and lend layers of metaphoric meaning to the global circulation of goods or art objects (Figure 2.14). Adventure, status and pedigree here merge with yet another phenomenon in which Bickerton is deeply imbricated: the commercial sponsorship of sports and increasingly of other cultural activities. Bickerton is much involved with surfing culture in the Hawaiian Islands and in the South Sea Islands, and he has written eloquently of the development of the surfboard from 'air brushed mandalas and pure white surfboards to boards massively smeared with corporate sponsorship decals'.[81] Thus their use value is doubly encoded both as sports goods and as billboards for the commercial interests they advertise.

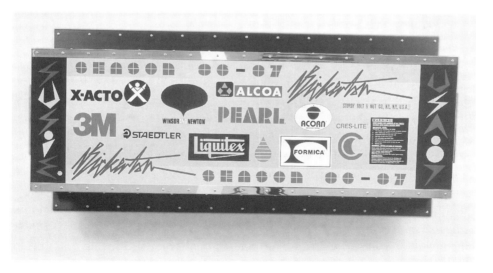

Figure 2.13 Ashley Bickerton, *Le Art* (*Composition with Logos*), 1987. Courtesy of the Sonnabend Gallery, New York

Figure 2.14 Ashley Bickerton, *Plan for Seascape: Transporter for the Waste of its Own Construction*, 1988. Courtesy of the Sonnabend Gallery, New York

This fusion of circulatory practices with the abbreviated significatory might of the logo is in fact a recognition of the degree to which an entire world of knowledges and experiences is reduced to the level of commodity exchange. In *Abstract Painting for People #4 (Bad)* (1987) and in *Drawing for a Good Painting* (1988) Bickerton produces a semiotic of logos as well as an intertextual field between seemingly unrelated brand names and historical signs. The 'bad' painting (Figure 2.15) combines swastika with death's heads, syringes, missiles, radioactivity warning signs, sharks, scorpions and sharp knives. The 'good' painting (Figure 2.16) combines the cross and the star of David with the logos of the United Nations, the Seal of the President of the United States and the logo of the International Committee of the Olympic Games, with dollar signs, smiley faces, non-smoking exhortations and the words *freedom*, *justice* and *paradise*. In the 'good' painting the shark has been replaced with a dolphin and instead of the stormtroopers' insignia we find the international code of tourism with signs for gas, food, lodgings and swimming.

Here vast histories and political systems have been codified to signify at the level of commercial logos and internationally circulating languages of tourism and commerce. In the process what gets revealed is the degree to which these suture on to one another, creating endless levels of inferred meaning and inferred approval, disapproval, fear or reassurance precisely through an acute distanciation between sign and signifier. The entire chain of semiotic activity gets halted at the activation of the signifier, and the

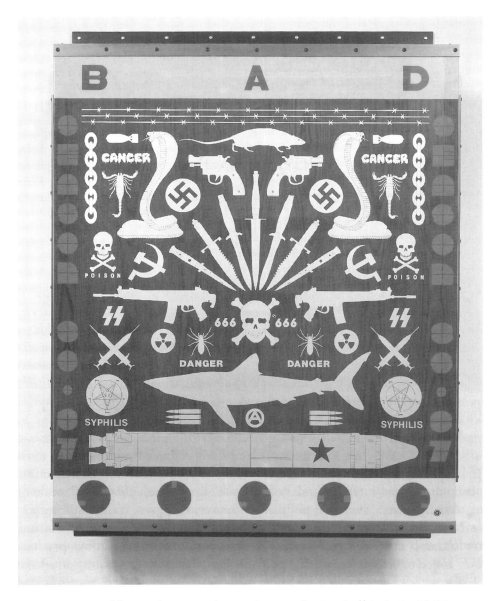

Figure 2.15 Ashley Bickerton, *Abstract Painting for People #4 (Bad)*, 1987. Courtesy of the Sonnabend Gallery, New York

journey into the arena of the signified never takes place since one sign lends the moralistic framework for all the other ones, and history as it were, becomes an unnecessary context for their meaning. Bickerton's work might seem to have a flattening effect, but, when one thinks of the communicative strategies of such groups as the National Front in Britain, the Right Radicals in Germany or the Aryan Nation in the USA with their reactivating

in its first decades. This is post-empire in transition, but what of Rushdie's empire within? The title *The Blues* is used here as a metaphor signifying the black voice – as a voice of resistance. The work uses the codes of movie posters as a popular form, to construct in each 'untold story' a critical moment in the confrontation between black and white. What the black man is confronting is the state of whiteness (Figures 2.21–2.22). No matter what position he is put in – under police interrogation, in prison, in a low-paid job, as a servant – the black man questions the white man's identity. Yet the black voice is still a black man's voice. The work uses the codes of movie posters as a popular form to construct in each 'untold story' a critical moment in the confrontation between black and white. What the black man is confronting is the state of whiteness. The color blue is also an integral part of the mise-en-scène of crime movies. So the work begins with the confrontation between men and ends up with the encounter between the black man and the black woman. Tabrizian says:

> A challenge to any racist ideology must begin with making 'visible' what is usually 'invisible'; in this case those racist traits woven into the unconscious of white society to expose the fiction of identity. What is at stake here is the crisis of identity (the ability of white culture to construct a black identity which serves its own purposes and its position of power which allows it to control the representations of that identity). And what is important is the process of subjectification rather than the identification of images as positive or negative. This is certainly not the only kind of intervention. But it is one strategy that attempts to question any absolute definition of the white and of the black, the meanings of which are polarized around fixed relations of domination and of subordination, displaced from the language of history on to the language of 'nature'.
>
> At the end of this project we find the double bind of 'Other's Others'. If male desire and male fantasy get transposed *onto woman* rather than being provoked *by woman*, that woman as the other acts as the guarantee for male identity.
>
> So the work begins with the confrontation between men and ends up with the encounter between the black man and the black woman.[89]

What happens then when one figure, the figure of the black woman, occupies both of these positions simultaneously, the other of the white and the other of the masculine? Here then we can discern Homi Bhabha's 'identity in the process of formation', internally fragmented in relation to the two most dom-

inant of Western patriarchy's discourses. Thus the luggage which is here signified bespeaks the immense shifts of an identity in the process of formation, of transition and of self-claiming. Multiple and fragmented otherness becomes a manifestation of Deleuze's aforementioned molecular flow: 'A threshold is crossed that doesn't necessarily coincide with a segment of more visible lines'. The female protagonist of Tabrizian's 'The Interior' (see Plate 6) isn't so much moving out as moving on in an altered relation to the social political gravity that ties her down, following Deleuze's 'line of gravity or celerity, the line of flight with the steepest gradient . . . This line seems to surge up afterwards, detaching itself from the other two [the segmented and the molecular discussed in Chapter 4] . . . if indeed it ever does.'[90] A moment of 1980s cautionary discourse of racism and spectatorship and invisibility and discrimination becomes the passage beyond a threshold, a shift in the Deleuzean sense from a line of migration to a nomadic line of flight, a flow of deterritorialization. 'The line of flight, allotted a negative sign, is blocked in despotic regimes,' says Deleuze, accorded a political specificity of gender, it breaks through the morass of racist discrimination towards an unknown narrative, 'but that's just it, the line can break through, *anywhere*'.[91] This anywhere is the mark of unhomed geographies, of a location through unfixity and process.

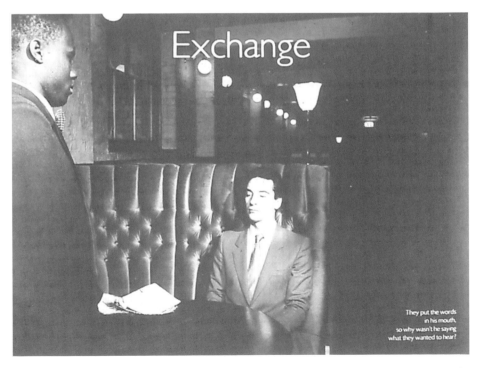

Figure 2.21 Mitra Tabrizian, 'Exchange' from *The Blues*, 1988. Courtesy of the artist

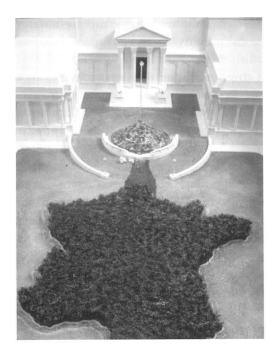

Figure 3.1 Hans Haacke, *Calligraphie*, 1989. © VG – Bildkunst

assumptions they are nevertheless respectively synchronic and diachronic and thus, as intersecting principles, serve to question each other's assumptions.

While Simon Patterson's work undoes at the level of paradigms, categories and naming activities and their mutual interdependence, other work sets out to disavow historical claims of ownership through shifts in the symbolic status of language. Hans Haacke's *Calligraphie* (Plate 8, Figure 3.1) was made in response to an invitation to participate in a competition for a permanent installation in the Cour d'Honneur of the Palais Bourbon in Paris, commemorating the founding of the Assemblée Nationale in 1789.[100]

The project was intended to cover the entire area of the courtyard, 39 feet in diameter. At its center would be a large map of France made up of seasonal crops grown in cycles (the overseas territories still belonging to France would have been in small off-site maps in the nearby Hôtel de Lassay). At the top of the courtyard, nestled by colonnades, would be a cone-shaped mound reminiscent of the revolutionary architecture of Boullée and the spirit of the Enlightenment leading up to the *Declaration of the Rights of Man*. The cone would be made up of rocks which equalled in number the members of the National Assembly. It was intended that each elected deputy should provide a rock from the region they represented. On the cone in raised gold letters would be the Arabic translation of 'Liberty, Equality, Fraternity'. A great jet of water would shoot from the cone up in the air to be drained away and used in the watering of the crops grown within the delineated map of France.

Needless to say, this project was not chosen for the site. The translation of the ultimate democratic and revolutionary slogan which has circulated around the globe for over two hundred years, into one of the languages in which it was received and which sustained the domestic economy which made much of this activity possible, was not deemed acceptable. While most

of North Africa, and much of the Levant and of the Middle East spoke French, France did not and does not speak Arabic – despite the current number of North African and French African residents of France, some of whom are at this very moment being deported back to Africa. The map of crops functions almost like the maternal body (France being spoken of in the feminine), ever changing and ever fecund, and it must have been the writing of that body in Arabic, in blazing gold calligraphy, which virtually transcribes the organic bodies of stones and fields with a 'foreign' cultural overlay, that caused the offense that the piece evidently did cause. Haacke's proposal functions at the level not of translation but rather of transformation. Clearly no translation can be made to signify the same thing as an original text – the play of the signifiers, stylistically, etymologically and historically, operates as a crucial aspect of the signification of the text. As Derrida states:

> Within the limits to which it is possible, or at least *appears* possible, translation practices the difference between signified and signifier. But if this difference is never pure, translation is no more so and for the notion of translation we would have to substitute a notion of *transformation*: a regulated transformation of one language by another, of one text by another. We will never have, and in fact have never had any 'transfer' of pure signified – from one language to another, or within one language – which would be left virgin and intact by the signifying instrument or 'vehicle'.[101]

Thus the transfer is a form of 'claiming' of the original for other purposes, very different from its imposition by any given powers over a culture to which it is positioned as dominant. Thus, if a French administration in a colonized French-speaking culture had provided a local translation of 'Liberté, Egalité, Fraternité', it would have functioned very differently from its re-importation into the heart of the culture via what Deleuze would have called a position of 'minority'. The surprise delivered by Haacke's proposed project, then, is that this clichéd expression of universal equality is neither transferrable nor claimable and therefore negates its own universal mythology.

Mapping/subjectivity

Interventions at the level of sign systems and rhetorical codes are one register at which counter-cartographies take place. Another is a mode of experimentation with mapping subjectivities and bodies of knowledge that are not

traditionally linked to cartographic forms. Abraham Verghese, the immigrant doctor whose cross-cultural narrative I quoted in Chapter 1, began attempting to map his puzzling findings regarding the numbers of AIDS patients he was treating in rural Tennessee in the early 1980s. In actual fact what he was doing was spatializing his findings so as to reveal the narrative structure and the social relations that underlay the statistics. As Michel de Certeau has argued:

> In this respect, narrative structures have the status of spatial syntaxes. By means of a whole panoply of codes, ordered ways of proceeding and constraints, they regulate changes in space (or moves from one place to another) made by stories in the form of places put in linear or interlaced series.[102]

Here is Verghese's account of his findings described as two mappings. Lest my choice of text fragments mislead the reader into believing that there is some crass pragmatism at work here, I would want to reassure you that there are few such deeply empathetic and insightful accounts of the devastation of AIDS as Verghese's to be found anywhere. In addition it is important to note that this particular doctor subsequently devoted several years to ensuring that these rural patients' voices and those of their remarkable families and communities were heard around the world.

> There was a pattern in my HIV practice, a paradigm I could see but wanted to flesh out. I had carried copies of patient files and records from the clinic to my house. I kept feeling if I could concentrate hard enough, step back and look carefully, I could draw a kind of blueprint that explained what was happening here in Johnson City, Tennessee, and perhaps in the process explain what was also happening in every little community like ours across the country . . .
>
> Here we were in late 1989, and the picture of AIDS in our town had changed radically from the day when I walked into the Connection. In 1985 we were in our age of innocence. I was an AIDS expert with no AIDS in sight, a rookie looking for a challenge. Now, we had over eighty HIV-infected persons in our practice, we were AIDS seasoned and all sense of innocence had vanished . . .
>
> I began to think about the patients we were following. Our town's high risk folks – gay men – were not infected: several surveys . . . had shown us that. Then where did our eighty-odd patients come from?

Spread out on my living room floor, I compiled a list of every person with HIV that we had seen in the office, the VA, the Miracle Center or the hospitals in our neighboring communities. I made a line-listing with three columns: patient name, address and a blank column in which I pencilled in what I knew about each patient's story, how and where he or she had acquired their illness. I consulted my personal journal, in which for four years now, usually late at night, I had written down the stories behind the medical facts I knew.

I went to Steven's room and took down the map from his wall. Steven loved maps and had a precocious knowledge of the world's geography. He knew India, Ethiopia, Boston, Tennessee, all the places that were significant in his life or that of his parents.

I traced out in pencil a map of the quad-state area – Tennessee, Viginia, North Carolina and Kentucky. I labelled this quad-state map; 'Domicile'. I pencilled in tiny red cannon balls for the current residences of my patients . . . Next, I traced out the outline of the entire United States, leaving out all the detail within. I titled this map 'Acquisition'. I was after something different on this map: I wanted to locate the places where each patient used to live between 1979 and 1985 . . . As I neared the end, I could see a distinct pattern of dots emerging on this larger map of the USA. All evening I had been on the threshold of seeing. Now I fully understood . . . The dots on the larger map, the 'acquisition' map, were no longer confined to the rectangle of Tennessee and its neighboring states as they had been on the 'Domicile' map. Instead they seemed to circle the periphery of the United States, they seemed to wink at me like lights ringing a roadside sign. The numbers were small, but the two maps unequivocally confirmed what individual stories of Otis, Gordon, and so many others had suggested: infection with HIV in rural Tennessee was largely an imported disease. Imported from the city to the country. Imported by native sons who had left long ago and were now returning because of HIV infection.

But if AIDS was a disease imported to East Tennessee, I needed to explain the dots clumped around Johnson City on both maps – the 'local-locals' as we came to refer to them . . . The first name I wrote down – Rodney Tester – provided the clue to the 'local-locals': he was a hemophiliac. Rodney Tester was the recipient of tainted factor VIII that, courtesy of an efficient manufacturing and distributing system, had been delivered to his doorstep in rural Appalachia as soon as it was available anywhere else in the country. But there were still more 'local-locals' –

persons whose dots occupied the same position on both maps; there were blood transfusion recipients, there were partners of infected patients, there were gay men . . . who had not resided outside the area but made frequent trips to the big city (or to highway rest-stops where they had met people from the big cities and engaged in unprotected and high risk sexual encounters). Finally there were a few men who did not fit into any of the categories. They may have contracted . . . their HIV infection in Johnson City. Or else they were not entirely forthcoming about their travel and risk factors . . . It was after midnight but I was still on the porch. I was too wired to contemplate sleeping. Here in our corner of rural America, my patients, trickling in over the past years in ones and twos, had revealed a pattern to me. Their collective story spoke of an elaborate migration . . . the first step in this circuitous migration was a disappearance from home, a departure from the country – the first two steps of the paradigm – leaving home and then the period of urban living – were followed by the long voyage back . . . the circuitous voyage, the migration and return – ended in death.

The paper was a beginning, a rough start on a larger story, the story of how a generation of young men, raised to self-hatred, had risen above the definitions that their society and upbringings had used to define them. It was the story of hard and sometimes lonely jouneys they took far from home into a world more complicated than they imagined and far more dangerous than anyone could have known. There was something courageous about this voyage, the breakaway, the attempt to create places where they could live with pride.

No matter how long I practice medicine, no matter what happens with this retrovirus, I will not be able to forget these young men, the little towns they came from, and the cruel, cruel irony of what awaited them in the big city.[103]

Verghese's account of mapping and spatializing an epidemic through sexuality's intersection with rural culture ends up revealing hidden aspects of that life that have little to do with concealed sexual preferences. The conversations with the patients' families – of tolerances and acceptances and incomprehensions and love spoken through 'Jesus' or some other codes we might otherwise have read as deeply conservative or intolerant – bring to mind Michel de Certeau's observation that 'Places are fragmentary and inward turning histories, pasts that others are not allowed to read, accumulated times that can be unfolded but like stories held in reserve, remaining

in an enigmatic state, symbolizations encysted in the pain or the pleasure of the body'.[104] Verghese's maps have layered a dissonant sexual disruption upon a surface of a seemingly certain, God-fearing faith, and serve to excavate unexpected aspects of both that in turn diminish their readings as conflictual. Two utopias, one of sexual freedom and another of so-called 'simple faith of rural folk', become an example of Foucault's counter-sites, a heterotopia in which 'all the real sites which can be found within the culture are simultaneously represented, contested and inverted'.[105] Certainly the ongoing fascination with Verghese's book is its active construction of a subject for itself which will not allow it to settle into the category of medicine, or rural geography or migration culture or alternative sexualities, but uses each to interrogate and actually *hear* the other through their contiguous spatialization.

Can maps be read as de Certeau's 'symbolizations encysted in the pain or the pleasure of the body'? Their cool codes cannot simply be refuted through the narration of the devastating facts that they mask; some aspect of the work of translation from human tragedy to codes of signification needs to be played out in order for the map to become an enacted heterotopia. A possible example of this translation is a 1993 map by Israeli artist Joshua Glotman.[106] The map (Plate 9, Figure 3.2) shows much of the territory of the state of Israel under various partition agreements and territorial occupations. It is under camouflage, a common sight and one immediately recognizable to any citizen of the war-weary Middle East with its constant presence of uniforms, weaponry, military debris and of course camouflage nets which hide such equipment from patrolling espionage planes and satellite surveillance. Therefore in the first instance the map, the tool of location and emplacement, of clarity and illumination, is transformed into a hidden, veiled, somewhat indecipherable and evidently secret, or secreted, object. Its primary act of self-negation, however, takes place in the linguistic shift that is effected. All of the linguistic indicators on the map are written in Arabic – a language which most of the European-origin citizens of Israel do not speak and which of course represents a set of cultures and nations with which the state of Israel is locked in mortal combat. To make matters even more complicated, it is only the territory of Israel in which the settlements are indicated linguistically, while everywhere beyond the borders of the state a glaring absence of language is in evidence. A secret, hidden, camouflaged usurpation of land and language – so many of the ancient cities of the Holy Land exist under numerous names; Christian, Muslim, Jewish, relics of this or that empire, this or that conquest: their naming is a function of the use the speaking subject wishes to claim for them. But it is in relation to land ownership that this map functions critically and eerily. Its emphasis of the northern part of the state of Israel focuses on the heavily industrialized and heavily populated and predominantly agricultural

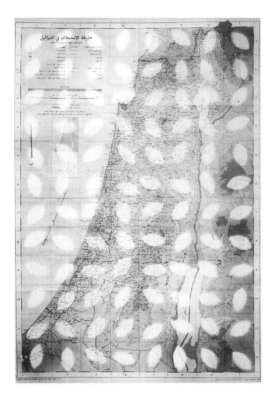

Figure 3.2 Joshua Glotman, *Untitled*,
1993. Courtesy of the artist

areas of the country. It was in these areas that the greatest usurpation of land from original Palestinian inhabitants had taken place and in which consequently the technologies of modern industry and modern agriculture rule with pride. The southern part of the country, arid and desert-like and inhabited originally primarily by Bedouin tribes,[107] has been less disputed; its uses have been more strategic and less symbolic than the fertile north with its layers of symbolic biblical allusions. It is language which occupies the land through processes of naming that appropriate and override existing histories, says Glotman's map: change the language and one changes the very ownership of both the terrain and the history. Glotman's map work is done with found objects, the debris of military conflict littering the floor of abandoned camps and command rooms which do not carry the highest level of security clearance.

The deadpan innocuousness of these found documents and objects masks their potential power and menace. Susan Slymovics, in a very remarkable book entitled *The Object of Memory – Arabs and Jews Narrate the Palestinian Village*, whose subject is memory books founded in oral knowledge, focuses on a single village, Ein Houd, Ein Hod, evacuated of its Palestinian population in 1948, resettled as an Israeli artists' colony, with the evacuated Palestinian population or what remained of it settled slightly further uphill in a newly built echo of their old village – a double inhabitation of a single named entity, a territorial and linguistic usurpation. The discussion of this contested history of one named space speaks of 'mapping loss' – the memory maps and books of Palestinian villages destroyed by the state of Israel after 1948 work towards a 'locability which has disappeared as a reference point, to say nothing of the ways in which the issue of ownership has been elided'. These memory maps and sketches, says Slymovics, 'evoke social worlds of the past. They are also refracted images that are value laden, being neither

inert records of the landscape nor passive reflections of the world of objects. We read these maps far from the traditional cartographic binary opposition between true and false, accurate and inaccurate, literal and symbolic'.[108]

Glotman's camouflaged, linguistically reverted map is neither a memory map nor an act of direct political protest against occupation and appropriation. It works at the level of cartographic 'translation' in Derrida's previously discussed understanding. The violent rupture inherent in each process of conversion from one language to another is never neutral and instrumental and always an act of transformation — what better way to point to the violent transformations of the past than by reliving them in the present and reversing the protagonists and the dominant languages? Thus what begins to emerge here, through this particular reading, is a cartographic engagement with dislocation in which the process of translation is understood to be inherently inscribed with loss. Not only does translation imply transformation but that transformation harbors a deep loss, a loss of all the originary resonances and perceptions of place which can never be reproduced. It is translation which has abandoned 'polysemia' with its possibility of multiple meaning and reaches out towards an unanchored play of textual disseminations.

At the level of other representational codes Glotman is working against the grain of a certain earlier photographic tradition in service of the nascent Israeli state and of Zionist ideology.[109] This earlier photographic tradition emphasized the heroism of the everyday life of work and country-building using the tropes of socialist realism (this is discussed at length in Chapter 5). Within the local culture the map of the Israeli state, long and narrow and seemingly detached from any hinterland, a veritable sliver carved out of something else, is a permanent visual presence in everyday life — Glotman's tampering is so unexpected that it captures the viewer's attention at the level of the familiar and then proceeds to make that strange. This is not a map of the place nor of its occupation but of the haunting that is the ongoing reality of co-inhabited spaces in which one presence is always at the expense of the other, of what Mahmud Darwish calls Palestine and Palestinian identity as a process of 'setting out on the trail of a fragrance (of a country they have never known)'.[110]

Liberated enclaves – the mapping of divisions and fragmentations

Recently in the eastern Mediterranean, the 'trail of that fragrance' has been confronted with the extreme oddity of territorial disengagements which form part of the Oslo peace agreement and have produced the first officially sanctioned cartographic articulations of that process.

In September 1993, at a ceremony on the lawn of the White House, an accord was signed between Palestine and Israel which was meant to begin implementing the terms of the Oslo Peace Treaty. It was in many people's view an accord between unequal partners in which the Palestinians had to accept the terms dictated by the Israeli state with little possibility of determining what would be realistic and conducive conditions for the formation of a burgeoning Palestinian state. Every aspect of this accord and its implementation simultaneously manifests efforts at territorial withdrawal as well as less acknowledged efforts at division and fragmentation of the indigenous population. Edward Said has been one of the most consistent and analytical of its critics, and he described the first level of division:

> For the first time in our recent past. we accepted the division of our people – whose unity we had fought for as a national movement since 1948 – into residents of the Occupied Territories and all the others, who happen today to constitute over 55 percent of the Palestinian population; they exist in another, lesser category, not covered by the peace process.[111]

A glaring recognition of the other levels of division came when the maps of the actual territorial disengagement were unveiled to the public. City neighborhoods and clusters of houses appeared everywhere separated by a *cordon sanitaire* of Israeli presence – expansive stretches of land to be liberated from Israeli occupation were few and far between and the whole map looked as if it had been eaten up by woodworm, leaving tiny ridges in what had once been a coherent land mass. Everywhere amidst the liberated enclaves remained the Israeli settlements in which vehement territorial claims are often supported by equally vehement religious justifications, a seething hostile presence on the West Bank, often accompanied by outbreaks of murderous aggression. A local friend said with bitter irony which echoed all the disappointed hopes of those months, that the entire international mobilization for peace in the Middle East had resulted in 'the liberated neighborhood of Southern Jericho'.

In 1996 Mona Hatoum, a Palestinian born in Beirut and working in London, went to East Jerusalem to make and exhibit a piece of work while returning and visiting Palestine for the first time (Figures 3.3–3.4, Plate 10).

> Going to Jerusalem was a very significant journey for me, because I had never been there. My parents are Palestinian. They come from Haifa, but have never been able to go back since they left in 1948. Jack Pereskian, who had this little gallery in East Jerusalem, and I had been discussing the possibility of doing the

exhibition there for two years. I kept postponing it because emotionally it's a very heavy thing, and I wanted to be able to spend a whole month out there, producing the work.

I ended up making about 10 works. I made three installations and a number of photographic works and small objects. The ideas I had proposed beforehand seemed to be about turning the gallery into a hostile environ-ment, but the environ-ment outside is so hostile

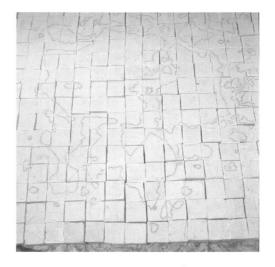

Figure 3.3 Mona Hatoum, from *Present Tense*. Courtesy of the Gallery Anadiel, Jerusalem

that people hardly needed reminding . . . On my first day in Jerusalem I came across a map divided into lots of little areas circled in red, like little islands with no continuity or connection between them. It was the map showing the territorial divisions arrived at under the Oslo agreement, and it represented the first phase of returning land to the Palestinian authorities. But really it was a map about dividing and controlling the area. At the first sign of trouble Israel practices the policy of closure, they close all the passages between the areas so the Arabs are completely isolated and paralyzed. Originally I was going to draw an outline of the map by pushing nails into the soap, but it looked quite aggressive and sad. I ended up using little glass beads which pressed into the soap. The piece is called 'Present Tense': it's about the situation as it was then (Figure 3.3). Now with the change in government some of these areas are not being returned to the Arabs. The Palestinians who came to the gallery recognized the smell and the material immediately. I saw that particular soap as a symbol of resistance. It is one of those traditional Palestinian productions that have carried on despite drastic changes in the area. If you go to one of the factories in Nablus, the city north of Jerusalem which specializes in its production, you feel you have stepped into the last century. Every part of the process is still done by hand, from mixing the solution in a large stone vat, to

pouring it on the floor, to cutting and packing it. I also used it because of its transient nature. In fact one visitor asked 'Did you draw the map on soap because when it dissolved we won't have any of these stupid borders?'[112]

Those maps produced for the military disengagement of Israel from Palestine on the West Bank, in all of their fragmentation and erosion of the concreteness of the land, made manifest the profound ambivalence at the heart of the peace process – which had been launched more as a form of resignation than as a genuine desire for a massive reordering of rights and identities. Hatoum accompanied her 'map translations' with a series of photographs of the textures of daily life, of produce and cooking and shopping traditions that shore up some bit of the eroded sense of relations between identities and land (Figure 3.4). The various forms of offal and other local delicacies, the olive oil soap made in Nablus, famous throughout the Levant, whose fragrance suffuses both households and memories: those are the heart of Darwish's sense of Palestine as the 'trail of a fragrance'. In this work they have ceased to be a nostalgic dead end of unfulfillable hankerings and have become a textured relationality to a place of belonging. The maps that Hatoum reproduced with soap blocks and jeweled red beads represent the

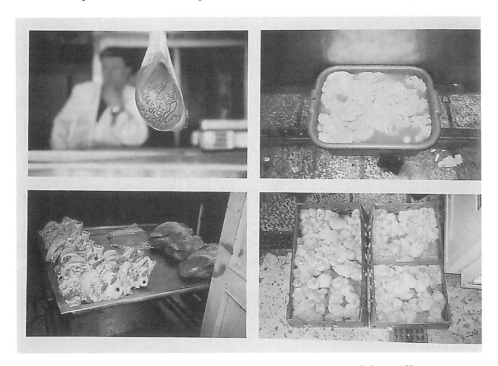

Figure 3.4 Mona Hatoum, from *Present Tense*. Courtesy of the Gallery Anadiel, Jerusalem

official discourse of the state while the daily foods and objects maintain an ongoing insistence about a relation to place rooted in de Certeau's 'encysted body' that cannot be denied no matter what sophisticated mechanisms and epistemological traditions and military occupations are imposed on it.

In tandem with these photographs taken by Hatoum an entire inter-textual field opened in my mind which included a recent piece by Moshe Ninio, an Israeli artist of Arab Jewish heritage, whose work takes various textile and food textures and extracts them from orientalizing, nostalgic indulgences through a severe aesthetic isolation, as if they had been put under a microscope. Amongst the works are a hologram of folded oriental carpets, and a video piece of a pot of gleaming golden amber honey turning round and round in the light, its glow absorbing climatic conditions and the flora and scents of the region. These are as much a reality of life in the eastern Mediterranean as are the widely publicized wars and military and civil altercations, and their presence often crosses borders divided under the allegiances of conflict. In one video piece we see a tubful of water with blueing agent in which a T-shirt is being dyed; an anonymous pair of hands obsessively ties and unties and scrubs the shirt as if willing it to take on the dye beyond the fibres' ability to absorb it chemically.[113] Here is a shirt being forced to become local, and it brought to mind a vast spectrum of associ-ations with laundry blue: the smells of laundry day on the roof of my grandparents' collective house in Tel Aviv in the late 1950s, and Yona the Yemeni woman who was in charge of orchestrating this bimonthly festival of fragrant cleanliness with its huge boiling tubs and blue-tinted white sheets billowing in the sun.

It also sutured on to itself a fragment from Hanan Ashrawi's memoirs in which she described her sister's account of the family's first encounter with Israeli soldiers after the 1967 war that began the story of occupation of the West Bank of Jordan:

> They had their first glimpse of the occupation when Israeli soldiers banged on the door demanding 'whitesheez'. Abla having diffi-culty understanding their accent and wondering at the strange priorities of this enemy, ran to the kitchen to get them a plate of white cheese. Every Palestinian household stocks this home-preserved goat's milk cheese, boiled and kept in salt. Maybe it was a peace offering, Abla figured – a variation on breaking bread. Instead of the expected conciliatory response the soldiers grew more and more frustrated, repeatedly shouting, 'whitesheez' and pointing to the roof. Then they added 'blue' to their demands, and Alba finally understood that they wanted white sheets and blue color to prepare a makeshift Israeli flag to hoist on top of

the building across the street from our house which was a prison and the Jordanian Officers Club. Abla found one of her daughter's large cloth diapers and dug up some laundry blueing. The soldiers drew two blue lines and a Star of David in the middle, hoisted their artwork on a broomstick and announced their occupancy of the place across the street.[114]

Everywhere in these texts and images we find maps that separate and fragment and embody conflict while the foods and soaps and laundry blueing cross the lines of imaginary belongings. Mona Hatoum recounts:

When the exhibition opened and Israeli people came from Tel Aviv, they started reading a reference in the soap to concentration camps. This couldn't be further from my thoughts. These two readings of the work give you an idea of the very different backgrounds and histories of the two cultures trying to co-exist.

For another piece I brought into the gallery a metal bed which I'd found in the street. I attached castors to the legs and then proceeded to immobilize it by tying it down to the floor with fishing wire. The wires were invisible, you almost tripped over them before you saw them. I called it Lili(stay)put . . . one visitor said that it felt just like their situation, that everything is trying to push them out but invisible threads tie them down. I was impressed that he'd made the connection between an inanimate object and his situation.[115]

The extreme ungroundedness produced by Hatoum's remade maps is slightly stabilized through the effect of the smells and tastes of everyday life which continue unabated, cross back and forth between populations otherwise in conflict and circulate in diasporic culture.

Hatoum's exhibition, which was strategically located in Arab Jerusalem, opened during a period of intense 'Chamas'-led resistance which resulted in the West Bank and Gaza being closed off from Israel and its populations unable to move beyond those borders.[116]

'Anyway, the saddest thing in Jerusalem was the policy of 'closure' that restricted movement for the Arabs. I gave a piece the title 'No Way' as a response to that. It was a large spoon I'd found full of holes, and I decided to block all of them with nuts and bolts. At the same time it became an uncanny and threatening object, like a weapon.

It is interesting that both projects, Glotman's and Hatoum's, focus on Arabic as a language and on the fear and anxiety which it has been set up to provoke. As the final remaining demonized culture for the West, the Arabic language becomes the site around which issues of both nationalism and ethnic purity militate. But it is the conjunction of language and cartography in these two projects – for all their highly divergent contexts and histories – and the ways in which they reinforce each other's sense of threatened proprietary hold on the land written in the language, that illustrate Dennis Wood's previously mentioned point of maps making present the labor and the fears and anxieties of the past.

Diversions – pirates, bandits, explorers

So much for reading traditional cartographic texts, but our interests of course lie in their disruption and in the potentially new forms which might emerge in the wake of other fragmentations of collective histories. Before proceeding to some of this remaking within visual culture, I want to think about certain possibilities from within the readings of existing texts. We have seen the conjunctions of language and cartography and the way in which they link epistemic truth claims with territorial land claims, and we have seen the effect of extra-register images such as Hatoum's photographs in supplementing what the maps have left out, but there is also the matter of apparitions. Anyone who reads post-structuralist theory or postmodern literature must have noticed that here and there, twinkling like apparitions from an earlier pre-Enlightenment world, bandits, pirates, caravans and songlines make surprising appearances which serve to shock us into recognition of the logical orders from within which we perceive the world, and which make it impossible to think of it any other way.[118] It is a somewhat romantic practice but it serves a useful purpose much in the same way that Derrida's question regarding telepathy was so useful for locating that which is outside of theoretical frameworks – or, as Derrida says when speaking of telepathy, 'everything in our conception of knowledge is so constructed that telepathy is impossible, unthinkable, unknowable'.[119]

In Foucault's classic text 'Of Other Spaces', which first introduced the dichotomies of spatialized utopian and heterotopian spaces, pirates do indeed make an appearance – inhabiting a floating unanchored space, simultaneously nowhere and everywhere, policing the routes of capital circulation but nevertheless themselves the ultimate in unregulatedness. They serve as the quintessential form of geographical unframing, the boundary line which signals that there is an outside that is a form not of surveillance but of interference. And they have the last word when Foucault says, 'In civilizations

without boats, dreams dry up, espionage takes the place of adventure, and the police take the place of pirates.'[120]

In Dennis Wood's book, hidden within an endless taxonomy of atlases of everything from *The New State of War and Peace Atlas* to *The World Atlas of Wine*, in a category of general reference maps and a sub-category of physical-political reference maps there is something called 'cultural features'. These include political boundaries, cities, airports, dams, pipelines, ruins and, the author exclaims with surprise, *caravan routes*. The surprise the reader or author feels shifts the narrative from cartographic taxonomies to a children's story called 'Big Tiger and Christian'. Big Tiger had never held a map before, and his friend Christian explains about North and South, about color coding and about blank spots which indicate deserts but need to be seen since they don't convey the quality, don't show us what exists, they point toward a world we might know. 'That's a fine map' said Big Tiger. 'It's useful to be able to look beforehand at the places we reach later.' 'Are there really bandits about here?' asked Christian. 'Perhaps it's written on the map', Big Tiger ventured, 'Look and See'. Wood concludes his paragraph with: 'And if caravan routes . . . *why not bandits?*'[121]

What is so interesting to me here is that the slightest breach of the agreed-upon system of represented knowledge allows for everyone's flights of fancy to enter the argument, and that is as it should be but so rarely is.

Another disruption of the logical order takes place through a certain kind of narrative construction that can emerge from the recounting of historical pursuits of cartography. Ann Godlewska has written the history of the Napoleonic Survey of Egypt, subtitled 'A Masterpiece of Cartographic Compilation and Early Nineteenth-century Fieldwork'.[122] It is one of those inspired pieces of historical writing which is at once informative and imaginative and yet its substantial historical rigor is inflected by a certain slight disbelief at the story that is unfolding. There are two narratives at play. The first is a narrative of national glory in which heroic Napoleonic conquests in the eastern Mediterranean and sub-Saharan regions are made concrete through a mapping which serves to fix these unknown entities in and through European knowledge. Simultaneously it attempts to re-write a territorial acquisition into a colonialism of adventure and knowledge.

The mapping project took place over an extended period of three years between 1799 and 1801 in different locations, and required exceptional organization and technological resourcefulness within a hostile environment and a terrain completely unknown to the Frenchmen who were coming to chart it. The project resulted in a twenty-two-volume *Description de l'Egypte* and a fifty-sheet *Carte Topographique de l'Egypte* which apparently opened Egypt up to various European endeavors, which inevitably resulted in British colonialism. Much of the information of material conditions and of the

massive problems that accompanied this unprecedented cartographic survey comes from a memoir written by its chief compiler, Pierre Jacotin. The narrative is populated with numerous figures of statesmen and generals, modern engineers and backward-looking religious fanatics, Ottomans and Mamelukes, French and Egyptians, in the extraordinary meeting grounds that only the Levant in the nineteenth century could offer.

However, once Jacotin the protagonist enters Godlewska's historical/cultural account, the enormous world picture gives way to his odd narrative of the pursuit of knowledge against the odds. Here are a few sentences from Godlewska's retelling of Jacotin's narrative of exploration, adventure and despair.

> According to Jacotin, all Mapping for the survey ceased by March 1801 due to the declining power of the army and the increased incidence of spontaneous armed insurrection . . . It was in this period that Jacotin, in desperation abandoned his office and supervisory functions and attempted to map the large region of Northern Egypt between the Damietta branch of the Nile and the Isthmus of Suez and between Belbeis and the Southern reaches of Lake Menzaleh . . . Futile attempts were made to map the Nile during its annual flood, but most engineers, topographic and otherwise, had come to regard both planetable and reconnaissance mapping as too dangerous given the conditions.

The mapping expedition was dependent on various surveying tools such as chronometers. Here is the account of the fate of one such implement:

> It traveled badly from Paris to Toulon but seems to have settled down thereafter. Its time keeping was disturbed on numerous occasions, once by the fall of a donkey carrying it in Rosetta. On another occasion it was left in a tent for a day in which the temperature rose to approximately 112 degrees Fahrenheit. Finally, it was nearly lost altogether when a camel carrying it on expedition west of Sann drowned in a swamp.[123]

One might say that to draw out the anecdotal passages from a comprehensive and rigorous historical and geographical study that does much to re-animate that complex meeting of worlds that was Egypt at the beginning of the nineteenth century is to trivialize so great an effort. Alternatively one might say that to personalize this narrative by extracting Jacotin from a broad range of characters is to reproduce some of the myths of European colonialism in which some eccentric enthusiast driven by a passion for

modern knowledge battles the elements and the local culture and proves that he is up to its challenges in the name of progress. But between the floods, the melting chronometers, the stumbling donkeys and the drowning camels – all of which are by rights as much a geography as the survey they were hindering – I once again grasped that anxiety of being lost which Dennis Wood mentioned at the beginning of *The Power of Maps*. Lost in a foreign and alien country and lost in the survey he has been charged to make of it. Mostly lost in the task of impossible translation that is the project of transforming a non-European terrain into a body of European knowledge.

Since my interest in this project is not in the history of geography but in its modes of representation and in what they sustain, these moments of panic and despair and romantic grandiosity serve well to illustrate the degree to which geography in its cartographic forms serves as an anchoring structure which sustains subjects (abroad) through legible and familiar articulations of belonging. Colonial panic and colonial possessiveness and paranoia have been extensively theorized by Homi Bhabha, Robert Young, Lata Mani, Johannes Fabian, Michael Taussig, Robert Stam and Ella Shohat among many others. Their exploits and escapades in the pursuit of mapping are one of the narratives which underpin the irrational value which is projected on these supposedly logical and reality-reflecting texts which make up part of the armature of cognition.

Mapping out strategies of dislocation[124]

'Geography [is] the eye and the light of history . . . maps enable us to contemplate at home and right before our eyes things that are furthest away' (Johan Blaue, *Le Grande Atlas*, Amsterdam 1663).[125] Joshua Neustein's recent paintings of maps plunge us directly into the midst of a major contemporary debate concerning the relation between object and subject in image making and their foundations in epistemic structures. These paintings of maps, which abdicate their right neither to the status of art nor to their obvious association with cartography, serve as a visual discourse on a major post-structuralist polemic, namely the location of theories of cognition within the framework of ideological positions. In their very insistence on their right to live out such a duality and in their formal properties which combine a scale alien to map-making with an austerity alien to picture-making, Neustein's maps continually demand a confrontation between the conventions of both traditions and most importantly between their implications as modes of perceiving the world (Figures 3.5–3.10, Plate 11).

The two modes which are here juxtaposed are the tradition of scientific linear perspective and that of mapping as an artistic form. Linear perspec-

Figure 3.5 Joshua Neustein, *How History Became Geography*. Courtesy of the
artist

tive as thematized by Alberti was not just the process of binding the picture
to vision and visual perception but also the definition of what he chose to
term a picture; it was not just a surface but a plane serving as a window
that assumed a human observer whose eye level and distance from that plane
were the essential factors in determining its rendition. The making of the
picture was therefore defined by the positioned viewer, the frame and the
definition of the picture as a window through which an external viewer
looks. The emergent humanist approach of the Italian Renaissance, an
approach which increasingly foregrounded the new role of the spectator in
relation to the picture, was carried into the pictorial world itself when
Alberti insisted that all appearances of things are purely relative. Furthermore
it is the human figure alone which is capable of providing the measure of
whatever else the artist cares to represent.[126] The consequences of affording
'man' – the positioned viewer – the central determining role were to begin
with, as Erwin Panofsky noted, the dissolution of any pictorial equality and
the establishment of a qualitative process in which each planar direction and
each object were measured in terms of their own intrinsic worth.[127]

 This process, however, had far greater implications than the provision
of a fully articulated technique for the organization of pictorial space. As
Panofsky saw, the history of so-called 'scientific' linear perspective could

equally be seen as the triumph of a sense of reality which is founded on a notion of objectivity and on the creation of a distance between subject and object. Similarly it could be described as a triumph of overcoming the irrational will which denies the distance between subject and object. Most importantly, however, the increasing refinement of linear perspective allowed for a fixing and a systematization of external reality and for a furthering of the individual ego which controlled this process.[128] The legacy, therefore, is the construction of a world view which is founded in notions of objectivity and rationality and the recognition of a central beholder who possesses these qualities and reconstructs the world according to their rationale. Within such a reconstruction there is little room for a plurality of narratives or viewpoints or the recognition of realities, constructed through the binary opposition of difference, being acted out. Furthermore the logocentric reconstruction of space cannot be played out without the colonization and appropriation of that space and its insistent anchoring to the beholder.

The mapped view on the other hand suggests an encompassing of the world, without, however, asserting the order based on human measure that is offered by perspective pictures.[129] At its center we find the astonishing concept of the unpositioned viewer and its essence insists on the plausibility of the view from nowhere. This dispensing with the positioned viewer who upholds an entire logocentric construct therefore allows for a pluralism which transforms the mapped view into a variety of modes such as collective, national or individual narratives. For all of its expression through easily recognized conventions of knowledge, the mapped view in picture-making nevertheless recognizes that 'the geography of the land is, in the last resort, the geography of the mind'.[130] Joshua Neustein's maps can therefore be located within a new discursive space which is formed out of the tensions between these two positions (Figure 3.6). They encompass within themselves an entire range of contemporary dialectical tensions and binary opposites which form a challenge to the traditional concepts of epistemology.

Figure 3.6 Joshua Neustein, *Europe with Legends*. Courtesy of the artist

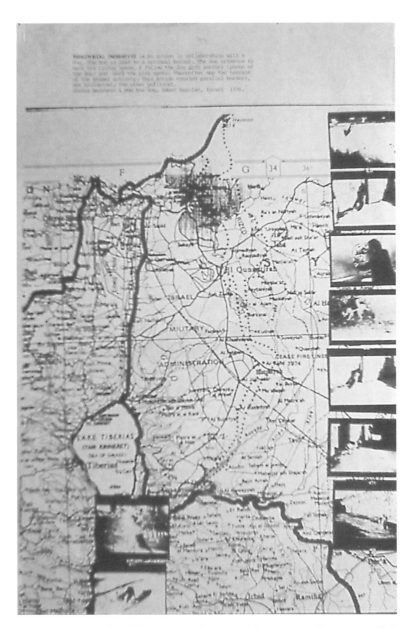

Figure 3.7 Joshua Neustein, *Territorial Imperative*. Courtesy of the artist

To my mind these maps can be read as the formulation of a theory of cognition which is in itself imbued with doubt concerning both the empirical basis and the spirit of logical positivism on which any theory of cognition must be founded. Instead we find presences, easily read cartographic texts, which in their very corporeality signal fundamental absences and challenge the conventions of the systematized relations between perception, verifica-

Figure 3.8 Joshua Neustein, *Territorial Imperative: Golan Heights*. Courtesy of
the artist

tion and representation. Thus for all of their cartographic detail these maps
set up a strategic resistance to being read empirically and challenge language
as a way of understanding texts. Within their space the domination of a
fixed position is abdicated while simultaneously normative codes of empir-
ical verification are constantly spun around in an interior debate on the
nature and validity of representation.

If these images are not maps according to the traditional European
conventions of cartography as picture-making, what are they? Increasingly
they strike me as being meditations on issues of boundaries and definitions
and the interactions between the two. These have their genesis in the mid-
1970s in a series of works done in Israel such as *Territorial Imperative* (Figures
3.7–3.8). Neustein, born in wartime Poland and living in New York, was
ironically drawn for a while to the multiple spatial inhabitation which is
Israeli/Palestine/The Holy Land as the site of a possible play with the
concept of homeland. Works such as these form a speculative visual discourse
on the illusory nature of the stability of borders within the context of
Arab–Israeli politics in the Middle East.

In *Territorial Imperative* a dog urinates on various sites in the Golan Heights
and a border line is drawn which connects these sites and superimposes
them on all of the more official border lines which criss-cross the area,
drawing attention to the arbitrariness of borders and to the demagogy of
the political rhetoric which has served to harden them into immutable facts.
The geographically limited state of Israel encompasses within its recent
history a wide range of shifting borders: vestiges of Greek, Roman, Persian,

Phoenician, Babylonian, Mameluk and many other empires which dominated the region and occupied the land.[131] There are other borders designated by international mandates and United Nations resolution and yet others resulting from armed combats, green lines which signal memories and good intentions and heavily fortified ones which protect all the previously specified borders contained within them.

Historically too, the narrow strip of land which is modern Israel is traversed with the older borders of numerous conquests and settlements of the two great empires, Ottoman and British, each of which defined its achievements by establishing its boundaries. Within the perpetually volatile current political situation and amidst the considerable internal debates on the validity of what is being defined by the different sets of boundary lines which signify the different sets of political and ideological beliefs, clearly distinguishable borders have become a parallel to the achievement of coherent identities. The proximity between how boundaries both determine and how they undo identity has been described by Edward Said as follows:

> Just beyond the perimeter of what nationalism constructs as the nation, at the frontier separating 'us' from what is alien, is the perilous territory of not-belonging. This is where in primitive times people were banished and in the modern era, immense aggregates of humanity loiter as refugees and displaced persons.[132]

In *Nature Morte* (Figure 3.9) Neustein staged an action on the Israeli/Lebanon border during the Israeli invasion of southern Lebanon in 1983. He arranged rubber tires in the shape of an airplane and set fire to them so that from the air they looked as if a plane had crashed and was burning on the ground. As expected, a great deal of panic ensued, and the artist was severely reprimanded for taking up the time of the army with what was considered frivolous play. This intervention in the most disputed of all of Israel's territorial occupations, the one occupation for which not even the government of the day could produce a legitimizing narrative of threat to national security, takes up the very images and tools of military warfare in order to evacuate them of all meaning. Instead it is the panic and anxiety that the border invokes when it is transformed overnight from a fairly benign field of separation to the barricaded site of active hostility. The continuity of the landscape, as we can see in this image, is suddenly ruptures by a barbed wire fence whose malevolence is articulated by the needlessly burning tires.

While I do not want to privilege biography as an analytical tool, one must nevertheless recognize the degree to which correlations between moving borders and shifting identities play a consistently central role in

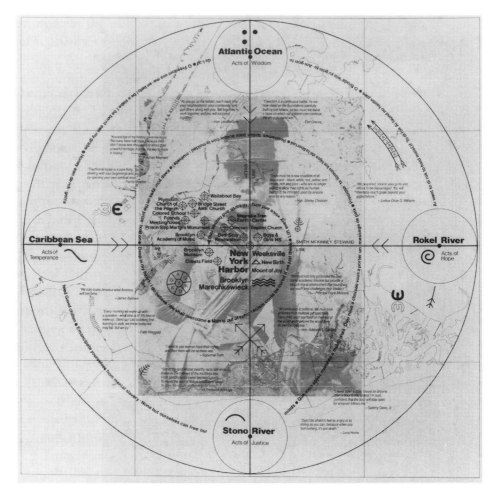

Figure 3.12 Houston Conwill, *The New Merengue*. Courtesy of the artist

to overwrite some of the existing topographies which associate a landmass with only one group of people through the knowledge they have imposed on to its rendering.

In recent work, for example, a dance or a sequence of music becomes the organizing principle through which mapped knowledge is assembled. A dance such as the New Merengue or the New Cakewalk becomes the first order by which historical and spatial material gets organized. The dances, like the music of the blues and jazz, were a major African contribution to the nascent culture of the United States. These particular dances have an interesting hybridity since they stem from slave parodies of the stiff and awkward bearing and movements of white people in the eyes of African slaves. These dances were then taken up by the very whites they parody as extremely

fashionable and subsequently redanced within the Black community as a parody of a parody. Like the music which inspired them, the dance movements slide across continents, creating unconscious hybrid cultural forms that operate within exceedingly hostile, racialized social positions. The mapping form in these works is cosmographic and galactic, rather than topographical; it posits oceans and rivers at the edges of the terrain sketched out and writes segments of African histories on to the sites which are usually associated with European settler histories. At the center of Conwill's *The New Merengue* (Figures 3.11–3.12) is New York Harbor. Usually associated with Dutch settlers, in this rendition we have an emphasis on the spiritual life of numerous communities, including Quakers and Africans. In concentric circles are the songlines, in Krio, Gullah, Spanish, French, Caribbean English etc., the many languages and idioms that make up the cultural worlds flowing into and around the Harbor, and below is the indexical key to the map, separated into Dance Partners, Spiritual Signposts and Songlines. Underneath, or perhaps imposed above, is a sepia-tinted photo of Sojourner Truth, a former slave in Victorian dress, a fierce fighter against slavery who advocated women's rights – a passionate speaker whose phrase 'Ain't I a Woman?' has reverberated through Anglo-American feminism for many decades.

Conwill applies principles of cartography, a European tool of knowledge, to stamp the geographical terrain with unacknowledged African histories and uses a singing, dancing body to mark out and inhabit this terrain.

> The Africanity of the epistemology which posits the corporeal as essential to knowledge, (including historical knowledge) and which underlies this performative practice, is obvious . . . in Conwill's work. Conwill's work has been underlain by the motif of the journey, of travel, of wandering and of trying to find one's way . . . Journeying as such may be nomadic. One's center is largely internalized even if projected in some situations on the landscapes. A physical place of return does not exist.
>
> Or, journeying may be closer to exile, in which a return to an externalized center is always envisioned if never actualized. The productive anxiety of African America also lies in our uncertainty as to whether the journey ought to be considered nomadic, or whether it remains an exile. Thus the recurrent center of a spiraling journey such as is implied in the Cakewalk or the New Merengue . . . seems to represent a re-creation of the tragedy of the exile become sojourner (resident?), a transformation of the tragic into a productive instrument for contemporary struggles . . . for negotiating around difficulty . . . for historicizing.[137]

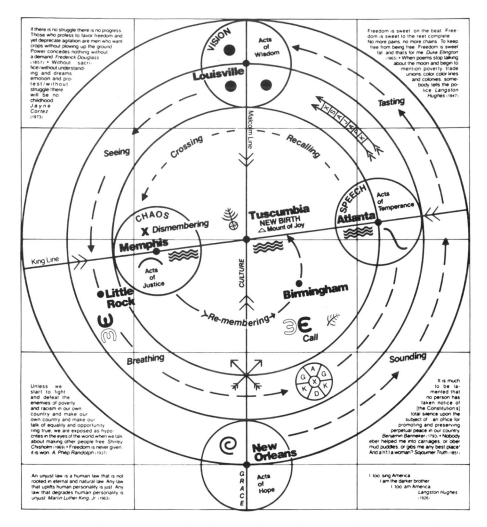

Figure 3.15 Houston Conwill, *The New Cakewalk Humanifesto: A Cultural Libation*, 1989. Courtesy of the artist

add to existing knowledge but actually restructure it. Conwill has produced a Spatialized history charted on to an articulated location which in turn become a concrete manifestation of cultural double consciousness. In our post-colonial, post-slavery, post-migratory world only conditions of double or triple consciousness prevail and the task of fragmenting the signs and the languages of representation, so that we can make manifest the endless cultural disputes of our heritage, remains to both the writers and the readers of these sign systems. To accept that every topography and every text is doubly inhabited by often irreconcilable cultural positions is to undo the

universalism that attempted to bind us all together under the aegis of the dominant. However, to know how to read a disputed text is a strategy of ambivalences and contradictions and not a celebration of universal access to information. To make maps and mappings of the sites of historical 'flood-ings' is to produce a language for geographical double consciousness.

Borders

Divisions, traces, thresholds

BORDERS HAVE TRADITIONALLY been seen as lines of division, as the final line of resistance between a mythical 'us' and an equally mythical 'them'. Either a mode of containment or a final barrier leading up to an ultimate liberation and freedom.

As a device of such demarcations, the border is the line which needs to be crossed into a safe haven away from the tyranny of evil in narratives of both the Second World War and the Cold War. In the film genre which depicts the protagonists of the Second World War as purely evil and purely humane, the border – often crossed with the last gasp of human fortitude – indicates escape into safety. Concurrently, it is the line at which demonized threats from the outside are held at bay and waves of ejected or disaffected migrations are either kept in or kept out of the protected entity. Thus the logic of the border is far less one of containment than it is one of division. Those concepts of division fluctuate between the concrete boundaries between hostile and geographically embedded adversaries such as warring and safe havens, to symbolic cultural permissions for transgression. We find many instances in contemporary literature and in visual culture where the border is represented as a zone of danger in which norms get undone, temptations rear their head, transgression takes place and solid, reliable identity gets undone. Films such as *Touch of Evil* and advertising campaigns such as Taco Bell's 'Run for the Border' construe a notion of a border that is internal rather than external to the subject, a line of

containment which must be transgressed in order to reveal some 'truer' or 'wilder' self. Thus links are set up between the border as a psychically internalized concept of boundaries crossed and repressions breached and the external traces of a containment which holds one in, which does not allow for that very breach. It is this tension between internal fantasmatic border crossing and external collective armed containments which gives the 'border' its current cultural frisson, its cachet as a term which articulates a set of potentially rich cultural contradictions whose manifestations have been concepts such as 'border writing' or the 'Border Arts Workshop'.

Other manifestations of the border are of course those of the heavily armored and barricaded line of division between two segregated national entities – this is a border whose integrity must be kept at all costs, and those who attempt to pierce or contravene it pay a bitter price, doomed to stay in a place of danger and misery or to be kept out of the promise of safety and adequate conditions. Recent histories of 'ethnic cleansing' in the former Yugoslavia have made obscenely concrete the physically embodied and territorially grounded implications of borders which safeguard the 'purity' of that which is understood to be framed by the border. One of the most interesting aspects of this highly visible structure of a fortified border patrolled by guards and surveillance technologies is that it is not really there, it is the suspension of both the entities which have been kept apart and as such it is a voided entity, simultaneously overladen with meaning and ungraspable as we shall see later on in the discussion of Michal Rovner's film *Border*. The voiding that is necessitated both by the ferocity of conflict and by its location at the very center of the disputed territory, enfolded within the body as it were, is in marked contrast to the constitution of the borders of colonized spaces which are deemed at some remove from the centers both affected and not affected by their distant presence.

In the Terburen Museum, Belgium's Royal Museum of Central Africa, among the vast and ravishing collection of Congolese art and artifacts brought over at the height of colonial rule and now on display through the combined aesthetics of ethnography and 'natural history' in the outskirts of Brussels, there is one small room devoted to the art and objects of the colonizers. It is a motley collection which includes banal bits of European domestic comforts far from home juxtaposed with testimonials to the brutal cruelty of colonial rule. Amongst the artifacts in the old-fashioned glass vitrines is a square stone on which the letters D/B are carved (Figure 4.1). It is a border stone marking the division between Belgian Congo and Deutsche Ost Afrika (German East Africa) dating from the first decade of the twentieth century. The complex balances of power and negotiations and treaties back in Europe, where the actual lines of division and power relations were drawn and maintained, allows this spatial demarcation to function as a hint, or a trace, of its actual

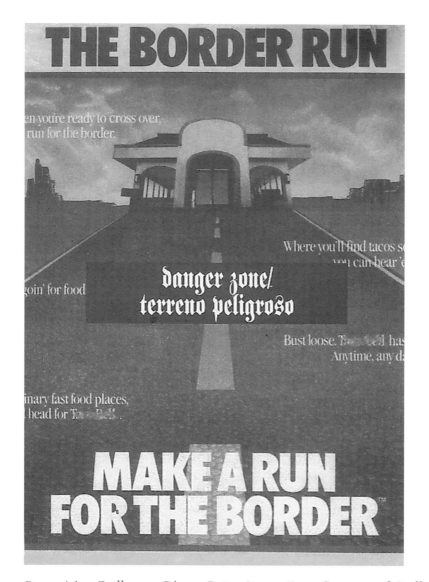

Figure 4.1 Guillermo Gómez-Peña, *Danger Zone*. Courtesy of Guillermo Gómez-Peña

self. This border, then, is not the embodiment of fierce efforts to keep separations intact but the tracing of another order, far removed and so powerful that it can maintain itself through a gesture so slight and unemphatic. Given the scale of the carnage that was effected throughout the African continent as a result of that famous Bismarckian act of geometric carving up across tribes and nations and languages, and given the legacy of that history which continues to determine political life in the Congo, this minute gesture of the border stone alerts us to the imaginary power of the border as concept

Figure 4.2 Border Stone. © Musée Royal de L'Afrique Centrale, Tervuren,
Belgium

– far removed from geological formations and patterns of settlement, a fantasy
of division projected on to the terrain from afar.

The potency of these partitions and boundaries, their historical legacy
in the law and in the formations of nations, in reflecting power structures
and resonant fears is such that they clearly need some complex level of
differentiation and unraveling. Gilles Deleuze, in trying to theorize a shift
from lines of division and separation to those which might carry us across
unknown thresholds, distinguishes between three types of lines. The first
order of lines 'that forms us (there are many of this type) is segmentary,
or rigidly segmented . . . Each time, from one segment to another, we are
told, "now you are no longer a child": then at school "now you are no
longer at home" . . . all kinds of well defined segments, going in every
direction, which carve us up in every sense, these bundles of segmented
lines.'[139] The second order are:

> much more supple, that are somehow molecular . . . they trace
> out small modifications, cause detours, suggest 'highs' or periods
> of depression, yet they are just as well defined, and even govern
> many irreversible processes. Rather than being segmented molar
> lines these are molecular flows (*flux*) with thresholds or quanta.
> A threshold is crossed that doesn't necessarily coincide with a
> segment of more visible lines.[140]

. . . At the same time again, there is a third type of line, even stranger still, as if something were carrying us away, through our segments but also across our thresholds, towards an unknown destination . . . this line though simple and abstract, is the most complicated and tortuous of all: it is the line of gravity or celerity, the line of flight with the steepest gradient . . .

In any case these three lines (i.e. segmentary, molecular and gravity) are immanent and caught up in each other.[141]

Here we have the first inkling of a possibility of linking borders away from the ebb and flow, advance and retreat that are the direct results of battles lost and won, conquests, occupations and negotiated concessions and withdrawals. Not least of the possibilities is the understanding of lines as active; of flight, of crossings, of the ability to carry us away. Any discussion which attempts to understand this taxonomy of lines of division, contamination, separation and flight in terms of their representation and their symbolic presence must effect the shift of threshold as passage from one place to the other, to a Deleuzean concept of becoming, a process rather than an act.

In the heroic old narratives of lines of division between good and evil the border is often depicted as an abyss, a romantic and dangerous gorge, a rite of passage. The East German painter A. R. Penck crossed over to West Germany in the early 1960s. He joined the corps of highly dramatic heroes whose resistance of 'the East' and willingness to put themselves in mortal danger in order to join their lot with 'the West' made them the

Figure 4.3 A. R. Penck, *The Crossing Over*, 1963 (acrylic on canvas).
Courtesy of Museum Ludwig, Cologne

Plate 1 Charlotte Salomon, 'Kapitel: Der Abschied' from *Life? Or Theatre?* 1992. Courtesy of the Jewish Historical Museum Amsterdam, Charlotte Salomon Foundation

Plate 2 Diller and Scofidio, *Suitcase Studies – Tourisms of War*, 1991. Installation, Walker Art Center. Courtesy of the artists

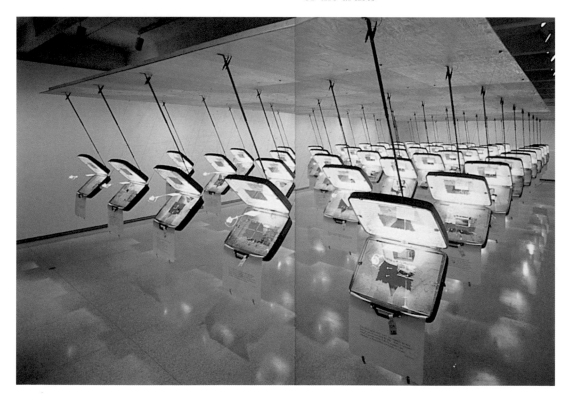

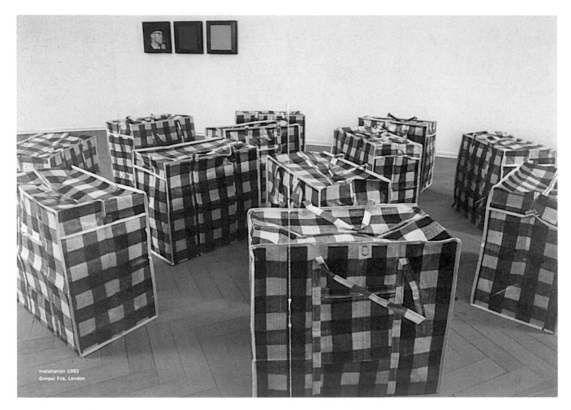

Plate 3 Art In Ruins, *Conceptual Debt*, 1992. Courtesy of Art in Ruins

Plate 4 Ashley Bickerton, *Commercial Piece #3*, 1990. Courtesy of Sonnabend Gallery, New York

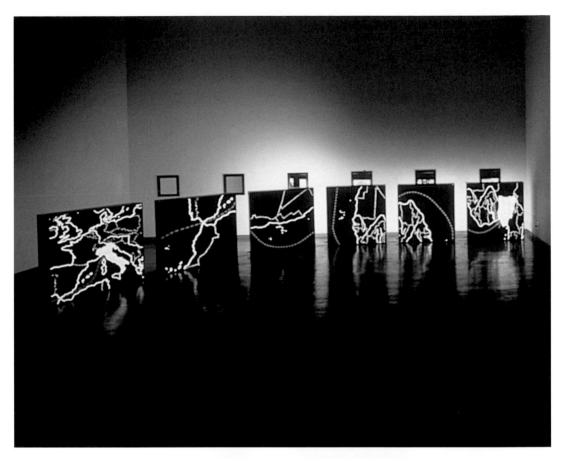

Plate 5 Alfredo Jaar,
Geography=War, 1990
(installation shot). Courtesy of
Galerie Lelong, New York

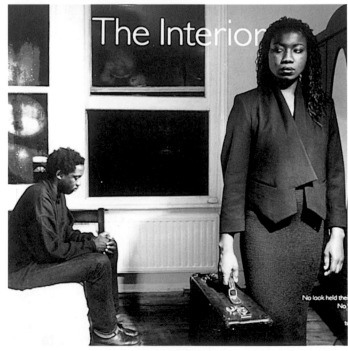

Plate 6 Mitra Tabrizian,
'The Interior' from
The Blues, 1988. Courtesy of
the artist

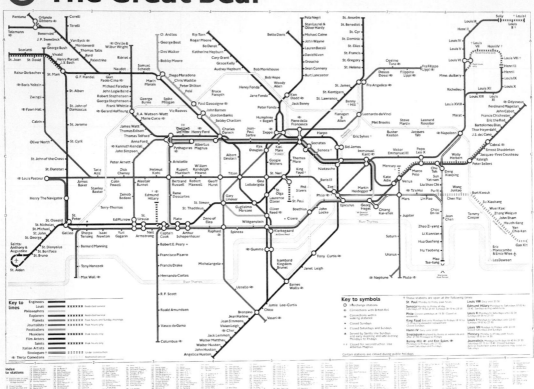

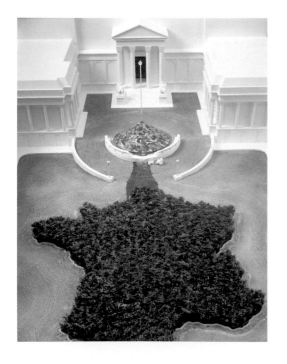

Plate 7 Simon Patterson, *The Great Bear*, 1992. Courtesy of the Lisson Gallery, London

Plate 8 Hans Haacke, *Calligraphie*, 1989. Architectural model, proposal for Palais Bourbon (Assemblée Nationale), Paris. © VG – Bildkunst

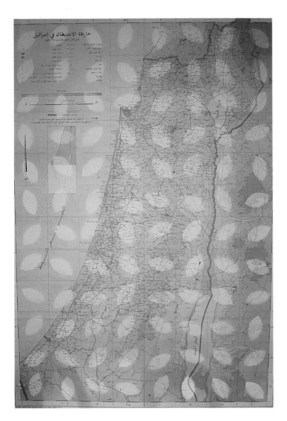

Plate 9 Joshua Glotman, *Untitled*, 1993.
Courtesy of the artist

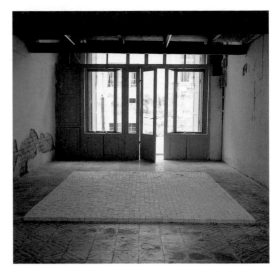

Plate 10 Mona Hatoum, *Present Tense*.
Courtesy of Gallery Anadiel, Jerusalem

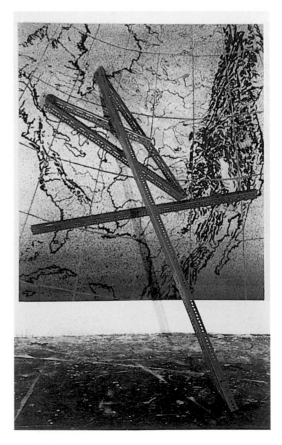

Plate 11 Joshua Neustein, *Continental
Tracker*, 1987. Courtesy of the artist

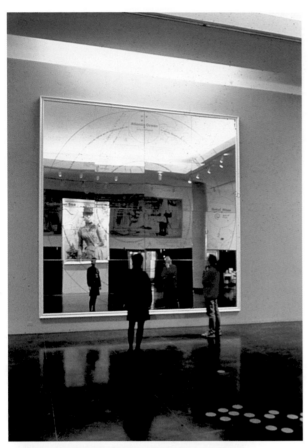

Plate 12 Houston Conwill, *The New Merengue, 1992* (installation shot at the Brooklyn Museum). Courtesy of the artist

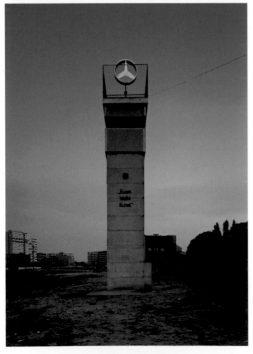

Plate 13 Hans Haacke, *Die Freiheit wird jetzt einfach gesponsert-aus der Portokasse*, 1990. Photo: Werner Zellien. © VG – Bildkunst

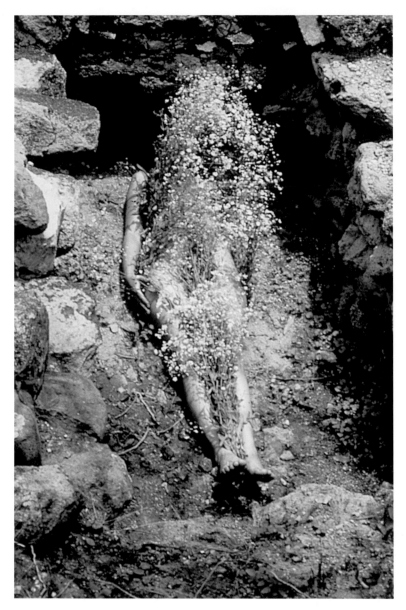

Plate 14 Ana Mendieta, Documenting earth work, *Silueta
Works in Mexico*, 1973–7. Courtesy of Galerie Lelong, New York

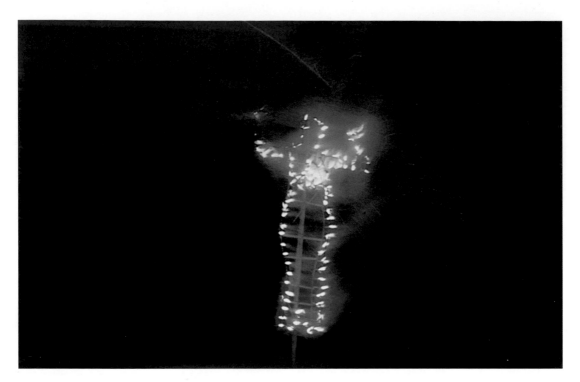

Plate 15 Ana Mendieta, Firecracker silueta, *Silueta Works in Mexico*, 1973–7. Courtesy of Galerie Lelong, New York

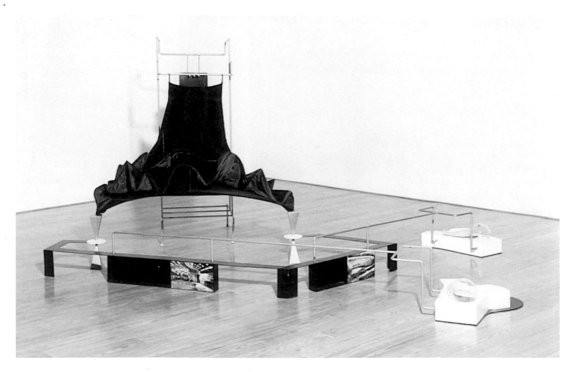

Plate 16 Sigal Primor, *Signorita*, 1989 (installation shot). Courtesy of the artist

cultural darlings of West Germany and some of the rest of Europe. In Penck's image of 1963 (Figure 4.3) he is crossing over a literal abyss on a rope of fire: the metaphors are too obvious to require much interpretative work. Suffice it only to say that masculinity indicated by a prominent penis, religiosity indicated by the ability to walk on fire over a void and acrobatics indicated by the stance of the circus wire walker all join forces as the required components for making the crossing. This crossing is rooted in the binary opposites and fixed poles of 'History' as a metanarrative and it pits the world-historical oppositions of East and West, of communism and so-called democracy against the cult of the individual artist who is able to transcend them through vision and commitment. Most interestingly this offers a remarkable testimony to Cold War sentiments, and it is effected by the closure of having reached the 'right' side across the border.

In contrast to this traditional view is the Deleuzean crossing: 'A threshold is crossed that doesn't necessarily coincide with a segment of more visible lines . . . Many things happen along the line becomings, 'micro-becomings' – that don't have the same rhythm as our "*history*".'[142] Before we can attempt the visual location of Deleuze's 'lines of flight' we need to recognize some of the signifactory practices by which concepts of 'border' circulate.

The culture of the border

On the other side, from whichever perspective that other side is viewed, there is always a specter of a demonized population, its character traits exaggerated, and its ability to contain itself doubtful, its menacing ambitions to spill over and flood the protected entity forever threatening. Perhaps the most celebrated border of cultural production is the Mexican–American border which has been the focus of much paranoid legislation, much tragic film-making and an exceptionally elaborate body of work by such groups as the Border Arts Workshop, writers like Emily Hicks and artists such as Guillermo Gómez-Peña and Coco Fusco.[143]

Guillermo Gómez-Peña has done much to push these vilifications to a point where they must turn in on themselves and on the currency of demonization they have produced out of the sense of border as threat.

In dramatic and elaborately theatrical performances he has given comic form to the overwrought fears of an invasion of barbarian hordes from Mexico. In *Seditious Members of La Pocha Nostra* (1996) (Figure 4.4), a play on several political threats, from the mob to national liberation movements to peasant insurrections, he stages a border invasion by a ludicrous premodern armed vehicle with a death's head shield at the prow and populated by the most preposterous US visions of over-decorated Mexicans, half

Figure 4.4 Guillermo Gómez-Peña, *Seditious Members of La Pocha Nostra*, *News from Aztlan Liberado*, 1996. Courtesy of Guillermo Gómez-Peña

pirates and half generalissimos, courtesy of the Hollywood imagination. Running ahead of their war machine vehicle, these imaginary warriors manage to address all possible threats attributed to potential Mexican immigration; they negate modernity and its technologies and invoke mechanical backwardness, they perform a violent and aggressive invasiveness and they defy the codes of politeness set out by corporate culture. The border is also the site of erasures: cultural, civic and linguistic. In *There Used to Be a Mexican Inside this Body* (1996) (Figure 4.5), a silenced and impoverished Gómez-Peña seems reduced to the sign language of street begging. Crossing the border to the USA, usually accompanied by aspirations to wealth and worldly goods and capitalist dreams, has here had the exact opposite effect – one of stripping and erasing any cultural and communicative baggage that may have accompanied the subject on his journey.

All of this insistent, theatrical and hyperbolic pushing on the pressure point of the feared and dreaded Mexican–American 'border' works to put into quite ridiculous perspective the degree to which it serves to mask the realities

of an endlessly hybridized culture between Latin America, the Caribbean, Mexico and the Mexican-American chicano population. The 'border' works to reduce the complexities and richness of all of these mutual influences by reducing them to the status of a geographically localized 'problem' of migration across the Mexican–American border and its ensuing economic and cultural feared threats. Part of its effectiveness is the degree to which it provides an exaggerated imagery of embodied dreads from the US side of the border. Only in the work's discursive materials does the complex culture on the Mexican side – such as collaborations with groups of artists and intellectuals in Mexico whose work harks back to the great social projects of the 1930s, with modernist theory in Latin America and Cuba and

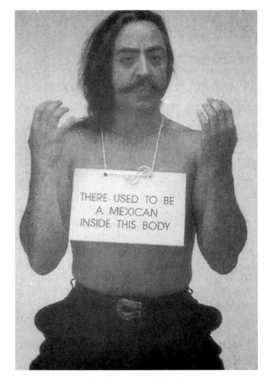

Figure 4.5 Guillermo Gómez-Peña, *There Used to be a Mexican Inside this Body*, 1996. Photo: Ira Shrank. Courtesy of Guillermo Gómez-Peña

of course with the very substantial cultural work being carried out throughout the USA by chicano and other Latino artists, writers and intellectuals – begin to defy the reductive alarm of the images.[144]

Viewed from the US side of the American border with any of its Central American neighbors, there is either the unwelcome specter of poverty, evoking an uneasy sense of responsibility, or alternatively a spectacle of the exotic discovery of blatant cultural difference. Gómez-Peña in a joint performance with Coco Fusco entitled *The Guatinaui World Tour* performed the exotic 'discovered' living in a golden cage within various art-world contexts and thereby making the spectators the subject of the performance. Presenting themselves as 'undiscovered AmerIndians' from an island in the Gulf of Mexico that had somehow been overlooked by Europeans for five centuries, they called their homeland Guatinau and themselves Guatinauis. 'Our cage became the metaphor for our condition, linking the racism implicit in ethnographic paradigms of discovery with the exoticizing rhetoric of "world beat"

multiculturalism.'[145] They are both dressed as the proverbial 'savages' (except for her tennis shoes) standing behind the bars of a cage staring impassively at the photographers who inadvertently and unbeknown to them have become a replication of the original Western gapers at imported exotics from other cultures within such spectacles as world fairs and circuses. This project was part of a much larger one in which both artists took on the spectacle dimension of the 'discovery' of the Americas and staged themselves, and everyone around them who came to watch, as the protagonists of the original spectacle which had greeted Columbus and his men.

Fusco says:

> Our project concentrated on the 'degree zero' of intercultural relations in an attempt to define a point of origin for the debates that link 'discovery' and 'Otherness'. We worked within disciplines that blur distinctions between the art object and the body (performance), between fantasy and reality (live spectacle) and between history and dramatic reenactment (the diorama). The performance was interactive focusing less on what we did than on how people interacted with us and interpreted our actions.[146]

One of the curious dimensions of all this border work is that it posits a persistent belief in immutable borders within the popular imagination, and that these are still consistently viewed as strictly policed lines of separation in which countries, cultures and languages do remain divided and hostile. It is curious because it assumes some cohesion on each side of the border, each country an internally unified entity and identity. Internally fragmented collective identities would find it far more difficult to cohere a hostility outwards, and of course our understanding of the world has become far more one of internal dissolutions of totalizing identities. So why not our understanding of borders: how can they remain strict and absolute lines of division when they are separating tentative and nebulous and incoherent entities?

To begin with, it has been important to expand the vocabulary beyond countries, nations and states. All of these are countered by the zones which provide resistance through processes of disidentification: international free cities, no man's land, demilitarized zones, *cordons sanitaires*, ghettos, border areas etc., and the identification of these as challenges to a stable geographical order works in turn towards our recognition of traditional geography as a sign system in crisis.[147] While a national geographic entity produces and policies identity, the notion of a 'zone' is one suspended between various identities – a site of evacuation in which the 'law' of each identity does not apply, having been supplanted by a set of contingent 'rules'.

Such zones of disidentification are made manifest in the abandoned, evacuated sites such as the one Hans Haacke took on in *Freedom is Now Simply Going to Be Sponsored — Out of Petty Cash* (1990) (Figure 4.6, Plate 8), situated in the previous 'no man's land' between the two Berlins, as part of a public site exhibition the city of Berlin put on in 1990 entitled *The Finiteness of Freedom*.[148] Haacke chose the ultimate space of disidentification in this site. The GDR had built in 1961 a zone of empty space between the newly divided parts of the city delineated by unscalable walls, electrified fences, landmines and dog runs. Aside from these the so-called 'Border of Peace' was under constant surveillance from watchtowers equipped with powerful searchlights. Haacke chose one of these abandoned towers for his site. Its windows were newly fitted with tinted glass reminiscent of the most luxurious West Berlin office blocks and the searchlight was replaced with the Daimler-Benz golden star.

Figure 4.6 Hans Haacke, *Die Frieheit wird jetzt einfach gesponsert-aus dem Portokasse*, 1990 (installation shot). Photo: Werner Zellien. © VG – Bildkunst

As the most conspicuous sign of international German trade and West German capitalism, the Mercedes star also has long roots in the fascist past as an industrial promoter of Hitler's rise to power. The star is protected by a transparent shield of the kind which guarded West German police vehicles against rioters and various insurgents from within. On one side of the watchtower appear the ominous words 'To be Prepared is Everything' and on the other side that romantic fallacy of artistic transcendence, 'Art Remains Art'. Clearly the conjunctions between capital and redevelopment and art and the desire to erase the past have been established on the former watchtower. I am particularly interested in how this has been spatialized within the topography of the city. A true zone of disidentification has been conceptually established here, not through the initial violence of the old regime of the GDR, which stripped subjects of identity by force, but through creating a spatial axis of contradictions and clashing aspirations.

Haacke's mode of creating a zone of disidentification has been to produce a concrete manifestation of Foucault's concept of heterotopia. I am using Foucault's formulation of both utopian and heterotopian sites:[149] sites with no real places, they supposedly represent society itself in perfected form. In the process of being transformed from instruments of state oppression to the sites of public spectacle of capitalist triumph and socialism's defeat which they are today, these utopian fictions of pure separation have been transformed into what Foucault termed 'heterotopias' – counter-sites in which all the other real sites which can be found in culture are simultaneously represented, contested and inverted.

In the middle of all the euphoria of unification, Haacke has animated the evacuated border and spatialized it as a heterotopia of internal contradictions. This work manifests a kind of physical stamping of the terrain, an insistence on a border where everyone else is denying its existence. It leads us to the main discussion of this chapter: Ana Mendieta's insistence on creating borders and tracing lines of separate spheres and of autonomous ownership throughout a geographical terrain which comes to stand in for a metaphorical art-world occupation.[150]

Mysterious Death in the Art World[151]

Thus screamed the headline of a recent book review, one of many articles which have in recent years attempted to deal with the unclear circumstances of Ana Mendieta's death in 1985. With hindsight it would seem that both her life and her death have somehow been contained within a very particular geographical location, that of the art world. While the art world cannot claim for itself a fixed and concrete location, a mapped terrain with distinct boundaries, it is nevertheless a world unto itself, with a distinct cultural and linguistic tradition and a vehement sense of territoriality.

In attempting to spatialize the cultural narrative that has emerged around the work, life and death of Ana Mendieta, I am claiming that these have been constructed out of a set of territorial imperatives which continue to privilege a Eurocentric, urban and commodity-oriented artistic culture whose center it is claimed is the New York art world. Mendieta herself, Cuban, female, a conceptual artist working in geographically peripheral areas, not only rejected such centrist organizing principles but sought to replace them with alternative geographies, which brought together natural topographies with the landscape of a female body imposed, inserted and cast upon them (Figures 4.7–4.12).

The folkloric location by the press of her work and her life has served to characterize it in a particular way, one reserved for the defiant outsider.

By invoking the concept of geography, of what Edward Soja terms 'the politicised spatiality of social life',[152] I am attempting to reframe, or relocate, it within a cultural sphere which is concentric and multicultural rather than centrist and hierarchical. Above all else the issue these visual discourses of place and identity point to is that of positionality, the newly arrived at, oblique and circuitous ways in which the self is positioned in relation to the great traditions, be these of epistemic structures, the signification of specific location and its national/cultural identification or gendered narratives and histories.

It is precisely because this effort cannot be contained within conventional systems of sign interpretation that it opens up possibilities of the representation of displaced identities. If the representations of geographies in Mendieta's reconstruction of acculturated earth plots do not work toward the signification of traditionally identified affiliations and locations, perhaps their resistance works toward a revised understanding of identity. The fact that these can be further differentiated by gender-related issues and practices opens up possibilities for visual discourses of gender and culture which work across one another.

Traditionally, coherent cultural identity has been seen as transcending such aspects of difference as gender or language while anchored in a shared participation in an overall historical narrative. Introducing these as further degrees of inherent difference with clear cultural manifestations may help to redefine positionality away from the traditional concept of rootedness within one specific and coherent given culture. How to make the invisible fragmentation of the subject which works against traditions of cultural coherency visible is the question being asked by many contemporary artists, and how to do so within the inherited language of signification and therefore disrupt its supposedly simple legibility is equally the subject of much contemporary critical discussion.

Early in the morning of 8 September 1985, the well-known minimalist sculptor Carl Andre was charged with murdering his Cuban-born wife Ana Mendieta, by flinging her out of the window of their thirty-fourth floor Greenwich Village apartment, a charge of which he was later acquitted. Art-world luminaries of the male sex gathered around Andre in support, and the quarter-of-a-million-dollar bail demanded by the New York district attorney for the charge of second-degree murder was posted by a who's who list of the great names of the 1960s and early 1970s art world. Andre was after all what artspeak terms 'museum class', a founding father of minimalism, his massive installations of bricks and copper tiles bought for hundreds of thousands of dollars by the great modern art collections of the world. Mendieta on the other hand was an inhabitant of the feminist subculture of the art world, an exhibitor in publicly funded arts projects of

short duration and a contributor to such journals as *Heresies*, definitely not 'museum class'.[153]

The tragedy served as the focus of one of the quintessential art-world circuses, the stuff from which myths of the excesses of bohemian life are made. Here were two prodigious drunks, she 'boisterous and euphoric' he 'sullen and taciturn', both of firm though wildly divergent leftist politics, notorious for their constant fights and reconciliations. Here the territory of 'the art world' intersects with another mythical terrain, that of 'bohemianism', to locate and explain certain transgressive conduct, an extreme and violent tragedy.

The geographies of Ana Mendieta

'I have been carrying on a dialogue', she wrote in a letter to a woman friend, between the landscape and the female body (based on my own silhouette). I believe this has been a direct result of my having been torn from my homeland [Cuba] during my adolescence. I am overwhelmed by the feeling of having been cast from the womb (nature). My art is the way I re-establish the bonds that tie me to the universe.'[154]

In another letter written in the early 1980s Ana Mendieta tells of an 'African custom which I think . . . is analogous to my work . . . The men from the Kimberley go outside their village to seek their brides. When a man brings his new wife home, the woman brings with her a sack of earth from her homeland and every night she eats a little bit of that earth. The earth will help her make the transition between her homeland and her new home'.[155] Mendieta and her own sack of earth had gone through a process of 'deterritorialization'. Caren Kaplan describes this as 'A term for the displacement of identities, persons and meanings that is endemic to the post-modern world system'.[156] This is founded on Deleuze and Guattari's use of the term *deterritorialization* to locate the moment of alienation and exile in language and literature. I do not want to privilege biography as an analytical tool in any way, but a few facts do seem significant.

Mendieta grew up in middle-class comfort in the Havana of the late 1940s and 1950s; her father was a highly politicized lawyer. A great-uncle had been president of Cuba, a great-grandfather, Carlos de Rioja, was a general in the 1895 war of independence. In 1958, when Battista was still in power, Ignacio Mendieta, Ana's father, was working secretly against the government. The revolution came but it did not go well for Ignacio Mendieta. Though pro-Castro he was anti-communist, a devout Roman Catholic who perceived the communists as anti-God. He refused to become a member of the Party and quickly fell out of favor and out of work. With

money becoming tight and suspicion becoming a way of life, the Mendietas sent their two daughters to the USA for what they thought would be a short sojourn. Armed with a letter giving power of attorney to the Catholic authorities and a vision of America founded on Troy Donahue and Sandra Dee adolescent romance films, the Mendieta sisters found themselves first in a camp in Miami and then an institution in Dubuque, Iowa, which was in essence a reform school whose inmates were orphans and socially dysfunctional children and subjected to brutal beatings and other horrors.

Over the next eight years a series of foster homes were to follow until her mother and brother finally joined them while her father remained in prison in Cuba. Ana later said that by the time she was seventeen she knew she had two choices: either to be a criminal or to be an artist, the only two sources of power available to her. Violence remains central to her early work, body art in which she encased her form in mud or blood or grass or flowers. After a rape at the University of Iowa, Mendieta did a violent rape series. In one she lay nude in the woods, her backside bloodied. In another, for which she invited the members of the workshop to come over to her apartment, she was tied to the table nude from the waist down and blood was all over the floor and the door. Both trauma and dislocation were converging on the geography of her own body.

In another work, a gallery performance entitled *Body Tracks* (see Figure 4.7), Mendieta dragged red paint over the wall, spreading the trace of her body, which can be seen in the illustration collapsed on its haunches. These performances, which foreground a female body as the site of violence, are not autobiographical per se. They begin the work that is further elaborated in the later *Silueta* series (see Figures 4.8–4.12), of both spatializing and geographizing gendered sites.

Mendieta's actual displacements were numerous and repeated: from Cuba and her family at the age of thirteen she moved to the United States, then to studies at Iowa University, to life in New York City's Soho, to work in Mexico and Cuba and finally to work in a studio in Rome as the recipient of the prestigious Prix de Rome. These moves were accompanied by a series of artistic moves from a minimal mode to an increasingly conceptual art involving actions, objects and documentation. The changes taking place within her artistic practice were thrown into sharp relief by Mendieta's increasing awareness and incorporation of the emergent discourses of cultural criticism involving gender, race and the cultural signification of certain sign systems into her overall understanding of her art.

There is little nostalgia or illusion about the recapitulation of previous cultural coherencies in any aspect of her work. She had prepared for her frequent returns to Cuba as an adult on working visits, in the Cuban section of Miami, in which conditions of exile, displacement and assimilation were

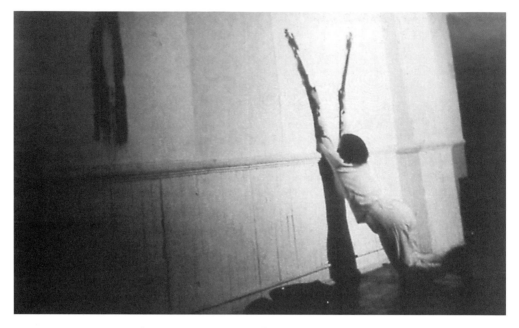

Figure 4.7 Ana Mendieta, *Body Tracks*, gallery performance, University of Iowa, 1974. Courtesy of Galerie Lelong, New York

everywhere being negotiated. In this context she made a figure-like form made out of the hair of Cuban exiles in Miami collected from local hair-dressing salons. This figure she attached to a local tree much used in ceremonial rituals by the immigrant population of the city. Every aspect of this complex project is inscribed with an understanding of loss, transition and emergent immigrant realities which build on but do not emulate or continue the original practices.

Within this artistic project in Miami we can observe no nostalgic hankering after some semblance of either the 'real' or 'original' culture, but rather a recognition of its supposedly secondary level of existence as displaced immigrant community, as a potent cultural reality. Of her actual return to Cuba as an adult Mendieta wrote, 'I was afraid before I went there because I've been living with this obsessive thing in my mind – what if I found out it has nothing to do with me?'[157] Between these lines we can read the presence of conflicting cultural traditions and of the artist's own location of herself within entirely opposite and conflicting political and ideo-logical systems of state communism and capitalist democracy. The interludes in Mexico and Rome thus assume a form of cultural mediation, Mexico being a host to many exiled Latin Americans who found that they could relocate their own preoccupations within a Spanish culture which has

sustained itself continuously over several hundred years and has an acute and fully articulated awareness of its own heritage.

Rome on the other hand is the source of the other culture which made up Ana Mendieta's world of reference, the Western tradition founded in classical antiquity and Roman civic practice. All of these journeys speak not only of disruption and cultural fragmentation but also of the collecting of tools, images and references which would help the work transcend the boundaries the artist wished to dissolve. These include narrow definitions of the type of work which qualifies for the category of 'art', the sites and locations which are considered credible for its display as art objects and above all the conventional linear histories into which this artistic practice could be slotted.

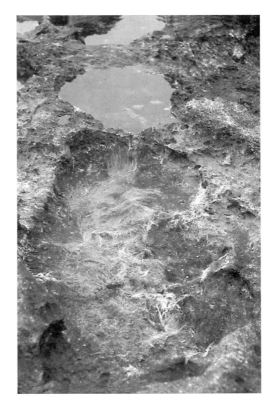

Figure 4.8 Ana Mendieta, *Silueta Works in Iowa*, 1976–8. Courtesy of Galerie Lelong, New York

Mendieta's process of deterritorialization had been effected through a framework of feminism, Third World cultural politics and First World avant-garde art practices of the late 1970s and 1980s. The relation of these elements to the great traditions and to her own work had gone through a series of sharp dislocations which were brought to an abrupt halt with her violent death in 1985 at the age of thirty-six.[158] The scope of the project she had begun was enormous and can be seen as only partially completed, but transience and discontinuity are inscribed in every aspect of this project and its untimely ending does not in any way diminish or qualify its significance. Both her premature death and her declared state of exile can, in hindsight, work in a derogatory way to sentimentalize readings of her work rather than work towards a recognition of the critiques of concepts of time and space as traditional cultural values, which she was working to deconstruct.

Mendieta's work of the last decade of her life had been closely bound to the earth. She worked through tracing the silhouette of her body on

earth, sand, tree trunks and fields in the environs of Iowa City where she had done her studies and in the Oaxaca region of Mexico and the hills of Jaruco near the city of Havana, Cuba (Figures 4.8–4.12, Plates 14–15). The works themselves use a rich variety of materials including gunpowder, fire, wood, paint mixed with blood, cloth, metal foils and many others. Some of these have been eased into place with a great delicacy that works to echo the existent lines of rock or earth formations while others have been etched through blasting with gunpowder or set up by fire with the intention of imposing their form on the landscape through extreme contrast. Freestanding silhouettes raised high on to the skyline and set alight like the military banners of ancient armies on the march served to illuminate and transform the horizon for a series of eerie moments and then collapse into small piles of ashes and charred fragments (Plate 15).

The transient status of the works, sites abandoned either to destruction or to change according to climatic and other conditions, echoes other states of transience all linked to an earth which defines everything but cannot be adhered to in any way. They function like a contemporary production of site-specific archeology which proceeds to play havoc with conventional notions of cultural time, of past and present, and yet in defying cultural time as a progressive sequence they do not attempt to impose some other non-specific notion of timelessness.

The project which Mendieta embarked on could best be described through Deleuze and Guattari's introduction of a parallel concept to 'deterritorialization', that of 'reterritorialization'. As Caren Kaplan understands this conception, its value

> lies in the paradoxical movement between minor and major – a refusal to admit either position as final or static. The issue is positionality. In modern autobiographical discourses for example, the self that is constructed is often construed to be evolving in a linear fashion from a stable place of origin towards a substantial present. In postmodern autobiographical writing such a singular linear construction of the self is often untenable or, at the very least, in tension with competing issues . . . Much of contemporary feminist theory proposes a strategy of reading and an analysis of positionality similar to Deleuze and Guattari's conception of 'becoming minor'. In working with issues of race, class and sexualities, as well as gender, feminist discourses have come to stress difference and oscillation of margin and centre in the construction of personal and political identities.[159]

Mendieta's process of reterritorialization, then, is the construction of a collective history based on gender as well as on race and on alternative cultural specificity. The artistic materials and tools that she employs in this project are matter versus contour as the essence of a personalized geography and place, or 'site' (i.e. determined by choice rather than fate) as opposed to location. In these she is working against the grain of the dominant artistic traditions in her total abnegation of all forms of boundaries.

To begin with, the works are made predominantly out of doors and remain there except for their photographic representations, thus negating the cultural boundaries in which works of art are produced and displayed: studios, galleries,

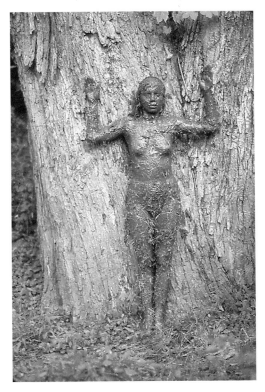

Figure 4.9 Ana Mendieta, *Series Arbol de la Vida*, Iowa, 1977. Courtesy of Galerie Lelong, New York

museums. This was in clear defiance of the art world's obsessive concern with 'the center' out of which small colonial offshoots could be tolerated but no more. In the immortal words of Joe Helman, 'if your work is traded in Prague, Bogota, Madrid, Paris and L.A. but not New York – you're a provincial artist. But if you're traded in New York and anywhere else, you're international'.[160] Thus the issues of cultural centrality and marginality take on a new twist with this emphasis on the siting of the work as an index of its value. Mendieta, who was culturally displaced between her Latin heritage and her American education and who increasingly attempted to employ models of analysis gleaned from Third World feminism in her own Western artistic practice, also displaced herself in relation to the art world by making ephemeral objects which were exhibited in distant and little-known rural spots.

Generically too these works defy definition and containment within a given style or mode, since they differ both from earth works and from pure body art by combining the two and by playing on the tension between a

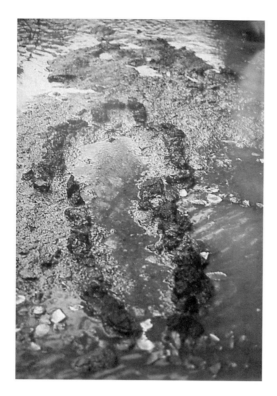

Figure 4.10 Ana Mendieta, *Silueta* series, 1979. Courtesy of Galerie Lelong, New York

performance art and a continuous slow deterioration of the pieces in nature. The works themselves too are without boundaries within their sites since there is no exact place in which they either begin or end; thus they cannot be framed or bound within conventional artistic or geographical territorialities. Their extreme materiality – sensuous, brutal, culturally and physically suggestive – plays the role of foregrounding quality, texture and substance as opposed to definition.

Lest all of this sound like an attempt at an archetypal 'feminine' artistic practice, I hasten to say that Mendieta's work cannot be summed up as a representation of the dreaded biologically essentialist 'feminine'. This is due primarily to her unceasing preoccupation with, and ability to find and articulate visually, different balances between universality and specificity. She carved, sculpted, dug, blasted, fired and painted figures inspired by the mythological metaphors of the Great Mothers, Gaea, Hades, Mother Earth, etc., in and on the many sites she worked through, but their universality is purely a function of their reception by European Western traditions. For Mendieta, a rigorous student of the religions and rituals of the Spanish and Latin American cultures, predominantly the Santeria in Cuba in the Middle Ages, these have a concrete historical specificity.[161]

Such a cultural and historical concreteness is in turn echoed in the ways that her work repeatedly negotiates sets of images and a set of materials with different sites. Her own vigilant insistence on concretizing the experience and its representation points to the fact that our responses to specificity require that it be within an acculturated hand's reach: a historical tradition in which we ourselves are positioned, a museum or an accessible or recognizable location. The fact that these works take place in little-known hills and river banks in Mexico or Cuba does not make their location any less

Figure 4.11 Ana Mendieta, *Anima*, 1979.
Courtesy of Galerie Lelong, New York

specific. Nor does their historical moment take the form of a nostalgic hankering for the primeval, the ahistorical and the timeless. The predominance of female figures in the iconography is not to do with an attempt to repopulate the world with a universal female form on which every mythical narrative and allegory can be hung, but rather with that of giving concrete visual forms to lost narratives by 'siting' them.

This supposedly lost, timeless quality has been projected on them by a Western historical narrative that constructs and determines place and designates time and excludes other narratives that cannot be located parallel to itself. I find Mendieta's restless travels, her constant search for sites, her insistence on named geographical locations for her works, to be the most telling part of her historical reterritorialization. Her very playfulness with regard to the transposition of culture in time and place leads to a new understanding of the strategic sense of knowledge and its deployment. Her invocation of myths, religions, symbols and materials seems to me, for all their transience and ephemerality, to stress the strategic and geographical as opposed to the temporal dimensions of human historical narratives. Geographies and their signification thus emerge not as the sites of secure and coherent identities but rather as those of disruptive interventions in the historical narratives of culture.

Figure 4.12 Ana Mendieta, *Silueta Works in Mexico*, 1973–7.
Courtesy of Galerie Lelong, New York

Mendieta's process of reterritorialization, of constructing what Said characterizes as 'a new world to rule', of making a collective gendered history rooted in a particular Latin America tradition and then consciously displaced again and again, is attractive precisely because it points to future possibilities rather than to closure. In 'becoming minor', in exploring that revolutionary potential that the recognition of difference and the negation of boundaries liberates at the heart of the great traditions, Ana Mendieta confers a rich potential reworking on the condition of exile.

The empire of art

My second reading has to with the media sensationalization of the death of Ana Mendieta in New York in 1985. The unclear circumstances of her death – her husband the minimalist sculptor Carl Andre was twice accused and twice acquitted of hurling her to her death from the window of their thirty-fourth floor apartment – and her own position within Third World feminist politics in relation to the New York art world produced an immensity of scandalous gossip. The literature on the subject is immense and spans tabloids, art journals, feminist publications and academic research. It has even produced a 420-page tome of excruciating, laborious detail, five years in the making and luridly entitled *Naked by the Window – The Fatal Marriage of Carl Andre and Ana Mendieta*.[162]

In the weeks following her death, her burial and the trial of Andre the papers were full of descriptions of the pair as 'wild, extravagant drunks'

and as 'virulent left wingers'. He had 'endless affairs with other women'; she 'went into continuous jealous rages and bouts of despair'. Their lives were described as a constant orgy of drink, political activism, artistic creativity, endless rows, extravagant threats and equally extravagant reconciliations, all of which apparently took place in restaurants in the company of large numbers of invited friends. She was described as jealous of his position in the art world; the possibility of her having committed suicide was dismissed in *New York Magazine* with the words that 'She was too pushy, too ambitious to do herself in'. Her memorial service was described as 'A demonstration by two hundred of the art world's dispossessed'; apparently no art-world celebrities turned up since most of them seemed to think that this was a way of protesting the innocence of Carl Andre. One brave journalist said, 'It's really coming down to this class thing and this race thing – He is museum class, she isn't. He is Anglo, she isn't.'[163]

Within this hyped-up atmosphere of gossip and rumor, Mendieta's actual political and artistic activity played virtually no role. Her feminist activism, her co-founding of *Heresies*, her Third World politics, the constant contact with Cuba, her promotion of Cuban artists in the United States, none of these was mentioned.[164] Her work as an artist – earth works and burning banners, flimsy and transient objects located in remote regions, not commodifiable as objects for sale and known primarily through photographic representations – were seen as events taking place far from the New York art world with its narcissistic sense of its own centrality and importance.

All of these certainly constituted an oppositional stance to the rules by which the New York art world existed in the 1980s. To address them, however, would have been the acknowledgment of another, alternative set of possibilities which were being followed by various groups involved with critical, oppositional practices. Instead Mendieta's entire world of art and of politics becomes gendered and racialized through vehement gossip to reestablish the operating rules by which the art world lived and to legitimate her death. 'She was this loony Cuban, so what can you expect?' quotes one of the newspapers.

The complex drama of a Third World woman's life in the heart of the West's art world becomes reduced to a saga of sex and violence. In the above-quoted feature article in *New York Magazine*, the subtitle of the cover page asks: 'Did Carl Andre, the Renowned Minimalist Sculptor, Hurl His Wife, a Fellow Artist, to Her Death?' He has a name and a designated stylistic affiliation while she remains unnamed, without an artistic style, anchored in the art world as 'his wife'. The entire article is illustrated by grave simple images of Andre the man and of his grave simple minimalist work while the numerous pictures of Mendieta show her with wine glasses, bottles of alcohol

and plates piled up with food, or laughing an uproarious, open-mouthed laugh at various companions of the evening. In the same article illustrations of her art work show only those works which she did using her own naked body (rather than her more common use of a loose formal reference to the female figure) and which are directly related to sexual violence. The caption underneath these images reads 'A Death Foretold?' and implies that her death was a result of some form of sexual violence, a claim for which there was absolutely no empirical basis. In all these images Mendieta is essentialized through an association with wild appetites and with unbounded female sexuality. She is racialized and sexualized as the 'other' and the animating force of this narrative of doomed and wild passions.

Here again we can recognize the constitution of a discourse of gossip about artistic dissolution and unruly immigrants as signaling the regrouping of a serious discourse on the subject of art, its demand for an attitude of responsibility, of commitment, of realism.

I want to revisit the site of the Mendieta narrative as told through the New York art-world journalistic gossip with my earlier question; what does it mean to have evidence of someone's sexual activities? of their sexuality? How can one even begin the assumption of that kind of knowledge except through the structures of fantasmatic projection? Therefore I would need to ask: is it possible to have gossip function *simultaneously* as a policing action for the re-instatement of contained and controllable genres *and* as the site for our most cherished fantasies about transgression and unruly excess? We find that lines, borders, boundaries between the ruly and unruly, the permitted and the forbidden, perform as the constant invocation of the law within the supposedly bohemian playing fields of the art world.

Tracing a line in the earth – theorizing borders

How do I bring my narratives together, how do I connect the work with the life, the moralizing fable told by pillars of the art world and the counter-moralizing fable told by the feminist community, and with the constant after-effects they have both continued to have within our world? The model I want to propose draws from both Roman agricultural law and Derrida's reading of the conditions from which any form of order can arise. It has to do with the historical and theoretical implications of 'drawing a line in the earth'. The relations of *jus terrundum* (the law of the land) to *jus scriptum* (the written law) arguing that the marking of a presence in the soil is the making of a law of ownership and territoriality.

Quoting from and adopting Cornelia Vismann's aforementioned article 'Concepts of Order in No Man's Land' I would like to offer an alternative

mode of reterritorialization which might be found in both Mendieta's *Silueta* series and in her numerous untitled works in the earth. Vismann argues that

> The Primordial scene of the Nomos (the Law) is enacted by drawing a line in the soil. This very act initiates a specific concept of law which derives order from notions of space. [It is from this very image] the plough draw lines — furrows in the field — to mark the space of 'the own'.
>
> As such, as ownership, the demarcating plough touches the juridical sphere. The space of what is owned marks either a private or a public sphere of control, either a possession of land or a state-territory.[165]

The primordial act as described here brings together land and law, not in that proto-fascist *Blut und Erde* sense of mythical belonging to the land but as an understanding of modes of writing as the modes by which orders are established and claims are legitimated. In *Of Grammatology* Derrida, speaking of 'writing by an ox' (performing the about-face of an ox alternating from left to right and right to left as it drags the plow through the designated field), says that, before any kind of universal or homogeneous order can emerge, order being the cultural conditions for any practice, 'The whole space is configured around its lodging and the inscription of "the own" body in it'. The order of the body and soil refers to a law before any positive law. The imprints that bodies leave in the soil mark the unique, the authentic according to the discourse that considers agriculture as a physical and even spatial inscription of 'the own'.

The body plays an important role for the legitimation of a *jus terrundum* (as opposed to a *jus scriptum*). The body which marks the soil gives evidence of the human power executed in the land. And that is exactly what functions as legitimation — the evidence of the body in the soil. Therefore Mendieta's markings can be read not as a form of sentimental, universalizing union of nature and culture but as the basis from which an order of knowledge and ownership can arise. Rather than drawing a line, a border (another Nomos, another law) which serves to differentiate between 'us' and 'them', we might have the line in the earth which serves to produce 'the own' and the orders of knowledge and of legitimate ownership which arise from them.

Mendieta, constantly marking the earth with the contours of her own body, seems to have been drawing boundaries, declaring territorialities, establishing distinct regions, and these served to draw attention to the regions at the center, to the 'empire of Art' that refuses its own naming and the recognition of how it polices and guards its own territorial imperatives.

Following the lines of Vismann's argument, I would like to look at Mendieta's body tracings as the primordial scene of the Nomos (the law, of the establishment of any form of order) which is enacted by drawing a line in the soil.[166] It is this very image of marking this the space of place, as the establishment of a structure of order – the line in the earth touches the juridical sphere. The primordial act as described here brings together land and law, body and writing.

'The furrow of agriculture', says Derrida, 'opens nature to culture (cultivation). And one also knows that writing is born with agriculture that happens only with sedentarization.'[167]

The body plays an important role for the legitimation of the law of the land. The body which marks the soil gives evidence of the human power executed in the land. And that is exactly what functions as legitimation – the evidence of the body in the soil.

> The imprints that bodies leave in the soil mark the unique, the authentic, according to the discourse that considers agriculture as a physical and even spatial inscription of the owned in the soil . . . Therefore the spatial, the chthonic, the telluric law, the *jus terrundi*, has its founding scene in the cultivation of the soil. It defends this ground against a law that starts not from scratch but from an already homogenized land [i.e. a land subject to 'geography']. This is the land of geometry, in which the line is the graph of a map, with a universalized scale, with a unified economy – bodies, abstract and arbitrary in its ordering units . . . At war is abstract normativism versus concrete order, arbitrary rules versus self legitimizing lawfulness, universal law versus spatial nomos, empty statehood versus 'Grossraum' (the greater space). Briefly the ground becomes a battleground between a *jus terrundum* versus a *jus scriptum*.[168]

These are not the cranky claims of essential belonging and of experience as the truth of ligitimation but a mode of exploding the legacies of logical positivism by insisting on spatializing all of the components of a reality in relation to each other.

One of the only ways in which it has been possible for me to bring together my various readings of the Mendieta narratives has been to think spatially and try and understand Mendieta not as producer of borders, or as the artist who had been set outside of the border, but as the actual border itself, demarcating and embodying the actual lines of difference. In the back of my mind I am convinced that the work and narrativized life of Ana Mendieta have somehow given form to that old Kantian claim that there is

no limit beyond which there is an outside. This is an odd responsibility to lay at the feet of a woman artist so often described as a quintessential 'outsider' – ethnically, culturally, artistically. Nevertheless, the spatialization of her life's narratives, the chronicling of contemporary and posthumous effects to make sure she has no place within 'the empire of art', her insistent work at making visible those boundries and borders so often denied in the sophisticated rhetoric of the art world, result not just in exposing but actually undoing the overdetermined divisions between inside and outside. A line of division had become a threshold.

Border – armored void

Perhaps the greatest insight for me of the various Mendieta narratives I have tried to bring together is that this concept of a boundary, such as that embodied by Mendieta in my reading, begins to produce understandings for us of entities whose divisions we may not have been equally aware of previously. Once we establish something as a border, it follows that we have to identify the entities on both sides and the relations between them.

Michal Rovner's film *Border* (1997) is ostensibly a fictional film about the border between Israel and southern Lebanon. A fiction, it is composed of documentary footage shot by Rovner, a New York-based Israeli artist, interviews and scenes in which she also participates, and its estrangement from reality is produced primarily in the editing, in the juxtaposition of shots and scenes whose lack of sequentiality makes one wonder about their factual truth. In actual fact the entire film is the attempt to produce a border, not necessarily from the scenes and fences and barbed wire and the technologies of surveillance, but out of questions and anxieties and incredulities and the sense of unreality that permeates such zones of disidentification. This of course is an actual border, it is the boundary line of two states, it has a concrete location and a set of geographic attributes. In reality this is, however, a far more complex and nebulous entity, traversed on both sides, a constant leakage of hostile bodies, never able to sustain the separations and protect the inhabitants in the way that its huge military mobilization set out to do.

This border is a particularly vexed one – it is the grating reminder of an occupation which does not call itself by that name, of an Israeli involvement in a civil war that virtually destroyed a once prosperous and sophisticated country, of alliances held in Lebanon and atrocities committed for which not even the most slippery politicians can produce rational legitimating narratives. Once called the 'Good Fence' it is now a border of shame, a daily reminder of the endless misery visited on all by the ongoing

conflict and of the inability or unwillingness to find a solution despite the remarkably high human casualties that this specific site of the conflict has cost. As a specific location it is constantly in the news, every inhabitant of the region can point to it on a map and every owner of a television set can describe the topography and landscape of its vicinity. Therefore it is particularly interesting to find this film struggling with the effort to bring the border into being, into vision, into straightforward acknowledgment – and that of course is one of the work's most interesting aspects.

I want to follow two paths through the film which are of consequence to the project of 'border construction' or 'border willing' Rovner has taken on herself. One path is somewhat formal and has to do with the conjunction of horizontal lines disappearing into the horizon, constantly traversed by the habitual stuff of spatial enclosure and the immense tension set up between these. The other has to do with a particular language of the border that Rovner has managed either to locate or to encourage to be spoken, in which it becomes the normally inadmissible boundary of fear.

Much of the film provides a taxonomy of the border, which is in fact quite a necessity for it allows the recognition that this is not an ephemeral entity which might disappear overnight, but actually one of vast investment. The long line of the film is echoed by long, empty eerie roads that disappear into the horizon, crossing the border from the Israel side and northwards into Lebanon. On occasion a figure runs down one of these roads or the film's two main protagonists walk up the road to a point permitted. For such a very small area the film produces an immensity of distance which stands in for the incomprehensible and the unimaginable. The various figures interviewed throughout the film treat the entire site as a mystery. 'Who knows what is going on there' they keep telling the artist. Since they clearly know every inch of the terrain, this puzzlement and professed ignorance has to do with its political and human rather than its territorial status. A border that defies and denies the possibility of being understood – a form of willful puzzlement that has accompanied the war in Yugoslavia throughout the 1990s in which much of the commentary has been of similar nature constantly declaring its puzzlement and incomprehension. Echoing the eerie lines of roads that disappear into the 'unknown' horizon (Figures 4.13–4.16) is the actual paraphernalia of the border as a combat zone; convoys, military vehicles, helicopters, tanks, guns, bunkers, searchlights, gun stations. Cutting across the movement forward are the blocking actions of fences, gates, barbed wire rolls, watchtowers, electronic barriers etc. Every time the filmmaker tries to persuade the border commander who is hosting her in the area to take her or allow her to go into Lebanon, he repeats to her the same sentence: 'Lebanon is out of the question.' The refrain comes to have various meanings in its context – partly that it is not permitted to her,

Figure 4.13 Michal Rovner, still from *Border*, 1997. Courtesy of the artist

Figure 4.14 Michal Rovner, still from *Border*, 1997. Courtesy of the artist

partly that it cannot be conceived of, understood, conceptualized or repre-
sented – that same willful puzzlement that allows us to not deal with issues
because their complexity puzzles and escapes our comprehension. In one of
their many intriguing conversations, the commander tells Rovner, 'I can't
explain to you because you, from the perspective of such a different world,
couldn't possibly understand.' Presumably this goes beyond the assumed
difference between the perception of the glamorous New York art world's
distance from the horrific realities of life on this border. It seems that the

Figure 4.15 Michal Rovner, still from *Border*, 1997. Courtesy of the artist

entire film is the attempt to come to terms with this assumed 'incomprehensibility'.

In Elia Suleiman's remarkable film *Chronicle of a Disappearance* of 1996, the story of his return from New York to Palestine in the wake of the promise of peace and his endless, patient waiting for that peace that seems delayed somewhere, we encounter a pair of intellectuals sitting in the courtyard of East Jerusalem's fabled American Colony Hotel. In as far as we can tell they are a pair of journalists or perhaps commentators on the region, one seems to be French while the other is another variant of indeterminable 'European'. They are engaged in deep and animated conversation which revolves around lecturing each other about the impossibility of in any way whatsoever comprehending the Middle East conflict – it is, they say, 'incomprehensible' and that is that. Suleiman's film is extremely ironic but it establishes a set of connections, in turn given great aesthetic form in Rovner's film, between ambiguity, incomprehensibility and inaction – the paralysis of waiting and watching.

Parallel to the straight lines of roads that go into the heart of the forbidden territory of Lebanon and the endless blockades and barriers which impede them, there is also the presence of distractions at the side of the

Figure 4.16 Michal Rovner, still from *Border*, 1997. Courtesy of the artist

main stage: a mysterious white car with Lebanese license plates cruises along the perimeter lines of the border, a group of men sit on a terrace on the Lebanese side engaged in some animated conversation, baiting and flirting with the soldiers and the film-maker who are watching them through binoculars. At the sides of the empty roads fires flicker and unknown things smoulder – had something exploded, are these debris of violence or of impromptu barbecues? Somehow all of these signs of everyday life are subordinate to the overriding military logic of the border with its soldiers, convoys, commands and straight lines. They are the civilian population of the area and Rovner very eloquently shows the degree to which they are seen as an irritant and a menacing distraction within the overall stratagem of the site.

The other main theme of the film is its very interesting gender politics. Superficially there is a certain play between the figure of the film-maker played by Rovner and that of the commander of the border area identified as Colonel G. – a kind of flirtatious dialog in which he inhabits the traditional role of the wise, world-weary figure rebuffing her attempts to push her way into his restricted and highly patriarchal world of the military. Colonel G. is a familiar figure within the annals of Israeli culture, which is as expected saturated with military mythology; he is what is often termed a 'poet-warrior' or a 'philosopher-soldier'. This is a figure meant to connote the deep humanity at the heart of the military, of professional soldiers who are also scholars and intellectuals, of an assumed ambivalence at the heart

of a militaristic culture which is not resolved but lived out in extremes which supposedly balance each other out. And so our highly poetic border commander patronizes and teases the film-maker in great long monologues in which he tells her just how clueless she is in the face of 'reality'. She, he says, is interested in 'art' and in capturing images of storks and other birds flying overhead in sweeping formations. She is 'culture' and 'nature' but not 'reality'. Her supposed innocence of 'reality' leads the colonel to say at one point, 'I am embarrassed to carry weapons around you' – which, given the plethora of military hardware everywhere around them, is yet again testimony to this extraordinary ability to separate private feeling and public functions – like the border itself we find here the formation of the split military subject.

In actual fact, Rovner as the film-maker has no great long dialogs. Instead she asks endless questions, repeating herself again and again until her relentless questions chip away at the seamless military integrity of the border. Her most often asked questions have to do with trying to determine from the various soldiers, and from the few civilians she encounters, whether they feel the area and situation are dangerous. Through all these questions and her very plain, matter-of-fact mode of posing them – nosy, impersonal, slightly curious – she elicits the most amazing chronicle of fear I have ever encountered within this domain.

She persistently questions the soldiers about the degree of danger, the exact topographical location of where it starts to become dangerous, the specifics of where it might come from, of their entertaining the possibility of their own death, of taking someone else's life. She asks whether they have killed anyone, how long they have been there and how long their tour of duty might go on for. In response they articulate a great stream of inadmissible fear, of the immense ambivalence of being there in the first place. 'Even one day in Lebanon', says one of the military drivers, 'is one day too long.' Even the heroic Colonel says at one point while driving by a formation of boulders at the side of the road that each time he drives by them he expects an explosion from behind one of them. The more they provide information the more it is effaced, denied, made irrelevant: the droning noises in the background, the trucks, tanks, helicopters and sirens, infiltrate the scene and emphasize the constant torturous presence of the anxiety.

There are no other female figures in the film beside the figure of the film-maker, apart from the shadowy figure of a Lebanese woman around the white car cruising the perimeter line, which comes to some violent end at the end of the film, with a noisy and shocking explosion whose meaning is not quite clear. The female protagonist and the border share certain attributes – zones of disidentification in which ambivalences and uncertainties are lived out in ways which can't quite be grasped, they both serve as vehicles

for making clear and visible what is masked by the busy theatrically of that reality. Slowly the void at the center of the border – heavily fortified, mobilized by the discourses of the state and the military, by endless political crises, by an exceptionally bitter reconciliation – becomes glaringly obvious through all of the military and political and geographic performances that sustain it. From an exceptionally concrete example of Deleuze's 'line of segmentation' a ghostly narrative of fear has been picked out from between the fortifications. The border is poised internally between a set of expectations, of good intentions, of bad intentions and false consciousness – 'we have no choice, we have to attack them' all underwritten by its contradictory spatial inhabitations.

Bodies

Reading the body as geographical ambivalence

CAN WE READ BODIES as 'geographically' marked? How does the representation of the body become the site of conflicting projected identities?

Commonly a marking of the body for the signification of identity would take the form of attributes such as clothes or tools or ethnographically marked objects. In the West, certain socialist, communist and fascist regimes in the twentieth century marked bodies on display by their physique and gestural code, through fantasmatic racial stereotypes, by class or occupation. These were bodies in the representational service of overt and publicly proclaimed ideological programs. Within these projects femininity has always been staged as the ideological counterpart of masculinity, either as the biologically determined extreme opposite (as within the public iconography of German fascism[169]) or as the egalitarian counterpart within a social project of labor (as in the heroic working bodies of Soviet communism[170]). In each of these representational strategies there is a clear mobilization of gender and of sexuality for the purposes of establishing a new visual language – anchored at the level of the body – for the dominant ideology. In each of these iconographical, visual strategies there is also a clear relation to the land. In the first it is a mystical relation of naturalized and exclusive belonging, while in the second it is a relation of labor, of gaining a right to the land through its cultivation, through its collectively productive use. While the female bodies in these representational tropes may be written in ideological compliance with these

dominant totalitarian regimes which produce them as reductive, performative counterparts to the male bodies who are the true disseminators of ideology in the public sphere, they are rarely read so. In Germany, where the legacy of such iconographic practices has weighed very heavily and has thus been subjected to readings through extremely sophisticated and critical theoretical models of analysis, we find an entire generation of film-makers, film theorists, artists and art historians who throughout the 1970s and 1980s engaged with the problematics of sexualized bodies in the service of state ideological imperatives. But the bodies in the films of Rainer Maria Fassbinder and of Werner Schroeter, in the analyses of Gertrude Koch and Thomas Elsaesser[171] or in the historicizations of Silke Wenk or George Mosse, are the highly extravagant bodies of a gendering and sexualization pushed to the limits of representational realism. Certainly more recent analyses have been far more preoccupied with our fascination with these bodies of extremism than with undoing any vestiges of claim they might still have to reflecting anything but the most inflated political rhetorics. These are the bodies of a traditional geography, one in which a unity between places and subjects has fused to the point that we can have ideologically marked bodies that signify the specificity of a people, or of a race's relation to a place. What happens, however, in the far less extravagant recesses in which gendered and sexualized bodies write historical or geographical narratives? How does one begin to read geographically ambivalent, rather than geographically emphatic, bodies?

As I set out to think about ambivalences of belonging at the level of the body, I have two examples in mind. The first is a remarkable exhibition I saw in Berlin in 1986 entitled *Perlonzeit – How Women Lived out their Economic Miracle*.[172] It was probably intended as a culturally materialist analysis of the oppression of women in the postwar era of prosperity and the re-domestication of women's lives which took place throughout the West but was more obvious in the context of German postwar devastation. But somehow the exhibition transcended its original intention. At the entrance were two large blown-up images which set out the perimeters of the moment of 1945, the last moment of the war. One was of a group of naked women, concentration camp inmates, huddled together, being shot into a mass grave. The second image was of some high-up Nazi ladies at an official gala evening, regally decked out in gowns and tiaras and medals and carrying great bouquets of roses. Two images of femininity poised at an abyss, a bottom line of defeat and annihilation, signified at the level of the body, the female body.

Everything that followed at that exhibition, all the images of happy housewives celebrating domestic technologies and of a hysterically domesticated and normativized female sexuality in the films of the 1950s, took

their cue from those two haunting images at the entrance. They seemed to do nothing more than to live them down, to produce an endless froth of normative trivia that would somehow lull the spirit into forgetting. The exhibition did, however, set up one of those moments in which it became apparent that one could arrive at an alternative critical discourse that was not being produced elsewhere, through a shift in the subject of the discourse itself, through a critical reading of the representations of women's bodies. It seemed increasingly possible that, at times of searching for a point of entry into either a triumphant or a self-flagellating historical narrative, it is often possible to re-write them by rewriting the history through a critical analysis of the representations of women's bodies in the service of specific ideologies and cultural strategies.[173]

My other example is the work of philosopher Elizabeth Grosz, who in her recent book *Volatile Bodies* has attempted to do precisely this: she rethinks an entire Western philosophical tradition through the female body, through that discourse's ability or inability or unwillingness to conceptualize corpo-reality, sexuality through structures of sexual difference. The argument Grosz leads us through is a negation of 'a dualism that postulates a rift between the mind and the body or the physical and the mental in the consti-tution of subjectivity'.[174] One of the theses within this complexly argued philosophical analysis is that philosophical discourse negates the body as the subordinated term 'which is merely the negation or the denial of the primary term (mind), its fall from grace; the primary term defines itself by expelling its other and in this process establishes its own boundaries and borders'.[175] Once we have recognized the validity of this argument against the privi-leging mind/body splits, it becomes necessary to mark the geographical metaphors that it employs. Clearly here is another strand in which an argument preoccupied with the constitution of a particular discourse depen-dent on its recognition or its exclusion of the subject at the level of the body, comes to constitute the discourse in and of itself. Clearly this line of argumentation linked with my own preoccupations in attempting to over-turn dominant historical narratives by subjecting them to a feminist theorization concerning sexual difference as an organizing principle, rather than subjecting them to feminist criticism concerning the absence of women within them. Thus if historical ambivalence could make itself manifest, if totalizing historical narratives could be punctured or fragmented by viewing the period and the problematic through a feminist inversion, perhaps a signi-fication of geographical ambivalence could be arrived at through similar means.

While this is seemingly a potentially exciting prospect to contemplate, I have nevertheless had some concerns about how to construct the analysis theoretically. What precisely is geographical ambivalence and how would

one go about establishing its languages of articulation? Obviously, it means more than the signification of certain reluctances to fully or singularly inhabit a named geographical terrain. Equally obviously, geographical ambivalence extends beyond the limitation of geographically named identity constitution; being a citizen of this or a native of that. The ambivalence I had in mind would attempt to think of how representations of the body which take on structures of difference in general, and of sexual difference in particular, might make manifest through the body an ambivalence that had no other form of articulation through official discourses and languages of signification.

Thus these bodies might be operating quite differently if read through official ideology and through the contexts of their own subjectivity. The need to be familiar both with such official ideological claims and with the unclaimed subjectivities at their margins has necessitated the decision to stick with a problematic that I know very well, that I know at the level of the body as it were. I have devoted this entire section to an analysis of European Israeli feminine identity constituted under the aegis of dominant Zionist ideology and signified via representations of the female body. This very familiar body seemed to me to be the site of numerous conflicts of the constitution of identity in relation to place. Such conflicts arise out of the body's ideological mobilizations in the service of a set of largely utopian and unreal political ideals and out of its use in the constitution of images of essentialized 'others'. But most interesting to me was that, in begining to think about these politically exploited images of female bodies, it became possible to see them as the potential site for certain resistances to that same ideological imposition or imperative. It became increasingly clear to me that the bodies on display were actually haunted by forbidden dreams of 'Europe', of a certain cultured, glamorous and largely fantasmatic femininity which could serve as a seemingly innocent lens through which to look backwards at the cultures from which some of the state's citizens (the culturally and politically dominant part) had been driven out. Female bodies as sites of geographical ambivalence and of hidden longings for a 'Westernness' seemed to provide a possibility for critically thinking through the official narratives of the state and of its production of vehement discourses of cultural belonging.

The production of 'belonging'

The Modern Myth of the Jew as pariah, outsider and wanderer has, ironically enough, been translated into the post modern myth of the Jew as 'other', an other that collapses into the equation:

writing = Jew = Book. Such an exclusive address ultimately obscures the necessity of mapping out a space in which the Jew *was* native, not a stranger but an absolute inhabitant of time and place.[176]

Alcalay's 'Jew as Pariah' transformed into the 'Jew as Book' is writ masculine, a metaphor extracted from material culture and conceived of in terms of the universalizing and homogenizing stereotypes of abstracted scholarship; out of time and out of place. The discussion I wish to pursue, that of European–Israeli feminine identity and its visual representations, is situated at the intersection of the two states described by Alcalay, those of belonging and of displacement and of their inevitable and mutual interdependence. It is an intersection in which the desire for an emplaced belonging, enacted by European Jews in Palestine and refracted through the edicts of Zionism, produced an internally contradictory range of vehement, performative and highly gendered identities. These produced identities would consequently serve an ideological purpose: they would make possible laying claims to land and writing histories for those claims. Within visual culture many of them are writ feminine and distinctly European, their tasks however defying the conventional codes of traditional feminine activity: women laundering and breaking stones for road paving, women posturing as soldiers and modeling swimwear, women making contemporary art from the gendered scraps of forbidden nostalgias. The images of European women are equally conscripted into the fervor to produce and represent that elusive concept of belonging, mapped on to modern, European bodies. At the same time they also act out a certain diasporic dissonance, a diasporic desire for a much-hankered-after yet unachievable state of belonging that is written in their bodies and gestures, in the veiling and performing of their sexuality, in their physically embodied challenge to the indigenous bodies around them. The extreme contrast between the representation of active, productive, machine-like European feminine bodies and the representation of passive, silent, immobile 'oriental' feminine bodies within the visual culture of Zionism attests to this production of 'belonging'.

Supposedly these very Western images exist within the framework of a nationalist rhetoric in which they are nothing more than the feminine counterpart to the radical socialist project of Zionism. By this I mean that they are the assumed representations of actual social, material and cultural conditions and actions in which these women's bodies participated as part of the collective heroics of early Zionist activity in Palestine. It remains to be seen whether the conjunction of feminist theory, post-colonial analysis and the study of visual culture can serve to puncture the surface of such totalizing nationalist rhetorics and nationalist imagery in order to reveal their funda-

mental incoherences. While feminist theory insists on the importance of situated knowledge, the study of visual culture insists that images are the sites of identity-constitution rather than a reflection of the cultural and material conditions of their making. Furthermore the emergent arena of visual culture analysis recognizes the importance of the bearer of the gaze and the range of subjectivities through which specifically thematized gazes and their cultural imaginaries reconstitute meanings. Thus the combined insights of both of these theoretical models of cultural analysis might work to reconfigure the purposes to which these wishfully charged images of women in Zionism were put, isolating their protagonists from any organic and naturalized relation to the land so as to be able to lay a claim to that very land.

That so much of Zionist Israeli culture should have paid so little attention to the cultures of Arab Jews, whose histories of regional belonging have been so ancient and so complex that these have not provided a model for the newly re-written relation between a people and a place, attests to the resolutely European nature of this model of a diasporic homecoming of the imagination. An analysis which genders every component of this process, from the ideological inscriptions of images to the gestural codes of performative bodies, might go some modest way towards dismantling the homogenizing aspects inherent in any modernist, totalizing, European ideology such as Zionism.

As a native Israeli I was taught to understand Judaism through the state of Israel, a moment of national coalescing which somehow also served as a rupture, or perhaps an assumed healing, within the paradigm of Judaism as pariahdom throughout the ages. Now I have begun to wonder about an inverse model, about the possibilities of reading Israel through the divergent histories of numerous Jewish communities outside of the state – perhaps the possibility of reading the state as a national discourse which mobilizes the desire to belong through a new definition, an outsider's definition of what and how it means to belong. In adolescence, every story I heard, every picture I saw, every song I sang served that capacity of constructing a culture of belonging in which we were both actors and audience, simultaneously producing that belonging and culturally surveying it, being seduced by it. In a history so overdetermined by one overriding anxiety and one overriding concern, it is obvious that a totalizing set of ideological imperatives would sweep aside any consideration of what we today might term 'difference' or of differentiated experiences. In fact much of the purpose of producing a culture of belonging was to eradicate the concept of 'difference' which had served to create the racial differentiation that marked European Jews as those outside the culture in their host countries, those who do not 'belong'. How would such a notion of difference, of feminine

or sexual difference in particular, affect the scenarios of belonging which were being woven in the culture I was raised in? It seems increasingly clear to me that one cannot have a culture of belonging without maintaining a consciousness of 'not belonging' against which it exists in a permanent state of defiance and self-definition. On the one hand there was the historical model of the 'unbelonging' of Jews in the so-called diaspora, and on the other the construction of a whole new category of 'unbelonging' under the aegis of Zionism such as that of Arab Jews and Palestinians. If this grounding binarism is indeed characteristic of the culture I am trying to engage with then it is imbued with a necessary nostalgia and desire for the 'old world' that are essential to its project but cannot be consciously acknowledged, for they are the very heart of what the new state has set itself to replace. So many of the avenues one would ordinarily pursue within a less forbidden and a less overdetermined terrain have been closed to me through moralizing historical discourses that a direct critique of Zionism via the terms it has set up and the paradigms it has determined are impossible: they would only sustain a true/false, right/wrong dichotomy. This is the reason I have ventured to examine the contradictory and conflicting desires of Zionist ideology through the representations of women within it.

Unacknowledged and unspoken ideological contradictions have always informed the ways in which cultures set up and represent femininity as a meeting point between rational and irrational discourses. Perhaps if I could gain insight into how the culture of belonging shaped the represented identities of women within it, I might also gain some perception of its own internal contradictions. Therefore what I am trying to do in this section, about European, privileged Israeli feminine identity and its relation to the diaspora it left behind, is not to define it in any way but to put together some of these elements of disruption, dislocation and narration and to see how they work one upon the other.

While it is both ideologically imperative and politically urgent to address the complexities of other, marginalized, non-European feminine identities within modern Israeli culture such as those of Arab Jewish women or Palestinian women, this does not absolve us of the responsibility of examining the actual identity formation of privileged positions. It is these Eurocentric cultural subject positions which have continued to dominate the popular imagination with regard to definitions of national identity and to determine all forms of otherness as inferior to themselves. Since the European Israeli identity does not question its own values or regard itself as anything but normative and universal, there has been little opportunity to acknowledge its own profound internal contradictions or to problematize its extremely uneasy relation to the European cultures upon which it builds and draws for its own overall hybrid identity. By using categories of

gender and Eurocentricity to read across fortified and barricaded narratives of nation, we may be able to illuminate some of the inherent contradictions which have worked to mold dominant Israeli culture in relation to the European cultures which had rejected its own founding fathers.

The critical models which have helped me think through some of these issues have emanated primarily from the work termed critical analyses of colonialism and minority discourse. These have posited complex and elaborate analyses both of the cultural systems constructed by Old World colonialism and of conditions of cultural and racial marginality and hybridity within the contemporary post-colonial world. At the heart of all of these discussions there are trajectories of cultural power relations between colonizers and colonized or between dominant hegemonic culture and emergent minority identities. The subject position I am attempting to deconstruct in this discussion, however, cannot be fully or exclusively accommodated within this theoretical framework. While European, middle-class Israeli identity is undoubtedly a colonizing presence within the regional political map as well as within the internal ethnic map of the state, the feminine subject positions within it are simultaneously colonized and marginalized in relation to both dominant ideology and the ensuing internal contradictions of its own gender-specific identity. The attempt to understand and locate such split subject positions – historically oppressed, inhabiting a performative ideological stance and functioning regionally as a local colonial power – has resulted in this instance in a somewhat fragmented and inconsistent form of theoretical bricolage. I have, in recent years, encountered far too many analyses in which the female component of colonial or colonizing powers was assumed to be cognate with and acting out of identical imperatives as its male counterparts albeit through a different set of social institutions such as the domestic rather than the public sphere. Thus the ensuing fragmented account is offered in the feminist hope that it may ultimately be helpful in articulating an emergent set of contradictions which have been so firmly glossed underneath the rhetoric of Western, progressive ideology.

How then can one attempt to understand the inherent tensions within this Israeli feminine identity as well as to disavow the authenticity and coherence which it has tended to claim for itself? Part of my intention in so doing is to suggest possibilities for a greater plurality of coexistent, fragmented voices and identities within the geographical region of Israel/Palestine – identities which do not necessarily have to claim for themselves a fully representative coherence or authenticity and therefore do not have to masquerade as the sole legitimate representation of an indigenous population. If the conflicts and struggles between Israelis and Palestinians are to be understood as more than territorial but as a struggle over the possession of an authentic and locally rooted identity, then a major part of our attempt to address and

understand these struggles critically must be invested in the claims which we make for our own identity. For, as Adorno said, 'It is part of morality not to be at home in one's home'[177] and it is in the name of (re)possessing this mythical home/land that much of the vehemently insistent nature of constructed Israeli identities has been mobilized.

It is equally important, to my mind, to address these issues within the arenas of culture, of a

> struggle [which] is an essential counterpart to political and economic struggle. Since cultural hegemony continues to play an invaluable role in the production of subjects who are compliant toward the economic and political domination of internal as well as external colonialism, and since it legitimates the acceptance of one mode of life and the exclusion – or extermination – of others, the function of cultural criticism and struggle is to contest continually the binary oppositions on which such legitimation is founded.[178]

For it is within the arena of radical culture, unlike those of party political rhetoric, that fragmentation of voices can occur, that modes of representation can be seen to engage in legitimate contestation with one another and that formal and stylistic disjunctures and experiments can be attempted, to capture, to some extent, our 'newly arrived at consciousness' of our incoherent selves. For in the words of Arif Dirlik,

> An authentically radical conception of culture is not only a way of seeing the world but also a way of making and changing it . . . Culture is not a thing, to paraphrase E. P. Thompson, but a relationship. It is not merely an autonomous principle that is expressive of the totality constituted by these relationships, a totality that once it has been constituted, appears as a seamless web of which culture is the architectonic principle, exterior to the socio-political and logically prior to them . . . Culture is an activity in which the social relations that are possible but absent, because they have been displaced or rendered impossible (or utopian) by existing social relations, are as fundamental as the relations whose existence it affirms.[179]

In attempting to introduce a dimension of sexual difference into the 'possible but absent' social relations of Israeli identity, we may simultaneously be able to extend the axis and historical dynamics of internal fragmentation as well as work towards a re-radicalization of culture.

Narratives

A couple of years ago a friend and I were sitting astride the fortified outer walls of the ancient Crusader city of Acre on the northern Mediterranean coast of modern Israel. We were, as is our wont, ignoring the multicultural profusion around us; the Israelis and the Palestinians, the earnest pink-nosed English tourists with their Baedekers and the elegant, laconic French ones lolling about drinking local wine, for we were immune to such panoramas of difference; we had both been born into the newly founded state of Israel, into a babble of immigrant cultures and tongues soon to become that most excruciating of cultural experiences, 'the 'melting pot'. Instead, as we dangled our feet toward the warm Mediterranean, we spoke of that most fascinating of all subjects: ourselves. 'Our tragedy', proclaimed my friend, 'is that we believe we are the real Europeans, that those people out there in France, Germany, Spain are simply fraudulent parvenus who have usurped our rightful cultural place'. 'Look at you', he continued, pointing an ironic crooked finger, 'Ninth generation in Palestine, first generation of an independent Jewish state, the fulfilment of so many generations' dreams and hopes and you spend your entire adult life immersed in the two cultures which have most oppressed your people in this century.' He was referring to the fact that I did all my studies and lived for many years in Britain and that I work, when I can persuade myself to be geographically and historically specific, on modern German culture. Look indeed, but do not speak, for ours is the shared experience of a childhood in the shadow of the recent European holocaust of which no one could speak, an omnipresent legitimating narrative for every form of aggression and discrimination perpetuated by the state and the culture, which could not, would not be acknowledged in language.

At the time this conversation was taking place I was reading a novel by Israeli author David Grossmann. The novel, which is called *See Under: Love*, defies any attempt at formal categorization or description: suffice it to say that it is a series of narrative voices, Israeli and European, past and present, which attempt to construct a language of the Holocaust; lived, experienced, received, misunderstood, mythologized and abused. At the novel's center is a nine-year-old boy named Momik growing up in Israel in the 1950s, the only child of two haunted survivors and living in the midst of other survivors whose utter disorientation is reflected in the confused babble of old and new tongues in which they communicate with the world, as if fearfully uncertain of who will be tuning in or of what they can speak clearly and what must remain coded and veiled. A secret society of mutes at the heart of the declamatory and abrasively proud new nation.

The following is a scene from Momik's childhood section of the novel:

Bella sits at one of the empty tables of her grocery/café all day long reading *Women's Own* and *Evening News*, smoking one cigarette after another. Bella isn't afraid of anything, and she always says exactly what she thinks, which is why, when the city inspectors came to throw Max and Moritz out of the storeroom, she gave them such a piece of her mind that they had a (bad) conscience for the rest of their lives, and she wasn't even afraid of Ben-Gurion and called him 'the little dictator from Plonsk', but she didn't always talk that way, because don't forget that like all the grown-ups that Momik knew Bella came from *Over There*, a place you weren't supposed to talk about too much, only think about in your heart and sigh with a long-drawn-out krechtz, the way they always do, but Bella is different somehow and Momik heard some really important things from her about it, and even though she wasn't supposed to reveal any secrets, she did drop hints about her parents home *Over There*, and it was from her that Momik first heard about the Nazi Beast. The truth is that in the beginning Momik thought Bella meant some imaginary monster or a huge dinosaur that once lived in the world which everyone was afraid of now. But he didn't dare ask anyone who or what. And then when the new grandfather showed up and Momik's mama and papa screamed and suffered in the night worse than ever, and things were getting impossible, Momik decided to ask Bella again, and Bella snapped back that there were some things a nine-year-old boy doesn't have to know yet, and she undid his collar button with a frown saying it choked her just to see him buttoned up like that, but Momik decided to persist this time and asked her straight out what kind of animal is the Nazi Beast, and Bella took a long puff of her cigarette and stubbed it out and sighed and looked at him and screwed her mouth up and didn't want to say, but she let it slip that the Nazi Beast could come out of any kind of animal if it got the right care and nourishment, and then she quickly took another cigarette, and her fingers shook a little and Momik saw he wasn't going to get any more out of her.[180]

The conjunction of these two narratives generated for me a series of speculations concerning diaspora and diasporic culture. Traditionally in our Israeli context the diaspora referred to the various scattered communities of Jews who had been exiled by the Roman conquerors of the land of Israel in the first century AD and had scattered throughout the world. In attempting to reconstruct that land in the twentieth century, we, the second generation

as it were, seem to have reversed that relationship and become in turn a diaspora of the host cultures into which our ancestors had been exiled and from which they had been banished. Ours then was a complex culture founded in nostalgias for imaginary, mythical locations in which we could function as oppositional marginals to the dominant order, as a constant disruptive 'other' against which the center could define itself. A new cultural construct had begun to emerge amongst us which viewed itself as the 'diaspora's diaspora'. This collapse of a clear historical order of center/diaspora relations led, in my mind at least, to the need to re-evaluate the relations between history and geography, between collective cultural narratives of 'Over Here' and the signification of that which is 'Over There'. Momik the self-styled spy and investigator eavesdrops whenever he can:

> Momik is so excited he forgets to shut his mouth! Because they are talking freely about *Over There*! It's almost dangerous the way they let themselves talk about it. But he has to make the most of this opportunity and remember everything, everything and then run home and write it down in his notebook and draw pictures because some things it is better to draw. So when they talk certain places *Over There* for instance, he can sketch them in this secret atlas he is preparing.

Analyses

I am attempting to construct an argument concerning geography and identity which revolves around questions of displacement viewed by a former member of the Israeli intelligentsia who has herself undergone several displacements backwards to the cultures which were previously considered to be 'diasporas'. The argument I am trying to present here concerns a contemporary siting which I would call the 'diaspora's diaspora' and negates the very basic historical assumptions that an old people could conceivably have a genuine 'new beginning'. It seems to me that there are several dynamics between 'home' and exile in existence within the problematic interaction of collective cultural and gendered identities as set up within the modern Jewish state.[181] The dominant narrative of 'return home' is problematic not only for the legitimation it provides for territorial claims but also for the seamless naturalization of the concept of 'home' which it puts forth as a cultural metanarrative.

Instead, I wanted to use the rather interesting conjunction of Judaism, femininity and modernity as an opportunity to speculate on the contemporary revisions and the internal contradictions of these supposedly progressive,

egalitarian and ungendered intersections. As in all so-called 'radical' societies, in the case of Israel too there was an imperative master narrative of struggle under which all other categories of potential difference and conflict were subsumed and trivialized. In the case of the modern Jewish state the dominant ideology of socialist Zionism was assumed to speak for two categories of oppression: for the Jews as an oppressed minority as well as for their transformation from marginal, reviled serfs into a revolutionary working class linked to an international struggle. In effect this was a transition from margins to center, countering traditional European anti-semitism with its exclusions and persecutions of Jews with a participatory political project which aligned the Jews with other oppressed elements in society within the context of an international movement that transcended national or regional belonging and authenticity.

That these were to be transposed into the Eastern Mediterranean, into a land already inhabited by a people with an equal set of claims to it, into a cultural location which could not be more different from the underground radical socialist movements of Central and Eastern Europe at the turn of the century, did not seem to overly worry the movement's ideologues. The supposedly seamlessly progressive identity of this society is constituted out of a discourse which is white, Eurocentric, bourgeois and masculine and assumes itself to be the norm and the measure of what it is to be Israeli, while masking a huge array of differences in internal and external injustices and discriminations against oriental Jews, local Arabs, Palestinians, not to mention those against women. Given the prominence of Israeli and related affairs within the international media, there is no need to go into a detailed critical analysis of this supposed identity, for its internal incoherence is in fact constantly being exposed through a variety of much-reported policies and the fierce debates which these generate both nationally and internationally.

For all of this criticism I am nevertheless a product of all of these uneasy corollaries and find it necessary to try to unravel them in some potentially interesting and questioning mode. This, then, is a position of cultural hybridity which produces the need to problematize the seamless rhetoric of constructed national identity through the transnational critical tools evolved within my own generation's movements of resistance to hegemonic culture and the categories through which it establishes itself as normative and indexical. Thus an examination of specific feminine identities within the modern Jewish state can actually provide some useful insights into the overall patterns of internal conflict and contradiction to which any form of Israeli identity would by necessity be subject. To begin with feminine identity is positioned as filial, 'the daughters of Zion' being a local variant of traditional Jewish femininity, which holds a secondary position within the traditional religious culture as well as being linked to the actual land in some filial and organic

manner. But the subservient and secondary nature of this feminine subject position is further exacerbated by the passive shouldering of the burden of history.

In a poem entitled 'No License to Die', Esther Fuchs, a young feminist poet and daughter of Holocaust survivors, tells of her abortive attempt at suicide:

> Their faces as I was led away
> on the stretcher
>
> No *Gestapo*, no *Kapo* is upon
> you are after all newly invented
> A Bride of Sunshine
> How dare you?
>
> The forgiveness I beg –
> They were in crematoria smoke
> I have no license to die.[182]

Esther Fuchs's poem speaks of the despair of attempting to actually possess an identity of one's own in a society in which collective trauma has served to simultaneously infantalize and bind one to duty, to make one responsible for the existence of a supposedly better world in which such a genocide could never occur. Within this trajectory the concerns of women born long after the war had ended and the state of Israel had been founded could not be viewed as anything but self-indulgent desires aimed at a form of bourgeois, individual gratification. In my youth the culture abounded in sentences such as, 'You do not know the meaning of horror, of hard work, of suffering, of sacrifice, of loss, of victimization etc. etc.' We were meant to be 'newly born' but at the same time we were supposed to provide a daily, conscious and not least a grateful reminder to the negation of the old world. Women, whose experiences, needs and desires had been completely subsumed under the rhetorical mantle of so much supposedly radical innovation and progress, seemed poised between two extreme models of femininity and identity, a radical European socialist one, which served as an oppositional stance to the world they had come from, and a passive timeless 'oriental' one which served as a mythologizing perception of the world they had migrated to.

Being much preoccupied with visual culture and the ways in which images construct meanings and mediate power relations, I would like to examine the following photographs (Figures 5.1–5.10) as the officially circulating representations of fictive, idealized femininity functioning as

Figure 5.1 Women in Palestine/Israel. Early immigrants from Eastern Europe.
Source: Ada Maimon, *Women Build a Land* (Herzel Press, New York) 1962

binary opposites between which no actual identity could be formulated. The
images derive from classroom textbooks and popular histories which circu-
late widely in modern Israel. The earliest images (Figures 5.1–5.3) show
pioneer women who had emigrated from Eastern Europe at the turn of the
century performing both private and public chores, laundering the clothes
and breaking up stones for the paving of roads and building of houses.[183] In
each case there is a staged quality to the photographic narrative. In the image
of the laundering there is an Arab man idly languishing against a post in the
background as if to declare that the women are doing this menial labor
for reasons of ideological conviction and refusing to have it done by the
indigenous population of the land which could conceivably be hired to do
so. The fictions have to do with an attempt to distance the protagonists,
the early pioneers, from the normative, exploitative codes of European
colonialism in the eastern Mediterranean and to emphasize the myth of
gender equality among the early communal societies of the first waves
of ideologically motivated 'aliyah' (as these early migrations were termed
in Hebrew). Contemporary accounts, however, alert us to the mythologized
nature of this equality. Fania, a woman pioneer of the second wave of immi-
grants and heroine of Sulamit Lapid's novel set in the Rosh Pina pioneer
settlement in the 1880s, *Gey Oni* (*Valley of Strength*), complains: 'Of all the
things that were said the one which constantly scorched her memory were
remarks casually made by the doctor, "There are nine Biluyim in Gedera
and one woman" . . . as if she were not a person! Nine persons and one
something else.'[184]

The dreamy, idealistic pioneer girls were within twenty years to become the thickset, severe, bespectacled matriarchs of the Labour movement, political hacks like Golda Meir who did little for the cause of women and conformed in every way to the dominant, masculinist mode of party power politics.[185] As the building of the fledgling community progressed, we find images of women building houses, plowing the land, working in light industry and in service industries such as the telephone and electricity companies (Figures 5.3–5.7). They are focused and attentive to their tasks, their bodies are veiled beneath layers of functional clothing, their sexual identity negated, subjugating themselves to their duties. Through their disciplined bodies, they have become work tools within a socialist culture which valorized labor as the highest achievement and the greatest agent of equality. It is

Figure 5.2 Women in Palestine/Israel. Early immigrants from Eastern Europe. Source: Ada Maimon, *Women Build a Land* (Herzel Press, New York) 1962

important to understand how these bodies are used to make claims to the land and to render those claims naturalized and organic. These representations of women linked to the land posit a new relationship, one in which the land is not owned or possessed, as within the feudal or colonial systems which immediately preceded it, but is served and nurtured and made fertile. Thus both the land and its occupation are feminized through internally linked dynamics of subordination, service and fertility.

Their direct opposites are the 'oriental' women (Figure 5.8) passive and quiet and self-absorbed, clothed in cumbersome traditional clothes which bespeak the exact opposite of the pioneer women's public physical work; touting small babies or sitting in traditional 'oriental' poses, they inhabit an arena of a historical timelessness, an exotic other against which the pioneer women's activities seem even more extraordinary and their revision of traditional femininity even more radical.[186] Not least, the fictive

Figure 5.3 Women in Palestine/Israel. Source: Ada Maimon, *Women Build a Land* (Herzel Press, New York) 1962

Figure 5.4 Women in Palestine/Israel. Women plowing the land. Source: Emil Feuerstein, *Women Who Made History* (Israel Ministry of Defence Publications, Tel Aviv) 1989

Figure 5.5 Women in Palestine/Israel. Women employed in the telephone industry. Source: Emil Feuerstein, *Women Who Made History* (Israel Ministry of Defence Publications, Tel Aviv) 1989

Figure 5.6 Women in Palestine/Israel.
Women at work in the armaments
industry. Source: Emil Feuerstein, *Women
Who Made History* (Israel Ministry of
Defence Publications, Tel Aviv) 1989

positioning of these women as passive and subdued served as a legitimizing narrative for the imposition of a set of foreign cultural values over the existing ones in the name of twentieth-century progress.

In the period leading up to the 'War of Independence' and the establishment of the state in 1948 we see a shift in the photographic construction of femininity circulating within the culture. There is an obvious escalation in the real level of participation by women in underground and military activities against the British Mandatory government and in preparation for what seemed to be an inevitable conflict with the indigenous Palestinians and neighbouring Arab states, a participation dictated by demographic scarcity since the Jewish population of Palestine numbered no more than six hundred thousand that point.

The images indicate, however, another set of shifts, in perception of a femininity mobilized for a cause, dictated by circumstances rather than by the severe strictures of ideological purity. If we examine the images of the women sitting astride a mountain of hand grenades, crouched in tortuous and implausible positions, or of the woman soldier with her hands on her hips in a confrontational pose belied by a sweet and charming smile, a distinct pattern begins to emerge. The degree of physical confrontation and the far greater emphasis on gendering these bodies as female, on situating them as on display, begins the process of humanizing belligerence through an insistence on a new and self-consciously aggressive femininity. The difference in signification has as much to do with the shift from choice to necessity as it has to do with the cultural conventions of specific historical moments. More importantly it is the moments at which the links with the two previously mentioned defining poles, the European and the Oriental, are radically

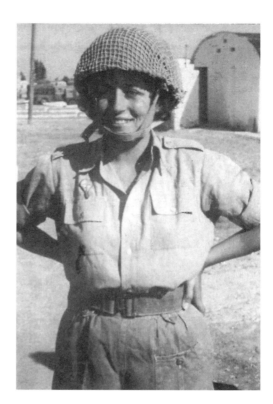

Figure 5.7 Women in Palestine/
Israel. Woman soldier. Source:
Emil Feuerstein, *Women Who Made
History* (Israel Ministry of Defence
Publications, Tel Aviv) 1989

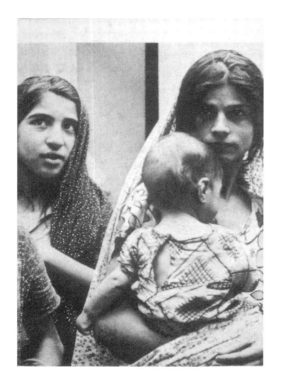

Figure 5.8 Women in
Palestine/Israel. 'Oriental'
women in traditional pose.
Source: Ada Maimon, *Women
Build a Land* (Herzel Press,
New York), 1962

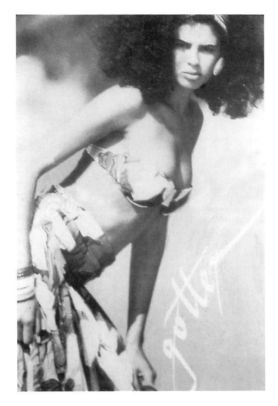

Figure 5.9 Gottex International, DSh.G.Ads, Tel Aviv, July 1989

redefined in favour of a newly born construct, the 'Israeli woman', who can be allowed neither the choices of the European woman nor the passivity of the Oriental. The surface aggression masks a level of filial subservience, this time to the state and the dominant Zionist ideology.

Forty years on, the cycle of aggression, destruction, injustice and loss of life seems to continue without cease. The state of Israel, founded on a rhetoric of socialist equality, has been continuously shaken by accusations of racial discrimination against Sephardic Jews and by gnawing voices insisting on recognition for the Palestinians. The situation of women, who had started out as supposedly equal partners in the radical social experiment of Zionism, has remained sadly unevolved. There are few women in public life, feminism is a marginal and ridiculed movement, the traditional family dominates every aspect of life and dictates the circumstances and priorities of women's existence and possibilities, and most importantly we can perceive an exceptionally acute crisis of identity.

The identity which had been forged between the two extreme poles of European and Oriental has now receded into those poles. The model in

the Gottex advertisement (Figure 5.9) conforms to every known cliché of the 'Mediterranean beauty': dark-haired and dark-skinned, her hair an unruly cloud of curls, her costume vaguely reminiscent of the harem, she is supposedly firmly situated in the specific geographical region.[187] The inherent contradiction between adopting a set of so-called oriental aesthetic values and then negating them through the display of the nearly naked body and the provocative posture is one that perfectly represents the internal contradictions of Israeli feminine identity. It attempts to adapt to a region with which it is engaged in active daily warfare, while dreaming nostalgically of lost European worlds. For example, the model on the cover of *Naamat* – a vaguely feminist mass-circulation women's magazine in Israel, linked to what was the Labour Party daily paper, *Davar* – has a mask of glittering, sophisticated make-up which adheres to a European aesthetic of the remote and distant feminine (Figure 5.10).[188] The contradiction manifests itself in simultaneously cloaking femininity in a mantle of emancipatory rhetoric and living out a traditional and contradictory life, which is a crisis of identity as well as also a crisis of context.

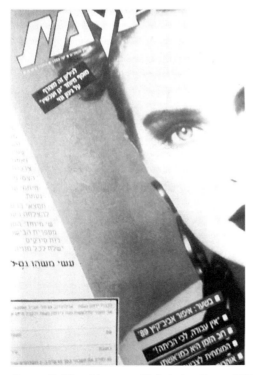

Figure 5.10 *Naamat*, Tel Aviv, June 1989

Gendering diasporic nostalgia

These different representations have been circulating within the culture throughout the twentieth century as an increasingly coherent and solid mythical narrative. In recent years the internal contradictions of these gendered identities have become the focal point of a few, far too few, interrogations within visual and textual culture. The cool, analytical work of Sigal Primor, a young Israeli visual artist who has only recently begun to exhibit her work internationally, is to my mind one of the most interesting speculations on this split identity.[189] The imaginary setting of the work is a fiction of urbane, European culture centered on the world of opera houses and concert halls. With this she acknowledges the extraordinary symbolic and ideological centrality that classical music has in Israeli cultural life, which is flooded with orchestras, visiting musicians and apparently one of the largest classical music concert-going publics in the world. Aside from the obvious historical reasons which make music the most international, transient and easily transportable of high cultural practices, it is also the one that supposedly transcends national cultural identities and thus can be appropriated as 'our' cultural heritage, one that is exclusive to the European population of Israel and denotes their privilege without being obviously discriminatory. In Primor's work (Figures 5.11, 5.12, Plate 16) we see the entire gamut of romantic narratives associated with the world of high musical culture: violin cases lined with velvet are echoed by reduced-scale evening gowns of glistening taffeta and velvet in glowing jeweled colours, all alluding to an acculturation of women's bodies and a recognition of the seduction and sexual allure of high culture (Plate 16). The extreme artificiality, the emphasis on identity as a form of staged theatrical production, is investigated through the endlessly intricate play with concert hall balconies, parapets and walkways which immediately bring to mind the opera house paintings of Renoir and Mary Cassatt. Primor's work articulates a perception of identity as a feminized cultural spectacle; it is a complex cultural gaze in which subtle intersections of a longed-for mythologized heritage and a remote and privileged femininity intertwine and define one another as in those Central European novels of the 1930s such as those by Vicki Baum, in which spectacles of high culture (opera houses, cafés, grand hotels) supposedly masked internal differences and struggles. There is an acknowledgment of the simultaneity of insidership and outsidership, of the conjunctions of heady and rapturous cultural experience and of the staging of desire through that experience. In a work entitled *The Bride and the Echo* (1989) (Figures 5.11–5.12) we see a photo of a generic 'European opera house': empty and cavernous it draws us into its vast spaces through the promise of opulence, romance and fulfilled desire that it holds forth to our cultural imaginations.

It is surrounded by plywood cutouts of female images holding out some printed sheaves of paper, perhaps musical manuscripts, perhaps romantic scenarios. Superimposed over the entire image we find the slick, cold metallic image of Duchamp's bride from the *Large Glass* narrative of *The Bride Stripped Bare by her Bachelors, Even*. This image by Duchamp stands in as the referent for all that is 'modern', European, technologically constituted and progressive. In one single artistic referent, the entire contextual, geographically located world of the Near East and the Levant can be dismissed and denied. The invocation of Duchamp has little to do with his actual work but rather with its reception and its position as groundbreaking and paradigm-shifting modernist work in which a machine aesthetic for the human body acquired a sexuality that went beyond the utilitarian mechanized working bodies which dominated the earlier historical avant-garde. In Duchamp's mechanized speculation on human sexuality in the crisis of modernism, the bride in the upper part of the work is being anchored down by the 'bachelors' in the form of chocolate grinders entitled *The Bachelor Grinds His Own Chocolate*. The two gendered panes of the *Large Glass* remain separate:

> If the 'Large Glass', and thus the 'love operation' of the two machines had been completed, the Bachelor Machine, 'all grease and lubricity' would have received 'love gasoline secreted by the Bride's sexual glands' in its 'malic' cylinders for ignition by 'the electrical sparks of the undressing' and mixing with the secretions of the ever-turning Grinder, would have produced the ultimate union. In its 'incomplete' state the Large Glass constitutes rather, an assertion of the impossibility of union – of the sexual alienation of man and woman in a situation which Lebel describes as 'onanism for two'.[190]

In Sigal Primor's works the bride has detached herself from the glass and from the oppressive binarism of the image of sexual alienation. Her mechanistic image of femininity, its metallic sinuousness representative of a rationalized female sexuality in the service of some modernist ideal or other, hovers longingly in front of the photo of the opera house, eager to penetrate the luscious mysteries of cultural promise it holds out to her. It is a poignant image of cultural nostalgia, of the ideals of modernism looking back to the seductive fictions of the old world and its belief in culture's ability to transcend reality.

The Bride's other is no longer the entire gamut of grinders and malic tools but the fictions of the past it wishes to escape into as if it holds some promise of a union, cultural rather than sexual, which being trapped in Duchamp's mechanized *Glass* has barred her from (Figure 5.12). The work viewed as a whole perceives culture as performative, as a gendered spec-

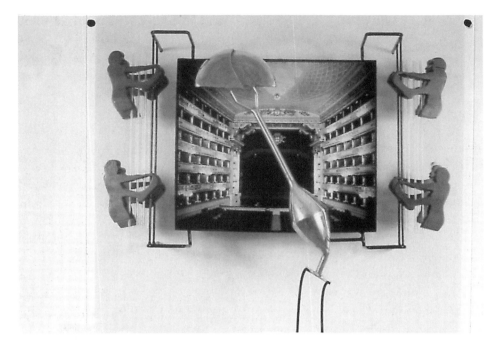

Figure 5.11 Sigal Primor, *The Bride and the Echo*, 1990 (installation shot).
Courtesy of the artist

tacle of the desire for culture in which femininity is both staged and
displayed, viewer and viewed. It seems particularly appropriate that all of
these dynamics and desires should be framed within the legitimating narra-
tive of 'modernism', for, like the relation between Zionism and international
socialism, it frames discourses within an illusionary internationalism and the
shared goals and ideals of an ideology of 'progress'.

I am particularly interested in Primor's work because it seems to me
to thematize and reflect on the condition of ambivalence and contradictory
longings which the European-oriented cultural life of the state of Israel mani-
fests. This is a Second World ambivalence toward cultures of origin rather
than a Third World relation to these, as can be seen via a comparison with
the condition described by Palestinian-born writer Anton Shammas, whose
first novel was written in Hebrew, his second language:

> In my humble case as a Palestinian who was ungracefully deter-
> ritorialised by the Hebrew language (which Dante had described
> in the fourteenth century as the language of Grace) – what I am
> trying to do is deterritorialise the Hebrew language, or, more
> bluntly to un-Jew the Hebrew language and make it the language
> of personal narrative discourse. In a certain sense, that is what

most of the writers of the Third World are doing these days: undoing the culture of the majority from within. The deterritorialisation of the colonisers' language is the only way to claim their own territory, and it is the only territory left to them to claim as an independent state – the only one they can afford to call a homeland.[191]

The clear purpose of such a project is denied within European-oriented Israeli culture, at least overtly, since the relationship with its oppression is more complex; after all it was the Jewish intelligentsia in many of these originary cultures who contributed to its cultural formation or who took part in internal processes of its deterritorialization. Perhaps it is a nostalgia for such a position which we are experiencing, a hankering after diaspora which allows us an internal oppositional role. Perhaps those of us who occupy positions of clearly articulated ambivalence and who work to thematize and research those past European cultures from which our ancestors were expelled and to which we at some level gravitate and try and make our own have become 'the diaspora's diaspora'. Nowhere are these

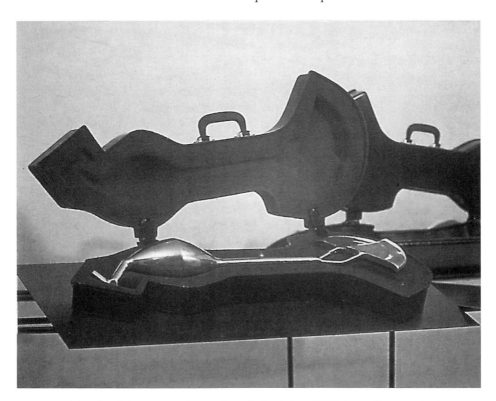

Figure 5.12 Sigal Primor, *The Bride and the Echo*, 1990 (installation shot). Courtesy of the artist

contradictions and ambivalent states more clearly visible than in the condition of femininity within the Israeli state, as I have tried to map out in this survey through encounters with a set of visual representations.

The value of Sigal Primor's work for my argument is that it is so insistent on critically examining the myths of cultural heritage and is so uncompromising in pointing out the subtle and insidiously positioned superiority of the European heritage within collective cultural fantasies and identity formations. In her astute recognition that culture and cultural rituals are profoundly gendered and provide a space of refuge from the sorrow and the constant unease which accompany the daily life of the state of Israel, she is also exposing the rhetorical fictions of women's identities. The external trappings of the 'new beginning' have collapsed back inwardly on to the extreme poles of feminine identity, each in its own way a fantasy projection of an impossibly romantic ideal which claims a new identity but seems unable to actually provide a set of new, or even revised, values for that identity. Instead it lives out its contradictory destiny and acute ambivalences through endless stagings of cultural desire and through the production of internally conflicted femininities which attempt, with great difficulty and at great cost, to bring about some form of denied reconciliation.

Notes

1 Henri Lefebvre, *The Production of Space* (Blackwell, Oxford and London) 1993. Neil Smith, *The New Urban Frontier – From the Revengist City to Urban Gentrification* (Routledge, London) 1996.
2 Rosalyn Deutsche, 'Boys Town' in *Society and Space*, Vol. 9, 1991, pp. 5–30. Subsequently published in her collection of essays, *Evictions – Art and Spatial Politics* (MIT Press, Cambridge, MA) 1997.
3 Iain Chambers, *Migrancy, Culture, Identity* (Routledge, London) 1996.
4 Sara Suleri, *Meatless Days* (Chicago University Press, Chicago) 1987.
5 Anton Shammas, *Arabesques* (Harper & Row, New York) 1988, and Anton Shammas in Philomena Mariani ed., *Critical Fictions – The Politics of Imaginative Writing*, DIA Center for the Arts, Discussions in Contemporary Culture, No. 7 (Bay Press, Seattle) 1991.
6 See Robert D. Kaplan, *Balkan Ghosts – A Journey through History* (St Martins Press, New York) 1993.
7 Jacqueline Rose, *States of Fantasy* (Clarendon Press, Oxford) 1996, p. 7.
8 Ibid., p. 15.
9 Theodor W. Adorno, 'On the Question "What is German"?' (translated by Thomas Y. Levin), *New German Critique,* Special issue on Heimat, No. 36, Fall 1985, p. 121.
10 All quotations here are from Freud's essay 'The Uncanny' in the *Standard Edition*, Vol. 21, pp. 219–53 (Hogarth Press, London) 1965.
11 Paul Gilroy, *The Black Atlantic – Modernity and Double Consciousness* (Harvard University Press, Cambridge, MA) 1993.
12 I am very indebted to Cornelia Vismann's paper 'Concepts of Order in No Man's Land' which I originally read in an unpublished English version

and which opened up several important interpretative models including those of zones of disidentification as well as others regarding the relation of the border as a line in the earth to concepts of the law and of ownership of the self through specific boundaries. Direct references to the published version appear in Chapter 6 (and see note 147).

13 Probably the most coherent arguments summarizing this shift are collected in Victor Burgin, *The End of Art Theory* (Macmillan, London) 1989; in Brian Wallis, ed., *Art After Modernism* (David Godine, Boston) 1989; and in Hal Foster, *Recodings – Art, Politics, Spactacle* (Bay Press, Seattle) 1990.

14 Gayatri Chakavorty Spivak, 'Can the Subaltern Speak?' in C. Nelson and L. Grossberg, eds *Marxism and the Interpretation of Culture* (University of Illinois Press, Champagne-Urbana) 1988.

15 Henri Lefebvre, *Everyday Life in the Modern World* (Penguin, London) 1971, pp. 158–60.

16 Salman Rushdie, 'Outside the Whale' in *Imaginary Homelands* (Granta Books, London) 1992, p. 99.

17 Neil Smith and Cindi Katz, 'Grounding Metaphor – Towards a Spatialized Politics' in Michael Keith and Steve Pile, *Place and the Politics of Identity* (Routledge) 1993, p. 68.

18 Kaja Silverman, *The Subject of Semiotics* (Oxford University Press, Oxford and New York) 1983, p. 111.

19 Ibid., p. 109.

20 Edward Said, 'Narrative and Geography', in *New Left Review*, no. 180 (1990).

21 Shoshana Felman, 'Camus' The Plague or A Monument to Witnessing' in S. Felman and D. L. Laub, eds, *Testimony – Crises of Witnessing in Literature, Psychoanalysis and History* (Routledge, New York and London) 1992.

22 Homi Bhabha, 'Introduction' to *The Location of Culture* (Routledge, New York and London) 1993, p. 9.

23 Abraham Verghese, *My Own Country* (Vintage, New York) pp. 14–19.

24 Derek Gregory, *Geographical Imaginations* (Blackwell, Oxford) 1995.

25 David Hooson, ed., *Geography and National Identity* (Blackwell, Oxford) 1994.

26 Neil Smith, *Uneven Development* (Blackwell, Oxford) 1990.

27 J. M. Blaut, *The Colonizer's Model of the World – Geographical Diffusionism and Eurocentric History* (Guilford Press, London and New York) 1993, pp. 28–9.

28 Claude Nicolet, *Space, Geography and Politics in the Early Roman Empire* (University of Michigan Press, Ann Arbor) 1991, p. 2. (Originally published as *L'Inventaire du Monde: Geographie et Politique aux Origines de l'Empire Romain* (Fayard, Paris) 1988.) I would like to thank Sandra Joshel, inspired scholar of antiquity, for bringing this book to my attention.

29 Lefebvre, *The Production of Space*, pp. 314–15. All of the following references to Lefebre's work have been adapted from this volume.

30 Two recent books pay very different homage to Lefebvre's role in establishing a discourse of space: see Edward Soja, *Third Space* (Blackwell, Oxford) 1996, and Victor Burgin, *In/Different Spaces* (University of California Press, Berkeley and Los Angeles) 1996.

31 Lefebvre, *The Production of Space*, pp. 27–9.

32 Donna Haraway, 'Situated Knowledges' in *Simians, Cyborgs and Women* (Routledge, New York) 1991, pp. 195–6.

33 The two articles I am referring to here are Rosalyn Deutsche, 'Men in Space', *Strategies*, No. 3, 1990, pp. 130–7, and the much longer 'Boys Town'. These are exceptional essays, the complexity of whose structure and argument I cannot do justice to in a schematic summary. I have chosen to focus on one small part of their argument relating to vision and feminist narratives but would like to acknowledge that this work in a way made possible a shift from feminist epistemology of situated knowledge to the arena of visuality and spectatorship. Both of these articles have more recently been published in Deutsche's collection of essays *Evictions* (see note 3).

34 Deutsche, 'Boys Town', pp. 9–10.

35 Michel de Certeau, *The Practice of Everyday Life* (University of California Press, Los Angeles) 1984, p. 92.

36 Deutsche, 'Boys Town', p. 18.

37 Glenn Ligon, *Picky*, 1993. Courtesy of the artist.

38 For a broader range of work in the field see Nicholas Mirzoeff, ed., *The Visual Culture Reader* (Routledge, London) 1999.

39 I am paraphrasing from a discussion after a lecture given by Gayatri Spivak at Harvard University's Center for Literary and Cultural Studies in 1987.

40 Trin, T. Minh-Ha, 'Cotton and Iron' in Russel Ferguson *et al.*, eds, *Out There – Marginalizations and Culture* (MIT Press, Cambridge, MA) 1992.

41 Laura Mulvey, 'Pandora – Topographies of the Mask and Curiosity' in Beatriz Colomina, ed., *Sexuality and Space* (Princeton University Press, Princeton) 1992.

42 Martin Jay, *Downcast Eyes* (University of California Press, Berkeley and Los Angeles) 1995.

43 Lefebvre, *The Production of Space*.

44 Kobena Mercer, 'Reading Racial Fetishism – The Photographs of Robert Mapplethorpe' in *Welcome to the Jungle* (Routledge, New York) 1994, pp. 171–221.

45 Erje Ayden, 'Sadness at Leaving' (Semiotexte, Foreign Agent Series, New York) 1972.

46 James Clifford, 'Travelling Cultures' (discussion section at end of paper, response to Homi Bhabha) in L. Grossberg *et al.*, eds, *Cultural Studies* (Routledge, London) 1992.

47 John Berger, *A Seventh Man* (Readers and Writers, London and New York) 1975, p. 64.

48 Rosemary Marangoly George, 'Travelling Light: Of Immigration, Invisible Suitcases and Gunny Sacks', *Differences*, Vol. 4, No. 2, 1992, p. 72. I would like to thank Vince Raphael for drawing my attention to this significant effort at theorizing luggage within post-colonial literary criticism.

49 M. G. Vassanji, *The Gunny Sack* (Heinemann, London) 1989.

50 Anita Desai, *Bye-Bye Blackbird* (Hind, Delhi) 1970.

51 Samuel Selvon, *The Lonely Londoners* (Longman Caribbean Writers, London) 1956.

52 Benedict Anderson, *Imagined Communities – Reflections on the Origins and Spread of Nationalism,* 2nd edition (Verso, London) 1991.

53 Homi K. Bhabha, 'DissemiNation: Time, Narrative and the Margins of the Modern Nation' in *The Location of Culture* (Routledge, London) 1994.

54 George, 'Travelling Light', p. 83.

55 Edward Said, *After the Last Sky* (Faber, London) 1986, p. 14.

56 Lynn Tillmann, 'Report from Ellis Island – The Museum of Hyphenated Americans', *Art in America*, September 1991.

57 James Young, *The Texture of Memory – Holocaust Monuments* (Yale University Press, New Haven and London) 1993.

58 I have developed some thoughts on the display strategies in German museums of history in Irit Rogoff, 'From Ruins to Debris – The Feminization of Fascism in German History Museums' in D. Sherman and I. Rogoff, eds, *Museum Culture – Histories/Discourses/Spectacles* (University of Minnesota Press, Minneapolis) 1994.

59 Shoshana Felman, 'In an Era of Testimony – Claude Lanzman's SHOA', *Yale French Studies*, No. 79, pp. 39–82. See also Felman's somewhat extended argument co-edited with Dori Laub, *Testimony – Crises of Witnessing in Literature, Psychoanalysis and History* (Routledge, New York and London) 1992.

60 For a further discussion of public commemoration, of the binarism of replacing absences with presences and of the counter-commemoration work of artist Jochen Gerz see my 'The Aesthetics of Post History – A German Perspective' in Stephen Melville and Bill Readings, eds, *Vision and Textuality* (Macmillan, London) 1994.

61 Charlotte Salomon, *Leben? Oder Theater?* Large sections of this work can be seen in *Charlotte: Life? or Theatre? An Autobiographical Play by Charlotte Salomon*, Judith Herzberg (introd.) (Viking, New York) 1981, and in *Charlotte Salomon – Life? or Theatre?* (Jood Historisch Museum Amsterdam, and Waanders Uitgevers, Zwolle) 1995.

62 Ibid., p. 34.

63 Gertrude Koch, *Der Einstellung ein Einstellung* (Suhrkamp, Berlin) 1993.

64 A recent translation and complete version of the book is now available to the English-language reader: *Charlotte Salomon: 'Life or Theatre?'* (Royal Academy of Art, London) 1999.

65 Terry MacMillen, *How Stella Got her Groove Back* (Viking Books, New York) 1996, pp. 29, 30–1.

66 *INSCRIPTIONS*, special issue *Travelling Theories / Traveling Theorists*, James Clifford and Vivek Dhareshwar, eds, Group for the Critical Study of Colonial Discourse and the Center for Cultural Studies, UCSC, 1989.

67 I am referring to Clifford's (note 46) 'Travelling Cultures' as well as to his recent book *Routes – Travel and Translation in the Late Twentieth Century* (Harvard University Press, Cambridge, MA) 1997. I would also like to clarify that I am using Clifford's work as an example of the enormous quality of work which has recently focused on travel: work such as Caren Kaplan's *Questions of Travel – Postmodern Discourses of Displacement* (Duke University Press, Durham, NC) 1996, which brings in issues of sexual difference, or Gilroy's *Black Atlantic*, which sets up dialogs between minority cultures and dominant mainstream narratives. While it has not been possible to refer to specific work on every occasion, I would like to make clear the embeddedness of my own project within this immense body of post-colonial critical writing.

68 Homi K. Bhabha, Introduction to *The Location of Culture* (Routledge, New York and London) 1994.

69 Gayatri Chakavorty Spivak, Translator's Preface to Jaques Derrida, *Of Grammatology* (Johns Hopkins Press, Baltimore) 1974, pp. 15–16. My emphasis.

70 Ibid., p. 144.

71 There are two sources of information concerning this project. One is a brief illustrated discussion by the artists in the *Journal of Philosophy and Visual Arts* (ed. Andrew Benjamin) devoted to *Architecture, Space, Painting*: 'Diller and Scofidio – Projects', pp. 58–68 (Academy Editions, London) 1992. A more substantive source is *Diller & Scofidio – Back to the Front, Tourisms of War*, which has both a complete documentation of each of the suitcases and a range of exceptionally interesting texts by various writers and theorists as well as by the artists. Published by FRAC – Basse Normandie on the occasion of an exhibition at the Abbaye-aux-Dames, Caen, in 1994 on the occasion of the fiftieth anniversary of the invasion of Normandy. The passages of description presented here are paraphrases of and direct quotes from the text accompanying the 'Tourism of War' project in this catalog, pp. 33–105.

72 Jean Baudrillard, *America* (Verso, New York and London) 1988, p. 27.

73 Susan Stewart, *On Longing – Narratives of the Miniature, the Gigantic, the Souvenir, the Collection* (Johns Hopkins University Press, Baltimore) 1984. Paraphrased by Diller and Scofidio, *Back to the Front*, p. 49.

74 Diller and Scofidio, *Back to the Front*.

75 David Lowenthal quoting Dennis, quoted in ibid., p. 77.

76 Diller and Scofidio, *Back to the Front*, p. 48.

77 Derrida, p. 145.

78 Art in Ruins, *Conceptual Debt* (DAAD, Berlin) 1992, p. 7.

79 Ashley Bickerton, in *Documents*, No. 3, 1993, p. 64.

80 Ashley Bickerton in conversation with Richard Phillips, *Journal of Contemporary Art*, Vol. 2, No. 1, p. 81.

81 Ibid.

82 Jean Baudrillard, 'Consumer Society' in *Jean Baudrillard – Selected Writings*, Mark Poster ed. (Stanford University Press, Palo Alto) 1988, p. 31.

83 Ibid., p. 31.

84 Ibid., p. 49.

85 See for example Cesare Poppi, 'From the Suburbs of the Global Village: Afterthoughts on *Magiciens de la Terre*', *Third Text*, No. 14, Spring 1991.

86 Alfredo Jaar, 'La Géographie ça sert, d'abord, a faie la guerre', *Contemporanea*, No. 2, 1989.

87 Ibid.

88 The most informative publication on this project is *Alfredo Jaar: Geography =War* (Anderson Gallery, Virginia Commonwealth University and the Virginia Museum of Fine Arts, Richmond) 1991. This catalog has both a range of images which give a fairly accurate progression of the installation and some very interesting readings by art critics and political economists.

89 Mitra Tabrizian, *Correct Distance* (Cornerhouse Publications, Manchester) 1990.

90 See notes 139–41.

91 Deleuze, in Gilles Deleuze and Félix Guattari, *On The Line* (Semiotexte, New York) 1983, p. 95.

92 Derrida, p. 145.

93 Robin Schott, *Cognition and Eros – A Critique of the Kantian Paradigm* (Beacon Press, Boston) 1988.

94 Dennis Wood, *The Power of Maps* (Guilford Press, New York and London, and the Cooper-Hewitt Museum of Art, New York) 1992.

95 See Blaut, Chapter 1.

96 Wood, p. 113.

97 Jean Baudrillard, 'Symbolic Exchange and Death', 1976, quoted from *Jean Baudrillard – Selected Writings*, Mark Poster, ed. (Stanford University Press, Palo Alto) 1988.

98 Ibid., p. 1.

99 Julia Kristeva, *Revolution in Poetic Language* (Columbia University Press, New York) 1984, p. 59.

100 Documentation can be found in Hans Haacke, *Bodenlos*, catalog of the German Pavilion at the 1993 Venice Biennale (Edition Cantz, Stuttgart).

101 Jacques Derrida, *Positions* (University of Chicago Press) 1981, p. 31.

102 Michel de Certeau, *The Practice of Everyday Life* (University of California Press, Berkeley and Los Angeles) 1988, p. 115.

103 Verghese, pp. 392–5, 402–3.

104 De Certeau, p. 108.

105 Michel Foucault, 'Of Other Spaces', *Diacritics*, Vol. 16, No. 1, Spring 1986, p. 24.

106 For a brief documentation of Glotman's map see *90–70–90*, exhibition catalog (Tel Aviv Museum of Art) 1994.

107 Smadar Lavie, *The Poetics of Occupation* (University of California Press, Los Angeles) 1991.

108 Susan Slymovics, *The Object of Memory – Arabs and Jews Narrate the Palestinian Village* (University of Pennsylvania Press, Philadelphia) 1998, p. 9.

109 See Rona Sela, 'When Values Become Forms – When Forms Become Values' in *90–70–90*, pp. 70–1.

110 Mahmud Darwish, *Memory for Forgetfulness, August, Beirut, 1982* (University of California Press, Berkeley) 1995, p. 17. Quoted in Slymovics p. 56.

111 Edward Said, *Peace and Its Discontents* (Vintage Books, New York) 1994, p. xxix.

112 Interview with Michael Archer in Michael Archer, Guy Brett and Catherine de Zegher, *Mona Hatoum* (Phaidon, London) 1997, pp. 26–9.

113 *Moshe Ninio*, exhibition catalog, Bart de Baere, ed. SMAK Ghent, 1998.

114 Hanan Ashrawi, *This Side of Peace* (Simon & Schuster, New York) 1995, pp. 21–2.

115 Interview with Michael Archer in *Mona Hatoum*, pp. 26–9.

116 Ibid.

117 Edward Said, 'Memory and Forgetfulness in the United States' in *Peace and Its Discontents* (Vintage Books, New York) 1995, p. 135.

118 In Michel Foucault's 'Of Other Spaces' *Diacritics*, 1988, we find pirates, in Wood there are numerous bandits and caravan routes, and in Bruce Chatwin's *Songlines* (Penguin, Harmondsworth) 1987.

119 Jacques Derrida, *Telepathie* (Paris) 1978, p. 216.

120 Foucault, 'Of Other Spaces', p. 27.

121 Wood, p. 12, quotes from Fritz Muhlenberg's 'Big Tiger and Christian'.

122 Ann Godlewska, *The Napoleonic Survey of Egypt*, a special issue of *Cartographica* (University of Toronto Press, Toronto) 1988.

123 Godlewska, pp. 16–19.

124 Part of the following text appeared in the exhibition catalog *Joshua Neustein* (Exit Art, New York) 1987. I would like to thank Exit Art's director, Jeannette Ingberman, for inviting me to contribute the text and for making great efforts on its behalf.

125 Quoted by Svetlana Alpers, *The Art of Describing* (Chicago University Press, Chicago) 1983, p. 159.

126 John White, *The Birth and Rebirth of Pictorial Space*, 2nd edition (London) 1967, p. 122.

127 Erwin Panofsky, 'Perspective as Symbolic Form' in *Aufsätze zu Grundfragen der Kunstwissenschaft* (Berlin) 1964, p. 101.

128 Ibid, p. 123.

129 This argument is taken from Svetlana Alpers's extensive discussion of seventeenth-century Dutch painting: 'The Mapping Impulse in Dutch Painting' in *The Art of Describing*, pp. 72–119.

130 J. Wreford Watson,, quoted in ibid., p. 125.

131 Shammas in *Critical Fictions* (note 5).

132 Edward Said, 'The Mind of Winter – Reflections on Life in Exile', *Harpers*, Vol. 269, Issue 1612, SE 1984, p. 51.

133 The artist's diary, August 26,1987.

134 September 3, 1987.

135 For a discussion of this hyphen status in Conwill's work see Ikemefuna Okoye, 'Shamanic Penumbra: Houston Conwill's Art of Color', *New Observations*, No. 97, October 1993.

136 Gilroy, *The Black Atlantic*, p. 2.

137 Okoye, p. 28.

138 Toni Morrison, 'The Site of Memory' in *Out There – Marginalization and Contemporary Cultures* (MIT Press, Cambridge, MA) 1992, p. 305.

139 Gilles Deleuze, 'Politics' in Deleuze and Guattari, *On the Line*, p. 69.

140 Ibid., p. 70.

141 Ibid., p. 71.

142 Ibid., p. 70.

143 Guillermo Gómez-Peña *et al.*, *The Border Arts Workshop – Published Writings and Art Projects* (published by the next artist) 1990; Emily Hicks, *Border Writing* (University of Minnesota Press, Minneapolis) 1994; Guillermo Gómez-Peña, *The New World Border* (City Lights, San Francisco) 1996; Coco Fusco, *English is Broken Here* (The New Press, New York) 1995.

144 Thus for example the conversation between Gómez-Peña and Fusco in 'Bilingualism, Biculturalism and Borders' in *English Is Broken Here*, pp. 150–61, charts out the exceptionally rich terrain of cultural activity on both sides of the border which is condensed into oblivion through the focus of all attention and the mobilization of all anxiety on the area of the border.

145 Fusco, p. 49.

146 Ibid., p. 50.

147 I am very indebted to Cornelia Vismann's paper 'Starting from Scratch – Concepts of Order in No Man's Land' in B. Huppauf, ed., *War, Violence and the Modern Condition* (Berlin, New York) 1997, which opened up several important interpretative models including those of Zones of Disidentification as well as others regarding the relation of the border as a line in the earth to concepts of the law and of ownership of the self

through specific boundaries. Extensive use and reference to this paper will be made towards the end of this chapter.

148 *Die Endlichkeit der Freiheit Berlin 1990 – Eijn Ausstellung in Ost und West* (Edition Hentrich, Berlin) 1990.

149 Foucault, 'Of Other Spaces'.

150 Two very eolquent and informative publications dealing with Medieta's work have recently appeared. One is *Ana Mendieta*, the 1996 catalog of a representative exhibition from the Centro Galego de Art Contemporanea in Santiago de Compostella, curated and edited by Gloria Moure, which provides a wealth of previously unavailable work and a very interesting essay by Charles Merewether. The other is Jane Blocker's book *Where is Ana Mendieta?* (Duke University Press, Durham, NC 1999) which provides a set of contexts and frameworks from within which to read Mendieta's work and which articulates some of the questions I had been struggling with in my own writing. I would refer the reader for more information, and analysis of the subject and its problematics, to Blocker's book.

151 Earlier versions of the following text appeared as part of my 'Terra Infirma – Geographies and Identities', *Journal of Philosophy and Visual Art*, Vol. 1, 1988, under the same title in *Camera Austria*, Vol. 42, 1994, as a chapter of Vera Zolberg, ed., *Outsider Art* (Cambridge University Press, Cambridge) 1997. I am grateful to all of these for the opportunity to develop the arguments presented here.

152 Edward Soja, Preface and Postscript, *Postmodern Geographies – The Reassertion of Space in Critical Social Theory* (Verso, London) 1989, p. 2.

153 The following series of quotations from art-world luminaries and hangers-on, gossips and socialites is taken from Kay Endell, 'A Death in Art', *New York Magazine*, December 1985.

154 Ana Mendieta, unpublished statement quoted in *Ana Mendieta – A Retrospective*, exhibition catalog (The New Museum of Contemporary Art, New York) 1987, p. 10.

155 Ibid., p. 31.

156 Caren Kaplan, 'Deterritorialization – The Rewriting of Home and Exile in Western Feminist Discourse', *Cultural Critique*, Vol. II, 1985, pp. 187–98.

157 Mendieta, p. 33.

158 The circumstances surrounding Mendieta's death and the disparity between the legal outcome of Carl Andre's trial and the constant rumors and accusations circulating in the art world have made it difficult to give any factual account of her death.

159 Kaplan, p. 189.

160 Richard Woodward, 'For Art, Coastal Convergences', *New York Times*, July 16, 1989, p. 33.

161 Mendieta, p. 28.

162 Robert Katz, *Naked by the Window* (Atlantic Monthly Press, New York) 1990.

163 All of the quotations reporting on the scandal which I have included here are taken from Joyce Wadler's 'A Death in Art – Did Carl Andre, the Renowned Minimalist Sculptor, Hurl His Wife, a Fellow Artist, to Her Death?' *New York Magazine*, December, 16, 1985. Cover and feature article.

164 For a documentation and analysis of her work see *Ana Mendieta: Retrospective*; Luis Camnitzer, 'Ana Mendieta', *Third Text*, No. 7, 1989; and Luis Camnitzer, *New Cuban Art* (University of Texas Press, Austin) 1994.

165 Vismann, pp. 46–7.

166 See note 12.

167 Derrida, *Of Grammatology*, p. 287.

168 Vismann, p.48.

169 George L. Mosse, *Nazi Culture: A Documentary History* (Schocken Books, New York) 1981.

170 Igor Golomstock, *Totalitarian Art* (Colins Harvill, London) 1990.

171 Gertrude Koch, *Die Einstellung ist die Einstellung: Visuelle Konstructionen des Judentums* (Suhrkamp, Frankfurt) 1992, and Thomas Elsaesser, *New German Cinema* (Rutgers University Press, New Brunswick) 1989.

172 *Perlonzeit: Wie die Frauen ihre Wirtschaftswunder erleben haben*, exhibition catalog (Elephant Press, Berlin) 1996.

173 Irit Rogoff, 'From Ruin to Debris: The Feminization of Fascism in German History Museums' in I. Rogoff and D. Sherman, *Museum Culture* (University of Minnesota Press, Minneapolis) 1994.

174 Elizabeth Grosz, *Volatile Bodies: Towards a Corporeal Feminism* (Indiana University Press, Bloomington) 1994, p. 8.

175 Ibid., p. 9.

176 Ammiel Alcalay, *After Jews and Arabs – Remaking Levantine Culture* (University of Minnesota Press, Minneapolis) 1993, p. 1. Of the many works, both scholarly and literary, which I have read in pursuit of these interests, two in particular stand out as having shaped my critical thinking on the constructed relations between European Jews and their sense of place. Alcalay's book showed me clearly that while there had indeed been a relationship between Jews and place it was not the claimed one of European Zionism but the lived one of the Arab Jews of the Levant and the religious Jews who settled their in the years prior to Zionist domination. Similarly Ella Shohat's book *Israeli Cinema – East/West and the Politics of Representation* (University of Texas Press, Austin) 1987, first began to explore a model of thinking Israeli culture in terms of First and Third World tensions and through the analytical models of the critical analysis of colonialism. While their work may not be quoted here extensively, since my preoccupation is primarily to interrogate dominant ideology

through an attention to gender and sexuality, it nevertheless serves to continuously inform and embolden my arguments.

177 Theodor Adorno, *Minima Moralia* (New Left Books, London) 1974, p. 36.

178 Abdul JanMohamed and David Lloyd, 'Towards a Theory of Minority Discourse', introduction to *Cultural Critique*, No. 6 (1989), pp. xx–xxii.

179 Arif Dirlik, 'Culturalism as Hegemonic Ideology and Liberating Practice', in *Cultural Critique*, No.6, p. 7.

180 David Grossmann, *See Under: Love* (Sifriyat Hapoalim, Jerusalem) 1986. All translations from Hebrew into English are my own.

181 For a radically new reading of the relation between Zionism, Judaism and territoriality as articulated through the ideology of a return to 'homeland', see Boaz Evron, *A National Reckoning* (Dvir Publishing, Tel Aviv) 1988.

182 Esther Fuchs, *No License to Die* (Ecked, Tel Aviv) 1983.

183 Ada Maimon, *Women Build a Land* (Herzel Press, New York) 1962.

184 Shulamit Lapid, *Gey Oni*, 1984, quoted in Mira Ariel, 'Creatures of Another Planet', *Politika*, No. 27, July 1989 (Keter Publishing, Jerusalem).

185 Daphna Izraeli, 'The Golda Meir Effect', *Politika*, No. 27, July 1989, p. 47.

186 Emil Feuerstein, *Women Who Made History* (Israel Ministry of Defence Publications, Tel Aviv) 1989.

187 D.G.Sh. advertising agency Tel Aviv for Gottex International, July 1989.

188 Cover photo, *Naamat*, June 1989.

189 *Feminine Presences* (Tel Aviv Museum of Art), Summer 1989.

190 William Rubin (incorporating quotations from Duchamp) in *Dada and Surrealist Art* (New York) 1968, p. 40.

191 Anton Shammas in Mariani, ed., *Critical Fictions* (note 5), p. 77.

Select bibliography

Catalogs

A. Solomon Godean: Mistaken Identities (University Art Museum, Santa Barbara) Araeen Rashid, *The Other Story* (Hayward Gallery, London) 1989.

Alfredo Jarre: Geography = War (Virginia Museum of Fine Arts, Richmond) 1991

Armando Rascon (Intar Latin American Gallery, New York) 1994

Art in Ruins Conceptual Debt (The British Council, London and DAAD Gallery, Berlin) 1992

Ana Mendieta: A Retrospective (The New Museum of Contemporary Art, New York) 1987

Ana Mendieta (CGAC (Centro Galego de Arte Contemporaea) Santiago de Compostela) 1996

Bordering on Fiction: Chantal Akerman's D'est (Jenkins Walker Art Center, Minneapolis) 1995

Carrie Mae Weems: Then What (CEPA Gallery, New York) 1990

Carrie Mae Weems (The National Museum of Women in the Arts, Washington) 1993

Charlotte Solomon: Life or Theatre? (Royal Academy of Art, London) 1999

Charlotte Solomon: Life or Theatre? (Jood Historisch Museum Amsterdam, and Waanders Uitgevers, Zwolle) 1995

The Decade Show (The New Museum of Contemporary Art, New York) 1990

Die Endlichkeit der Freiheit (Berlin 1990) (Edition Hentrich, Berlin)

Diller & Scofidio – Back to the Front – Tourisms of War, FRAC – Basse Normandie on the occasion of an exhibition at the Abbaye-aux-Dames, Caen 1994

Diller and Scofidio – Projects (Academy Editions, London), 1992

Fruitful Incoherence – Dialogues with Artists on Internationalism (ed. Gavin Janies) (INIVA London) 1998

Gordon Matta Clark (Städtischen Kunsthalle Düsseldorf, Düsseldorf) 1979

Gupta, Sunil *Disrupted Borders: An Intervention in Definitions of Boundaries* (Rivers Oram Press, London) 1993

Hirshorn Works 89 (Hirshorn Museum, Washington) 1990

The Hybrid State (Exit Art, New York) 1992

Joshua Neustein (Exit Art, New York) 1987

Lorna Simpson: For the Sake of the Viewer (Universe Publishing, New York) 1992

Map (INIVA, London) 1996

Moshe Ninio (ed. Bart de Bacrc) (SMAK Ghent) 1998

90–70–90 (Tel Aviv Museum of Art) 1994

Richard Long: Walking in Circles (Thames & Hudson, London) 1991

Ringgold, Faith *The French Collection Parts 1 and 2* (B Mow Press, New York) 1992

Routes of Wandering (The Israel Museum, Jerusalem) 1991

Sigal Primor: The Antarctic Challenge (The Israel Museum, Jerusalem) 1992

The Theater of Refusal: Black Art and Mainstream Criticism (University of California, Irvine Fine Arts Gallery, Irvine) 1993

Vogal, Susan, ed. *Africa Explores: twentieth Century African Art* (Center for African Art, New York) 1991

Whitney Museum, Biannual (Whitney Museum, New York) 1993

Journals

Architecture, Space, Painting, Journal of Philosophy and Visual Arts. Andrew Benjamin, ed.

Babylon, Vols 10–11 (Verlag Neu Kritik, Frankfurt) 1992

Camera Austria, Vol. 49 (Camera Austria, Graz) 1994

Color, special edition of *New Observations*, No. 97, Sept.–Oct. (New York) 1993

Critical Decade: Black British Photography in the 80's, Ten 8, Vol. 2, No. 3 (Birmingham) 1992

Culture Critique No. 6 Spring 1987

Culture Critique No. 7 Fall 1987

The City, special edition of *Differences*, Vol. 5 (Brown University, Providence, RI) 1995

Emergencies, Vol. 1 and 2 (UCLA, Los Angeles) 1989–90

Strategies, special issue of *In the City*, No. 3 (UCLA, Los Angeles) 1990

Diaspora, Journal of Transnational Studies 1991

Subjects in Space, special issue of *New Formations*, No. 11 (Routledge, London) Summer 1990

Third Text: Third World Perspectives on Contemporary Art and Culture (London) 1992–5

Transition, Vol. 54 (Oxford University Press, New York) 1992

Zone, eds, Hal Foster and Michael Faher, Vols 1 and 2 (Urzone, New York) 1987

Books and articles

The Empire Strikes Back: Race and Racism in 70's Britain (Hutchison University Library London) 1982

The Making of Maps (Marshall Cavendish, London) 1968

Alcalay, Ammiel *After Jews and Arabs* (University of Minnesota Press, Minneapolis) 1993

Allercamp, Andrea *Die innere Kolonisierung* (Bohlau, Köln) 1987

Alloula, Malek *The Colonial Harem* (University of Minnesota Press, Minneapolis) 1986

Amin, Samir *Eurocentrism* (Zed Books, London) 1988

Anzaldua, Gloria *Borderlands/La Frontera* (Aunt Lute, San Francisco) 1987

Archer, Michael, Guy Brett and Catherine de Zegher, eds *Mona Hatoum* (Phaidon, London) 1997

Ashrawi, Hanan *This Side of Peace* (New York, Simon & Schuster) 1995

Ayden, Erje *Sadness at Leaving* (Semiotexte, New York) 1982

Baddeley, Oriana and Valerie Fraser *Drawing the Line* (Verso, New York) 1989

Bammer, Angelika *Displacements* (Indiana University Press, Bloomington) 1994

Baudrillard, Jean *Jean Baudrillard – Selected Writings*, ed. Mark Poster (Stanford University Press, Palo Alto) 1988

Baudrillard, Jean *America* (Verso, New York and London) 1988

Berry, Chris *A Bit on the Side* (EM Press, Sydney) 1994

Bhabha, Homi K. *Nation and Narration* (Routledge) 1990

Bhabha, Homi K. *The Location of Culture* (Routledge) 1994

Bird, Jon, Barry Curtis, Tim Putnam and Lisa Tickner, eds *Mapping the Futures* (Routledge, London) 1993

Blaut, J. M. *Colonizer's Model of the World* (Guilford Press, New York) 1993

Blocker, Jean *Where is Ana Mendieta?* (Duke University Press, Durham, NC) 1999

Blunt, Alison and Gilian Rose *Writing Women and Space* (Guilford Press, New York) 1994

Boyarin, Daniel *Carnal Israel* (University of California Press, Berkeley) 1993

Brett, Guy *Through Our Own Eyes* (GMP, London) 1986

Burgin, Victor *In/Different Spaces* (University of California Press, Berkeley and Los Angeles) 1996

Camnitzer, Luis *New Cuban Art* (University of Texas Press, Austin) 1994

Chambers, Iain *Migrancy, Culture, Identity* (Routledge, London) 1997

Chatwin, Bruce *The Songlines* (Penguin, Harmondsworth) 1987

Chow, Ray *Writing Diaspora* (Indiana University Press, Bloomington) 1993

Clifford, James *The Predicament of Culture* (Harvard University Press, Cambridge, MA) 1988

Clifford, James, ed. *Traveling Theories: Traveling Theorists* (Inscriptions, Santa Cruz) 1989

Clifford, James, *Routes – Travel and Translation in the Late Twentieth Century* (Harvard University Press, Cambridge, MA) 1997

Cohn, Robert and Laurence Silberstein *The Other in Jewish Thought and History* (New York University Press, New York) 1994

Colomina, Beatriz *Sexuality and Space* (Princeton Architectural Press, Princeton) 1992

Colomina, Beatriz *Privacy and Publicity* (MIT Press, Cambridge, MA) 1996

Darwish, Mahmud *Memory for Forgetfulness, August, Beirut, 1982* (University of California Press, Berkeley) 1995

Davis, Mike *City of Quartz* (Verso, New York) 1995

de Certeau, Michel *The Practice of Everyday Life* (University of California Press, Los Angeles) 1984

de Certeau, Michel *Heterologies – Discourse on the Other* (University of Minnesota Press, Minneapolis) 1986

de Certeau, Michel *The Writing of History* (Columbia University Press, New York) 1989

De La Campa, Roman, Ann Kaplan and Michael Sprinker, eds *Late Imperial Culture* (Verso, New York) 1995

DeLanda, Manual *War in the Age of Intelligent Machines* (Zone Books, New York) 1991

Derrida, Jacques *Of Grammatology*, trans. G. C. Spivak (Johns Hopkins University Press, Baltimore) 1974

Derrida, Jacques *The Truth in Painting* (University of Chicago Press, Chicago) 1978

Derrida, Jacques *Positions* (University of Chicago Press, Chicago) 1981

Enzensberger, H. M. *Die grosse Wanderung 33 Markierungen* (Suhrkamp, Baden-Baden) 1992

Ettinger, Bracha Lichtenberg *Matrix Halal(a)-Lapsus* (Museum of Modern Art, Oxford) 1990

Fanon, Frantz *Black Skin White Mask* (Grove Press, New York) 1967

Fausch, Deborah, Paulette Singley and Zvi Efrat, eds *Architecture in Fashion* (Princeton University Press, Princeton) 1996

Felman, Shoshana and Laub, Dore *Testimony – Crisis of Witnessing in Literature, Psychoanalysis and History* (Routledge, New York and London) 1992

Forman, Frieda, Ethel Raicus and Margie Wolfe, eds *Found Treasures* (Second Story Press, Toronto) 1994

Freud, Sigmund *Standard Edition* Vol. 21, pp. 219–53 (Hogarth Press, London) 1965

Fusco, Coco *English Is Broken Here* (The New Press, New York) 1995

Thomas, Nicholas *Entangled Objects* (Harvard University Press, Cambridge, MA) 1991

Togovnick, Marianna *Gone Primitive* (University of Chicago Press, Chicago) 1990

Trinh Minh-Ha, *Woman, Native, Other* (Indiana University Press, Bloomington) 1989

Trinh Minh-Ha, *When the Moon Waxes Red* (Routledge, London) 1991

Turnbull, Douglas *Maps Are Territories* (University of Chicago Press, Chicago) 1989

Verghese, Abraham *My Own Country* (Vintage, New York) 1995

Vidler, Tony *The Architectural Uncanny* (MIT Press, Cambridge, MA) 1992

Villa, Carlos, ed. *Worlds in Collision* (International Scholars Publications, Bethesda) 1994

Walker, Clarence *Deromanticizing Black History* (University of Tennessee Press, Knoxville) 1991

Wall, Cheryl, ed. *Changing Our Own Words* (Rutgers University Press, New Brunswick) 1989

Wallace, Michele, *Invisibility Blues* (Verso, New York) 1990

Wallace, Michele, ed. *Black Popular Culture* (Bay Press, Seattle) 1992

Wallis, Brian *If You Lived Here* (Bay Press, Seattle) 1991

West, C., R. Ferguson, M. Grover and Trinh T. Minh-Ha, *Out There* (New Museum of Contemporary Art, New York) 1990

Wigley, Mark *Derrida's Haunt* (MIT Press, Cambridge, MA) 1995

Williams, Patricia *The Alchemy of Race and Rights* (Harvard University Press, Cambridge, MA) 1991

Wollen, Peter *Raiding the Icebox* (Verso, New York) 1993

Wood, Dennis *The Power of Maps* (Guilford Press, New York and London) 1992

Wood, Dennis *Home Rules* (Johns Hopkins University Press, Baltimore) 1996

Yerushalmi, Yosef *Zakhor: Jewish History and Jewish Memory* (University of Washington Press, Seattle) 1983

Young, Robert *White Mythologies* (Routledge, London) 1990

Young, Robert *Colonial Desire* (Routledge, London) 1995

Zolberg, Vera ed. *Outside Art* (Cambridge University Press, Cambridge) 1997

Index

Alphabetical arrangement is word-by-word. Added to page numbers, f denotes figures and ps denotes plate section